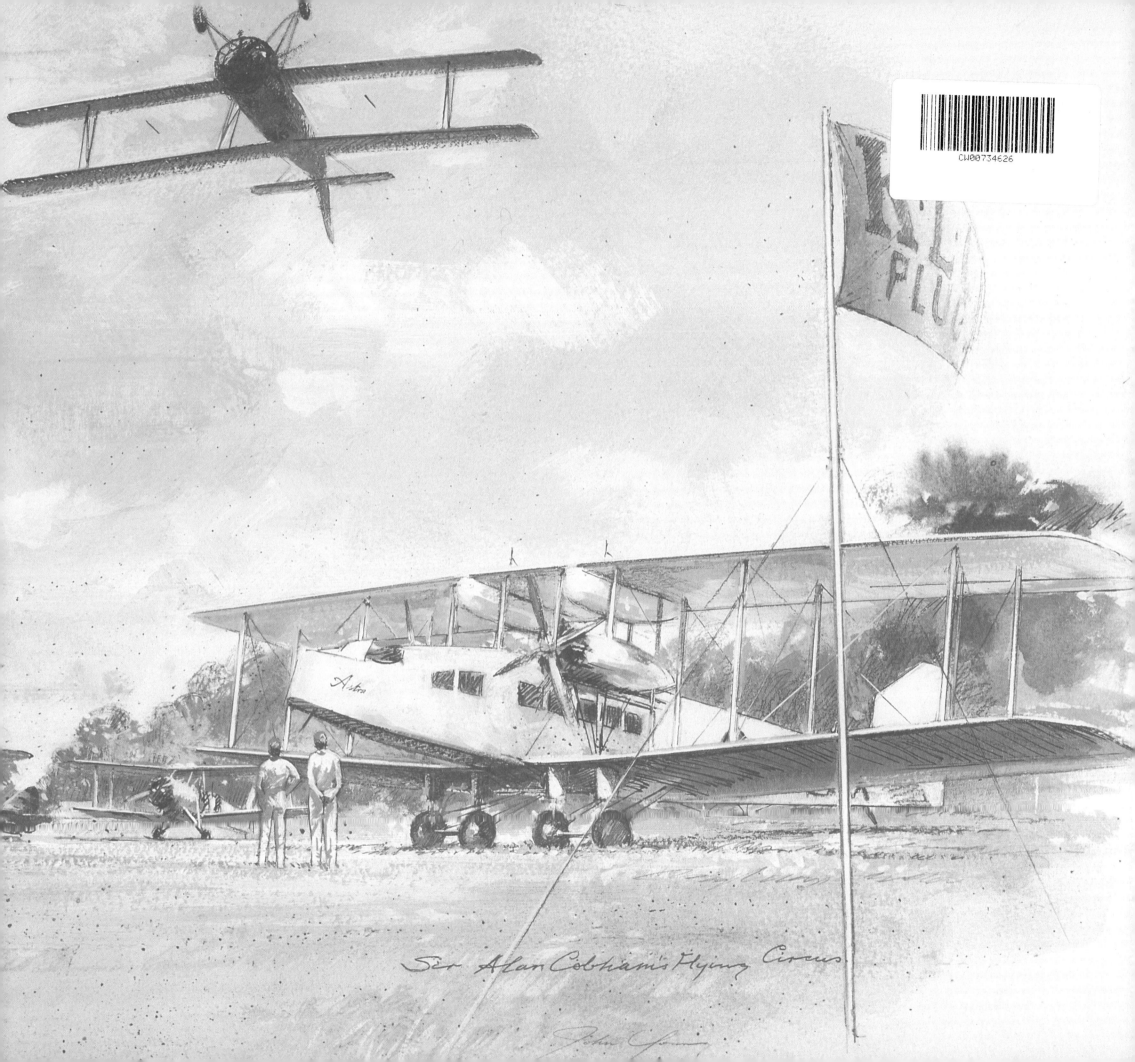

Sir Alan Cobham's Flying Circus

The Aviation Paintings of
JOHN YOUNG

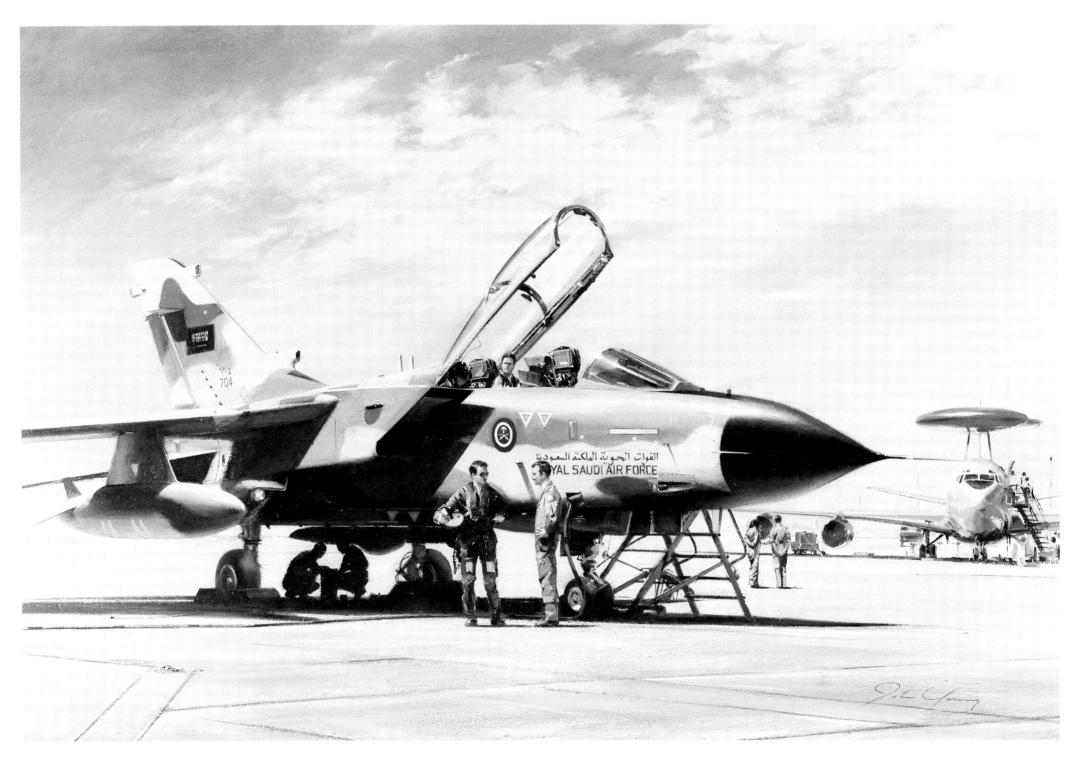

Desert Tornado
Panavia Tornado of the Royal Saudi Air Force.
Oil, 24ins x 34ins, 1987
Reproduced by courtesy of British Aerospace plc and the
Royal Saudi Air Force. The aircraft on the right is a Boeing
E-3A Sentry (AWACS).

The Aviation Paintings of
JOHN YOUNG

John Young

DAVID & CHARLES
Newton Abbot London

This book is for Barbara

Title page: Sopwith Camel

British Library Cataloguing in Publication Data
Young, John
 The aviation paintings of John Young.
 1. English paintings. Young, John
 I. Title
 759.2

 ISBN 0-7153-9395-2

Book designed by Michael Head

Typeset by ABM Typographics, Hull
and printed in Singapore
by C. S. Graphics Pte Ltd
for David & Charles Publishers plc
Brunel House Newton Abbot Devon

Water pump at the Wright Brothers' camp preserved at Kill
Devil Hills, Kitty Hawk, N. Carolina.

CONTENTS

Awards

FLIGHT INTERNATIONAL TROPHY 1967, 1969, 1974
 Runner up 1979, 1980

BRITISH AIRCRAFT CORPORATION TROPHY 1969, 1976
 Runner up 1975, 1979, 1982

QANTAS TROPHY 1972 Runner up 1975

THE AIRTOUR SWORD 1988

THE ROY NOCKOLDS TROPHY 1983, 1986, 1988

THE BRITISH LIGHT AVIATION CENTRE TROPHY 1977

THE GUILD OF AVIATION ARTISTS MEDAL 1983

Acknowledgements

Many individuals have chosen to help me on my way – to them, my gratitude is total. I regret that I am unable to acknowledge the names of owners of some paintings as their identity is unfortunately not known to me.

My thanks are due to Sir George Edwards for his Foreword and to Mr John Blake for his Introduction.

I gratefully acknowledge the assistance of the following individuals and organisations. Photo credits are indicated by page numbers in brackets.

Academy Communications Group; Aerodrome Press; John Batchelor; Michael Bignall; M.G.K. Byrne (26); British Aerospace plc; Chapel Studios, Berkhamsted; Edward Clarke; Christopher Cole Gallery, Beaconsfield; Flight International (25); Faith Glasgow of David & Charles; The Guild of Aviation Artists; Heritage Aviation Art (72); Hulton-Deutsch Collection (42); McCrudden Gallery, Rickmansworth; Ministry of Defence (30, bottom); R.G. Moulton (30, top); Stephen P. Peltz (7); Felix Rosenstiel's Widow & Son Ltd; The Royal Air Force; The Royal Air Force Museum, Hendon; Royal Air Force News; Jeremy Royle, Royle Publications Ltd; United Technologies, Sikorsky Aircraft; Wings Magazine, Canada (27).

Finally, my warmest thanks are reserved for my wife, Barbara, who translated my ramblings into readable words and typed the entire manuscript.

VC-10 at Gan
Crayon and wash, 1968
A VC-10 transport of the Royal Air Force stages through the Maldive Islands in the Indian Ocean, landing on the coral atoll of Gan, *en route* to Singapore from the UK.

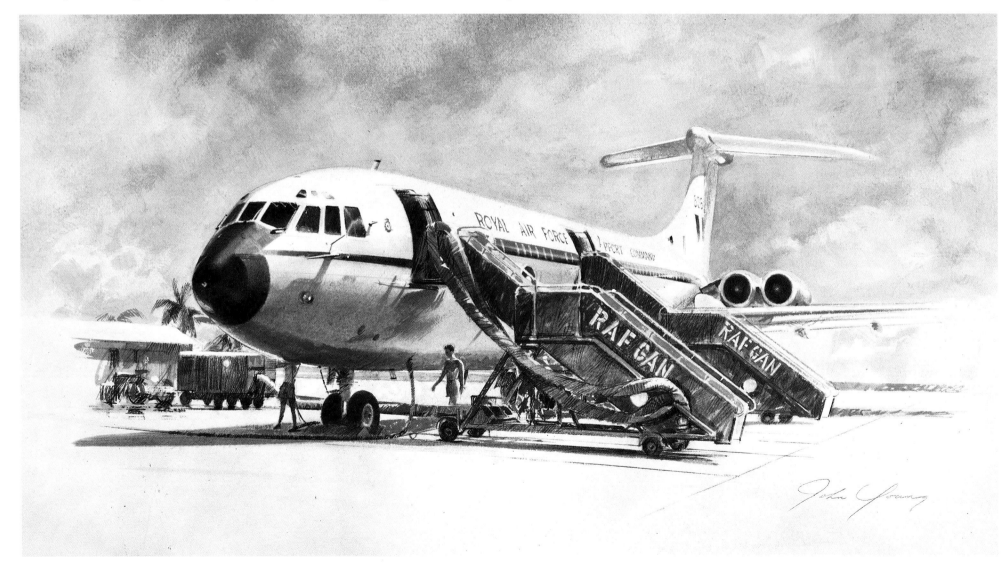

FOREWORD
by Sir George Edwards

This book is almost entirely devoted to John Young's paintings of aeroplanes, his interest in which began at an early age, when he saw Alan Cobham's circus. There is, however, much more to Young's painting than appears in this book. His landscapes, for example, are full of life and atmosphere, especially those of East Anglia.

Aeroplanes are a demanding subject. The painting is sure to be examined by experts of all opinions, including some of the chaps who designed the things in the first place. No scope for artist's licence here, I think. Yet lots of scope, as shown in this book, for an artist who knows about aeroplanes, getting the highlights and the setting right so that whatever beauty there may be in the basic design is brought out. After all, an aeroplane is only a chunk of metal, made into the shape which is best for the job it has to do.

I doubt very much if some of the great Impressionists and, more still, the post-Impressionists could paint an aeroplane. I am told that Sir Winston Churchill, when asked what he thought of some way-out paintings, said: 'I don't mind these chaps painting funny, but I want to see their credentials first.' When I hear of the exhortations of art teachers to their students to 'not worry too much about detail drawing, just express yourself freely in paint', I know not whether to laugh or cry.

Someone who could have painted aeroplanes was John Constable. Yet, in my humble opinion, his oil sketches qualify him as one of the first Impressionists – certainly before the French lot. Constable understood the disciplines and dedication which had to accompany the emotion and feeling – head as well as heart.

He once expressed his attitude to his work thus: 'There has never been a boy painter, nor can there be; the art requires a long apprenticeship, being mechanical as well as intellectual.'

I have gone on about Constable's versatility, his impressionism, his landscapes, his obvious love of nature and his ability to paint accurately and with discipline. I have drawn attention to John Young's possession of the same qualities, most especially as shown in his East Anglian landscapes. If, from all this, you gather that I think there are signs that the combination of qualities running through Constable's work are also to be found in John Young's, then you would be about right.

John Young is a more complete painter than this book can show. One day, I hope there will be one devoted to his other subjects.

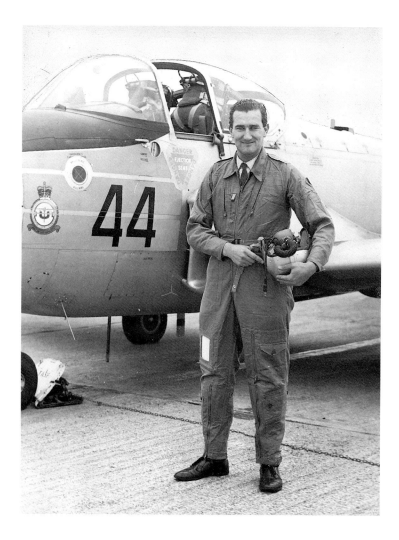

Sir George Edwards, OM,CBE,FRS.

A most accomplished designer of aircraft, Sir George was responsible for the design and production of some of the most successful aeroplanes of all time. His name will always be associated with the Viscount, Valiant, VC 10, One-Eleven and he is best known as the mastermind behind the Concorde.

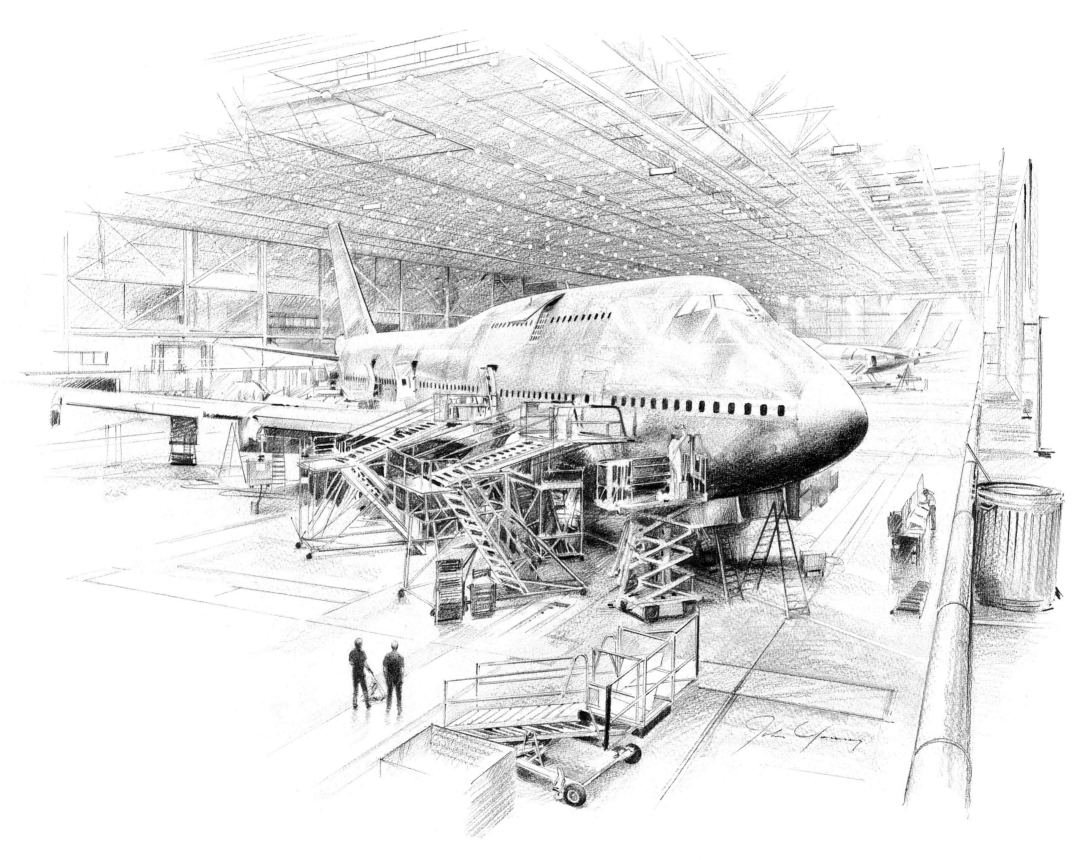

Final assembly of the world's largest commercial transport, the Boeing 747, takes place appropriately in the world's largest building, at Everett in Washington State, USA.

There are 68 acres of working space under one roof in the factory, and I have tried to capture the vastness of the subject in this sketch.

8

Introduction

One of the most interesting things about reading the autobiography of someone that you know well is the discovery that you do not, in fact, know very much about what he has been up to all these years after all. The other interesting thing, in this case, was to find that our early experiences in aviation had so many parallels. My own first introduction was via a Cobham Avro (but I got a flight) and my first military experience, like John's, was sitting in a Blenheim at RAF St Athan.

Like John, I also watched part of the great Arnhem armada flow overhead, but, with an advantage over him of some six years or so, it was at the other end of their journey! Shortly afterwards I got my second ever flight, in an ambulance Harrow. Alas I never had a Wellington on finals in my bedroom, though I did once have the front end of a real, live photo-recce Spitfire through the wall. Subsequently, our careers diverged and the rest of the book, for me is pure envy for opportunities well-earned and well-remembered.

I emphasise that 'well-earned'. It is too easy to forget, reading his light-hearted and enthusiastic descriptions of his various trips and looking at the apparently effortless results, that much hard work, pain and anguish were sandwiched between the inspiration and the result. How fortunate that he escaped an architectural fate; think what we would have missed. It was, I think, Brillat-Savarin who said: 'There are three fine arts known to mankind; music, painting and ornamental pastry-making – of this last, architecture is a subdivision.'

How fortunate, too, that he entered his studio career and formed his first characteristics as an artist at a time when the industry was in the later stages of a great artistic boom. In the years after the war the Society of British Aircraft Constructors launched a world-wide advertising campaign on behalf of the industry, until the individual companies got their own campaigns sorted out and were responsible for commissioning much of the work that started a number of professional artists on their careers, including John. One recalls vividly the impact of those early Woottons, Cuneos and Nockolds and – although at that time the name rang no bell – John Youngs. I still have a bulging folder of those advertisements, including a series called 'Sperry Weather' which John will no doubt recall.

My first personal contact with him came, like so many other good things, through membership of the Kronfeld Aviation Art Society. This was an offshoot of the Kronfeld Club itself, which was a very lively social focus in the fifties and sixties for gliding and home-built aircraft enthusiasts; an aviation parallel of the old Steering Wheel Club. In those early days our exhibitions were very different affairs from the highly professional Annual Open of the Guild of Aviation Artists; a Royal opening there is a far cry from the old Kronfeld with David Shepherd giving away the prizes standing on an empty beer crate.

Over the years it has been very interesting to watch the emergence of the romantic landscape and aviation artist from the talented representative of the commercial studio. The whole subject of the reaction of artists to the aeroplane is far too broad to investigate here, but it is interesting to see the responses of those with no natural aeronautical affiliations, when forced to come to terms with the aeroplane. In particular, Eric Ravillious and Michael Ayrton included aircraft among their subjects, the one because it was in his brief as a war artist, the other in commissioned series of woodcuts for an aviation advertising series. Despite their highly individual approaches, both had acutely analytical minds and could not deny the right-to-be-seen of the structure and design intent of the original.

John Young has inherited to a powerful degree this respect for structure and function, acknowledging the work of the aircraft designers and the specification parameters that have shaped his subject originally, and interpreting it to the viewer without feeling that it needs redesigning. He has, undoubtedly, devoloped as a Realist, rather than an Impressionist; he certainly exhibits the urge of the former group to plant yourself in front of the subject and paint what you see. His own words convey his approach to aviation painting lucidly and comprehensively and require no additional comment. His world-wide experience and recorded observations emerge from the text. How much this realistic approach developed naturally and how much resulted from commercial training would be difficult to say. Probably the road he has travelled was the only one that his hand and eye and mind would have let him travel, whatever. Aeroplanes are a challenge to the interpretive eye and his interpretations are superb. But he sees them as themselves and his love of every aspect of their appearance and their work appears clearly.

His interpretations are things of moods and settings, conveying qualities of materials and reflections of function as well as reflections of light. They capture the world in which an aircraft lives, whether poised in the golden bowl that sustains and surrounds it in flight, sinking back into the countryside that enfolds it upon its return, or resting tranquilly among the men and the man-made structures that shelter and minister to it.

In his Foreword to this book, Sir George Edwards doubts if the Impressionists or Post-Impressionists could have painted an aeroplane. The flying machine was too new for these European schools, so one will never know. Impressionist influences on John's work would appear to be small – except insofar as any painter of aircraft beomes inevitably absorbed in the problems of light reflecting from the textures and surfaces of his subject. All the same, one is tempted to take issue with Sir George; Impressionists grew up, so to speak, in the full flower of the Industrial Revolution and when they treated mechanical subjects, it was with an intelligent eye. Monet and Pissarro painted indentifiable railway engines and – like Paul Signac, Van Gogh and others – ships that would have floated and could have sailed.

John Young is best known to most of us for his aircraft paintings, but he is equally famous for his landscapes (also in the strong English tradition), as Sir George points out. He is equally at home with marine subjects; and in tracing the native influences upon him, one is here perhaps on surer ground. He himself likens aviation painting, with its infinity of viewpoint and wide choice of horizon levels, to painting under water. Even above or on the water, nautical artists have responded to this freedom to express the mood of their subject, and John's work is as much in the tradition of Constable's ship paintings as is that of his landscapes. In such works as Constable's *Coal Brigs on Brighton Beach* – and also in Turner's numerous nautical paintings and sketches before he dissolved into near abstraction – the artist could patently not deny the statement of the innate superiority of the correct shape. Here as much as anywhere, one feels, lie the origins of John Young's clarity of style, control of intricate details and feeling for structure. He is, indeed, a very English artist.

It is to a marine artist that one turns for a summing up of his particular qualities. Colin Ventry was speaking of ships, rather than aircraft, when he said that such painting should not be undertaken without careful thought and analysis. These subjects are particularly unforgiving to the indifferent draughtsman, and no amount of "arty verbosity" can conceal the lack of the ability to observe and draw.

John, I am sure, would agree with that.

John Blake succeeded John Young as Chairman of the Guild of Aviation Artists in 1989. He is famed, among other things, for his wit and wisdom as commentator of the Farnborough Air Show.

Background

A holiday in the Isle of Wight at the age of four is not easy for me to recall, but I do remember that my father, the son of a ship's captain, was eager for me to see the ocean liners passing Spithead on their way in and out of Southampton. Fascinated as all small boys are by giant machines and already familiar with steam trains, I was even more intrigued by yet another means of transport, an ungainly contraption which regularly defied gravity to bring passengers and newspapers to the island from Portsmouth: the aeroplane. It is probably significant that my memory of the landing and unloading of the Westland Wessex at Ryde Airport is clearer than my recollection of the big ships.

A year later came an event which is still startlingly vivid in my memory. A small biplane, side-slipping gracefully across a road near my home in Chesham, Buckinghamshire, landed beyond my sight in a local farmer's field. Its effect was extraordinary. At that time I was scribbling drawings like any child, but a deep need to make pictures must have already been implanted within me. This was the moment when aviation took over my life.

Light glinted on the propeller, slid along the shiny fuselage, tripped with a flash across the windscreen and glowed on the underside of the wings as it was reflected from the ground beneath. The puttering of the idling motor made music for this stirring sight. It was inexplicably beautiful to my eye, and I was smitten. And the experience, for me, had to be expressed on drawing paper.

That little Moth was the first arrival in the fleet of the National Aviation Day Campaign, the flying circus that Sir Alan Cobham, in the early thirties, took all over the British Isles in his crusade for air-mindedness. He believed that the air was the highway of the future and that all communities, even those of a modest size, would profit from a municipal aerodrome. His slogan 'Britain must have the freedom of the air' was carried

from one end of the country to the other wherever he could find a field big enough to take his aeroplanes. He was convinced, quite rightly, that cheap, brief flights would be a memorable and effective method of winning hearts and minds. He lured the locals to the field with a thrilling flying display of aerobatics, crazy flying, wing walking, racing, parachuting and gliding. People without any particular interest in aviation still talk of Geoffrey Tyson's feat of picking a handkerchief off the ground with a spike attached to the wingtip of his Tiger Moth, a test of true skill which he performed more than 800 times.

Filling the airliners with joy riders was the least of Alan Cobham's problems. Wide-eyed with wonder, ordinary townspeople looked down on their homes and wished for a longer flight – some cynics even complained that, on the approach for landing, the wheels were still spinning from the take-off! However, the majority had experienced the thrill of a lifetime which remained a talking point for years to come. The memoirs of countless people who have made a career in British aviation begin thus: 'It all started for me with a five-bob flip with Alan Cobham'. That was certainly where it all began for me, and I didn't even get a flight! At that time, the only member of my family to have flown was my father, who, as a Royal Engineers motor cyclist in the First World War, delivered despatches to French airfields. In July 1918, he had been given a half-hour flight in a Voisin biplane. But he did at least take me to see the Flying Circus, and henceforth the course of my life was to some extent decided.

Within seven years of the visit of the air circus, the same countryside echoed to the roar of bombers. There certainly were two sides to air-mindedness, and the freedom of the air had to be won the hard way.

I was born in Bristol, in 1930, just a week after Amy Johnson reached Australia, having flown solo from England. One London newspaper carried a two-word banner headline: 'She's there'. Aviation pioneers were certainly household names. Scott and Black were heroes of mine when they won the MacRobertson Air Race to Melbourne in 1934, and my part of the national enthusiasm took the form of a die-cast model of the winner, the Comet Racer. That little replica was my most tactile lesson on the shape of an aeroplane.

So far as significant pictures were concerned, the walls of my home were bare – the paintings which excited my eye were in books and magazines, usually the work of contemporary illustrators. Serious art education

was still a decade away. Meanwhile, my young days were ideally happy, with great encouragement from my parents for my various enthusiasms, usually in the shape of drawing materials. The most memorable was a slate. Hours passed with that uncomfortably thin pencil squeaking across the grey surface, creating an endless spidery procession of trains, ships and . . . planes.

The thirties were the heydays of the record-breakers, trail blazers and stuntmen. For Britain, the important task was to survey routes, and set up air links with the Empire. School teaching and influences such as the *Boy's Own Paper* emphasised the importance of the dominions and colonies, while the newspapers called for faster travel across the Commonwealth, often sponsoring expeditions, races and record attempts. We had the powerful lobby of the Air League of the British Empire, the Empire Air Routes, Empire flying boats and the Empire Test Pilots' school. Before the decade was half over, dreams of a world-ranging merchant air fleet had to take second place to the awakening realities of international politics. Even the youngest of us were aware of the talk of rearmament, so soon after the end of 'the war to end all wars'.

The Royal Air Force between the wars was conscious of the benefits of publicity and speed, and height and distance records were hailed as great achievements for both service and industry. The annual RAF display at Hendon became world-famous. Even the cards collected from my father's cigarette packets featured coloured pictures of the latest fighting aircraft.

My first chance to see the Air Force in the flesh was on Empire Air Day, 1939, when nearby RAF Halton held 'open house' and modern monoplanes were on show both on the ground and in the air. The 'Camp', as it was always called, was first used as a flying ground before the First World War and became a training school between 1914-18. By 1939, it was the largest educational establishment in the RAF, home of 'Trenchard's Brats' – the boy apprentices who went on to form the technical backbone of the air force, learning their trades on a variety of instructional airframes which were on show to the visitors. One of these, a time-expired Blenheim, was open for inspection and I went inside an aircraft for the first time. Entry to the cockpit of a Blenheim is through a hole in the roof – dropping into the pilot's seat. No sooner had I sat down to enjoy this new and exciting sensation and to inspect the mass of dials and switches in front of me, than it was someone else's turn and I had to get out.

Westland Wessex

The next excitement was the commencement of the flying display. A formation of Fairey Battles swept in out of low, scudding clouds, followed by a Hawker Hart and a handful of parachutists from a Vickers Valentia. My favourite Fury did a beat-up and then its successor the new Hurricane appeared. But the showstopper for me was my first sight of the beautiful Spitfire, which, combined with the magic sound of its Rolls-Royce Merlin engine, had me hooked all over again.

The aftermath of an air display was endless talk among the boys. My friends were passionate about engines and their horse power, top speeds and rates of climb, but I found my pleasures in the harmony of the colours of the aircraft, that exquisite and particular shade of duck-egg blue on the undersides (I have learned more than a little about colour-mixing in pursuit of that precise shade), contrasting with green and brown camouflage above. I was beginning to discover the thrill of producing effects with my pencil – a cast shadow, accurately recorded, gave such depth and realism to my early efforts. I still have some of the drawings made at school, reflecting the troubled times, every aircaft bristling with guns and dropping unbelievable loads of bombs. My parents recognised and encouraged my efforts and arranged at least one memorable excursion. A local timber merchant was removing trees from the fighter station at Northolt, fifteen miles from my home. He was told of my interest and took me on to the airfield and among the dispersal areas occupied by a couple of squadrons of Hurricanes. Here was a new brand of excitement, the hectic pace of an operational base working up for the fight that was to come. Oh boy, the front line wasn't going to be too far from home!

The Field of Conflict

I heard Prime Minister Chamberlain's broadcast at the outbreak of war, but cannot pretend that a nine-year-old was at all aware of the awesome implications of a conflict which would be brought by air to the ordinary people. At my level, I could sense my parents' anxiety through practical problems such as the difficulties of making a room gas-proof or maintaining total blackout. On the second day of the war, RAF bombers attacked north German naval bases, and I became an unofficial war artist overnight through sheer imagination, fed by

G.A. Monospar
Amersham Grammar School
1941

new visual stimuli like the night sky swept by clusters of searchlight beams and, by day, the new phenomenon of condensation trails left by high-flying aircraft. The local know-alls had wonderful explanations as to how they were caused, but as time went by every one was proved to be nonsense.

Before the war, in what were still pioneering days in aviation, there had been some forced landings in my local neighbourhood – relatively gentle arrivals, bruising nothing more than a pilot's ego, the rueful aviator standing by, removing wooden splinters from his clothing. The war brought heavier metal into collisions with our rolling Chiltern Hills. In one episode, a Blenheim bomber remained reasonably intact following a belly landing in a shallow valley known locally as 'Arber's 'Ole', although it appears on the map as Herbert's Hole. On the day in question, our headmaster short-circuited mass absenteeism by forming us into a crocodile of more than a hundred boys and marching us two miles to the crash site. We peered in astonished silence at the intruder and then marched back again.

Very little action in the Battle of Britain took place to the north of London, but one incident stands out in my memory because the date was 30 August 1940, my sister's birthday. The party going on in the garden was interrupted by the sound of anti-aircraft fire to the north – an unusual direction. Soon a formation of aircraft approached, under attack by fighters. The youngsters were bundled under cover but I remained where I could see any action. I have since discovered that a force of Heinkels had been bombing the Vauxhall Motors plant at Luton, and the Handley Page works at Radlett, twenty miles to the north-east. Two were

brought down by Hurricanes and, as they turned for home, passed over our garden, allowing me to witness one brief incident in the battle that changed history.

The battle was in full swing when the new school term commenced in September 1940, and I moved up to the Grammar School which possessed a large sports field. One morning, word spread that a Magister trainer had lobbed into the trees at the end of the field, some distance from the school buildings. Morning break was sounded, feet clattered, a horde of boys swept to the spot where the little wooden aircraft had splintered gently to the ground. By lunchtime, there was just the engine lying forlornly by a tree. I have my piece still. Not long after this show of airmindedness, the school acquired an instructional airframe, a twin-engined Monospar, in good condition, looking smart in its blue and silver pre-war livery. Parked beside the Air Training Corps hut it looked convincingly airworthy, perhaps misleadingly so. One overcast afternoon, hockey and football were in full swing. A Beaufighter came out of the cloud, circled and lowered its wheels, obviously intent upon landing. The pilot realised his mistake in time and flew away, but, mindful of what might have been a catastrophe, the school authorities sentenced the Monospar to be camouflaged and it ended its days in ignominy beneath a coat of sickly green distemper.

In 1943, I changed schools and was sent to the Royal Grammar in High Wycombe. The Air Squadron there had been given a Hawker Hind, a magnificent biplane which stood beside the dining hall. Waiting for lunch cheek by cowl with this beautiful machine every schoolday for a couple of years, I learned almost by un-

conscious observation about the anatomy of the aircraft's structure, about the behaviour of light and shadow in various kinds of weather, be it rain, frost or snow. The Hind has remained one of my favourite aeroplanes and was to become the subject of another interesting episode in my life some thirty years later (see p.43).

Looking back it is difficult to imagine how the nation's priorities were decided, with an all-out war going on, but great importance was placed on keeping the people informed. Manpower was somehow found to take aeroplanes apart, and to transport and assemble them for public display, particularly to support fund-raising campaigns like War Weapons Weeks. A Spitfire and a captured Messerschmitt were once exhibited in a local car park and my friends and I never forgot or figured out the reason for the strange smell of the German fighter.

War affected day to day life in many ways, and some of the measures taken to counter the anticipated enemy invasion in 1940 were unsophisticated to say the least. Near my home, for example, were a pair of road-blocks guarding a crossroad. Each consisted of a tree trunk mounted on the grass verge by means of a crude hinge. At the other end was a cartwheel, and, in theory, the device would be wheeled across the road on news of the invasion. The sturdy beeches were then expected to stem the tide of the Panzer Divisions!

Air-raid sirens wailed by day and night and many hours at school were spent sitting in darkness in air-raid shelters. The woodwork classroom was producing dummy rifles for the Local Defence Volunteers, later known as the Home Guard. Travelling to school, always carrying a gas-mask, we sometimes collected splinters of shrapnel in the streets. Signposts were removed from the roads, station names obliterated and church bells silenced to be held in reserve as a warning in the event of landings by parachute troops. The London balloon barrage was just visible from my bedroom window as a row of silver pin-pricks of light on the horizon. In my own possession was the ultimate lead balloon – a die-cast replica which I could haul up to the bedroom ceiling by pulley.

The school bus had hooded headlamps and gauze-covered windows. Our journeys usually brought us into contact with truckloads of prisoners of war, who were camped round about and working on the farms. Early exchanges of mutual abuse mellowed into civilised greetings as the war years went by. The build-up of the bomber offensive filled the sky with sound night and morning. The noise of scores of heavy bombers pulsed and merged to a dull roar, filling the air as they made height, outward bound with incredibly heavy loads. Coming downhill on the way home, they still managed to wake us each morning, often to discover gardens and trees festooned with metal foil strips, known as 'window', used to jam enemy radar. We never knew why so much of it landed on us.

Some damaged bombers made forced landings in the area. Explaining and speculating about bumps in the night was part of the ritual of arriving at school. One morning a classmate engaged every one's attention by announcing: 'There's a Lanc without any wings down at Oldhouse Farm, standing on its wheels in the big field and old Jake is knee-deep in leaflets.' I could hardly wait for the day to end so that I could cycle over to see for myself. The outer wings were lodged in two trees at the edge of the field. With some good judgement and a lot of luck, as it had probably been almost dark at the time, the skipper had steered through the gap to pull off a skilful landing. Propaganda leaflets in French and German were blowing all over the place and I added a few to my collection.

Staring at heaps of wreckage was all very well, but it did not contribute much to the business of drawing whole, flying aeroplanes which only passed at a distance. The nearest RAF station where one could see the real thing, taxying about, taking off and landing, was a thirty-mile round-trip cycle ride away. At about this time, fast, unarmed bombers were being introduced such as the Mosquito and they needed to practice flying at very low level. They would appear from nowhere at tree-top height, followed by a wall of sound from the twin engines, scaring man and beast. My mother never came to terms with the noise and I have a vivid memory of her clinging to the kitchen sink after one of these shattering passes. Nor did she like the Whitley bomber, never forgiving it for flying in a pronounced nose-down attitude, the very embodiment of evil, she said.

She would pack sandwiches for the occasional long cycle rides to airfields, but these excursions always seemed to be very hard work for very little result. RAF stations were well guarded and spectators discouraged. The wartime days dragged on with not enough to occupy my somewhat specialised interests. It was the US Cavalry which rode over my particular hill and saved me from any danger of boredom.

The Machines of War

My thirst for information was not satisfied by infrequent photographs of aircraft in newspapers. The radio would tell of new types in action and I wanted to know what they looked like. Searching around in the newsagents I came across *The Aeroplane Spotter* – could it be that for threepence, someone put out a small newspaper solely devoted to aircraft recognition? A new source of knowledge and pleasure, and affordable! Later, of course, I discovered that there was a whole press devoted to aviation, but that little *Spotter* with its Wren cartoons has a permanent place in my affections.

When rumours of an airfield being built near the village of Bovingdon only two miles from home turned, literally, to concrete, the youngsters visualised an endless source of pleasure whilst the parents could only see a likely enemy target. But despite some parental opposition, I was to spend many happy hours watching the flying from this field. It undoubtedly accounts for the large number of take-off and landing subjects among my paintings, and parental fears were fortunately unfounded.

The first B-17 Fortresses of the United States Eighth Air Force arrived during the school holidays of August 1942. The real shock for our insular country community then came, with the influx of three thousand Americans who were setting up a bomber training base. The unit was to be known as a Combat Crew Replacement Centre, responsible for the indoctrination of new aircrews, training them on the procedures used in the war in Europe. Occasionally they were called upon to fly an operational mission in support of the small force of Fortresses available at this time. I remember the tension of the preparation for one of these raids on 5 September. The mission was to bomb an aircraft factory at Meaulte in northern France. Fourteen of the older B-17Es were coaxed into a fit condition, while crew numbers were made up by taking along ground personnel including private soldiers. A story circulated after that raid that a corporal from the cookhouse shot down a German that day.

This sidelight on the early days of the embryo Eighth Air Force gives some idea of the general atmosphere at Bovingdon. The flying field proper was strictly out of bounds to sightseers, but the aircraft parking areas were dispersed into the surrounding farmland. One of these clusters of concrete panhandles was in the village of

Whelpley Hill, a few minutes' bike ride from home. The planes taxied across a public road to their parking spots, among the trees and farm buildings. Standing tentatively on the road to watch the activity around the aircraft soon led to friendly relationships with the ground crews. Their natural hospitality made me welcome in and around the Forts and a willing twelve-year-old would soon join in the cleaning and polishing jobs. Controls and some items of equipment were not to be touched and we were never allowed to see the Norden bombsight which was kept under a canvas cover at all times. It was still shrouded in secrecy long after it was known that the enemy had captured one intact.

I returned home with chewing gum and a new accent. The secret of this privileged access was knowing when to vanish. When the aircrews arrived, we retired to the sidelines to watch them struggle into heavy clothing and parachutes, listen to the whine of starter motors and the threshing of propellers. Smoke whipped back across quivering tailplanes, crew members waved, brakes squealed as they meandered away round the perimeter track, turned on to the runway and lumbered into the air. The faithful watchers were there when they returned and refused to go home until the last engine had ticked to silence.

The tempo of flying training was intense and my close contacts soon taught me that these big inanimate machines were surrounded by interesting people, most of whom shared the gift of humour in adversity. For instance, a new crew had had the adventure of a lifetime bringing a bomber across the Atlantic, finding our misty little isle with difficulty, only to be baffled by the un-American jumble of industry and agriculture below them, the balloon barrage and the sheer number of new airfields. Flushed with success at having found Bovingdon, they landed, fell in behind the 'Follow Me' jeep and taxied to a distant hard standing. There, grinning comrades held aloft a sign saying 'Welcome to Alconbury'! If this was war, it was OK by me.

I became obsessed with detail in my drawings as so much information was coming from close observation. They resembled technical diagrams at this stage but I was also demonstrating to my friends where I had been and what I had seen! The emphasis on technical accuracy was not a bad training for the future, but the hardest lesson to learn is one which only comes with maturity – what to put in and what to leave out. Mercifully none of these efforts survived although, in 1943, a line drawing of a B-17 appeared in the school magazine – my first published work!

The runways at Bovingdon were shorter than those of the East Anglian operational bases, and some misjudgements caused accidents in the fields on the approach. From a spotter's point of view, my main problem was a large mature hedge between the road and the airfield with no real vantage point to watch the take-offs and landings. The solution was provided by a B-17 Flying Fortress driver who, coming down the runway, ran out of brakes, concrete and ideas, in that order. He made a magnificent hole in the hedge which served all the young enthusiasts well for the rest of the war.

Aircraft 'nose art' is now quite a well-documented subject and we witnessed the beginnings as the crews of the Fortresses and Liberators engaged in the European theatre pasted pin-ups on their planes for luck. Being paper on metal, these did not last very long and the crews began to personalise their own machines with hand-painted names, pictures and slogans. The aircraft on the dispersal point where I spent all my leisure hours were christened Stinky, Johnny Reb, Peggy D, Alabama Exterminator and Yankee Doodle. Names with a *double entendre* came later. *Very Important Painting* on page 55 shows a ground crewman adding the latest score to the mission tally.

A tour of duty for a crew consisted of twenty-five operational missions and only the lucky ones made it to the end of a tour. In one week of October 1943, with the loss of 148 bombers, casualties reached a level which could only be alleviated by the provision of a fighter escort all the way to the targets deep in enemy-held territory. The legs of the Thunderbolts, Lightnings and the new Mustangs were just not long enough to go to Berlin and beyond. Sufficient fuel to overcome the problem was provided by carrying external, jettisonable fuel tanks, which were developed by a technical unit based at Bovingdon. This interested me, as the fighters used for testing moved into the parking areas normally occupied by B-17s in the dispersal area

Yankee Doodle
B-17E Fortress, which flew on the first B-17 operation, a raid on Rouen, 17 August 1942, with General Ira Eaker aboard. At Bovingdon, *Yankee Doodle* used to park on a hardstand behind the White Hart pub at Whelpley Hill.

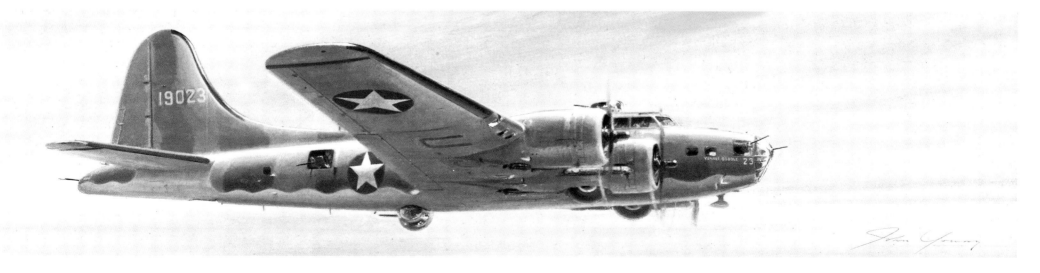

P.61 Black Widow
BOVINGDON '44

nearest to my home. The highly polished metal of these single-seater aircraft made a refreshing change from the decidedly weather-beaten camouflage of the old bombers – and anyway the fighters were definitely more glamorous!

A large number of visitors came to Bovingdon by air, usually to take advantage of the short road journeys to London and to various Headquarters establishments in the area. The log that I kept listed nearly every type of landplane in Allied service, plus the odd amphibian and several captured enemy types. It was not a bad spot for an aviation fanatic like me to find himself. By the end of 1943, Bovingdon was providing crews for the build-up of one of the biggest air forces of all time. During the summer of 1944 wave after wave of Fortresses formed up for battle, until more than a thousand aircraft were often visible in the sky at one time – a staggering and quite unforgettable sight.

In 1944, I did not have much time for drawing with the pressures of matriculation upon me, but all these sights and impressions were being stored for future reference. I spent as much time as I could at the base and there was little doubt in my mind that somehow aviation was going to be important to me. As the tide turned in Europe, following D-Day, I remember the armada of gliders and tugs which took the Airborne Forces to Arnhem in September 1944. The stream took hours to pass over us on a Sunday morning and I did make a brave attempt at a vast painting to try to capture the sight. It was too large for my limited skill to control. I had bitten off more than I could digest and the sad result looked more like a failed Bayeux Tapestry.

In this last summer of the European war, the London area came under attack by ground-launched cruise missiles, the V-1 flying bomb and later, the V-2 ballistic rockets. Both were terrifying weapons and a number strayed into our area, giving good reason to rejoice when peace finally came in May 1945. May 8th was a great day. We built a bonfire and the evening spent around it with friends and neighbours was one of pure happiness. As the party dispersed, instead of going home, something drew me back to my spot at the end of

the runway at Bovingdon. It was dark and quiet and I didn't really know why I was there – something to do with finishing off my war, I suppose. Suddenly a flare shot up from the control tower, then another, then another. Red, green and white, the brilliant pyrotechnics went on until the chaps in the tower had used everything they had. The dark nights were finished with; we could turn the lights on again. It had been a wonderful day with friends, but that private moment of celebration will be with me forever.

While some of the academic teaching had suffered from the problems of wartime life, not least because a great many male staff had gone off to war, my drawing instruction was of a very high standard, though my efforts to introduce aviation subjects into my work were not encouraged. I enjoyed every minute of the subject I was good at, dealing with questions of perspective, chiaroscuro and form, but I longed to paint. However, time and materials were not available and I had to deal with my general academic qualifications first. Once matric. was successfully accomplished, the way was clear for a full-time art training and in 1946 I entered High Wycombe School of Art.

Art School

The end of a six-year world war was a time of emotional upheaval and, having been no more than an observer, I still found the rush of events affecting. The world suddenly had nuclear weapons and terrible cruelties had come to light. On a personal level, daily routine and life in general were about to change again.

In the same month that Japan surrendered, my first holiday away from home since 1939 was at a boys' camp, at Beaumaris, overlooking the Menai Strait, between North Wales and the Isle of Anglesey. The road to the camp crossed a slipway on which flying boats were hauled to a modification centre, where radar was fitted before delivery to the squadrons. The holiday had a serious underlying purpose – to help us make up our minds on spiritual questions. This was just about the right time for me. I had attended a regular Sunday Bible class for many years, and was coming to the conclusion that life in a creative career could not be contemplated without acknowledgement of God's hand in the scheme of things.

Singing with friends around the campfire on a fine

evening with the sunset catching the water, surrounded by Catalinas and the mountains of Snowdonia, one wondered if life had more to offer. A straight-from-the-shoulder challenge from a squadron leader who had flown with the Pathfinders left me in no doubt that God had a claim on me, and that conviction has remained to this day. The ability to draw and paint is a gift from Him and not something for which I should be tempted to take any credit.

On return from this cathartic experience, I now looked forward to full-time art training. At art school I steadied myself to the demands of life drawing, wrestled with sculpture and, having to choose a craft subject, discovered the deep satisfaction of wood-working in the furniture design and cabinet-making course. I had an affinity with wood dating back to whittling with balsa wood as a child. I had built sailplanes which flew exceedingly well despite my rather impatient construction. Full-sized aircraft made of wood had indeed played a vital part in the war, none more so than the Mosquito. Large parts of its structure were sub-contracted to the furniture industry, and my daily bus ride to school used to pass a works where fuselage half-shells waited in rows for collection by de Havilland. It may well have been at this time that I made up my mind that 'D.H' made exceedingly good-looking aircraft and would be a very desirable company to work for. But drawing was the main discipline at High Wycombe with the only chance of serious painting tuition still a couple of years away. In the event, I gained an intermediate qualification, was called up for National Service and taught myself to paint.

I was having a battle with my parents to persuade them that there was any future in either my art or aviation. They would have preferred a safe bank clerk's stool, but mathematics was not one of my strong points. They were prepared to consider architecture, but I was set on somehow marrying my gifts and my passion. My argument was supported by the fact that the Government information services were anxious to continue the education of the public in airmindedness and several major exhibitions were mounted in London with this express purpose.

For me, Bovingdon offered new interests. It was now an airport, and airliners diverted from fogbound London often filled the concrete aprons. Charter companies blossomed and tried their luck with war-surplus aircraft. Like aerial tramp ships, they carried all manner of cargo around the world on a very happy-go-

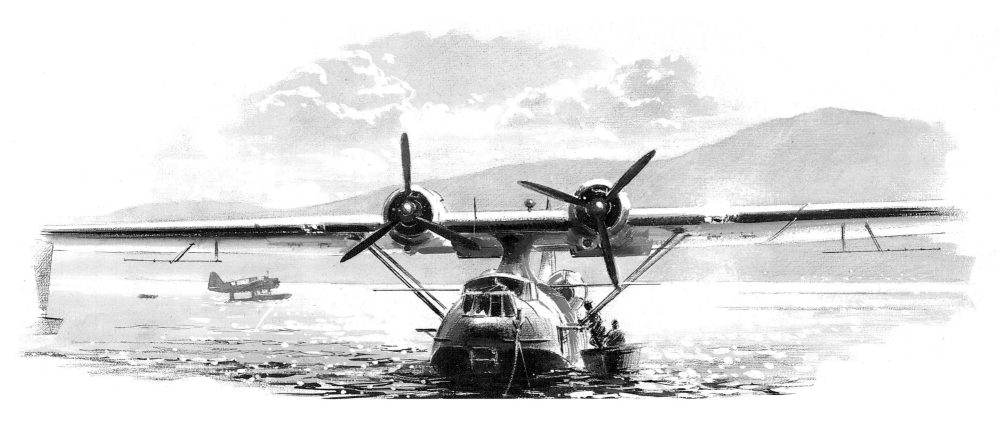

lucky basis. The crews, set loose from combat flying, revelled in this kind of buccaneering, although harsh economic conditions made commercial survival very difficult.

The skies were friendly for a very short time, and the crisis over the Russian blockade of Berlin produced the plan to supply the city entirely by air. It was Target Germany all over again. The charter companies, together with the British and American Air Forces, slogged to and fro through the narrow air corridors to the besieged city, transports flying in at five-minute intervals carrying coal and oil, food and clothing without a break for nearly a year. The Berlin Airlift proved that air power could not only win a war, it could be used to prevent one.

Pivotal Moment

Two-Six! This Halifax had to be moved. A cargo aircraft on charter, over-running the Bovingdon runway, had slewed into a ploughed field, leaving the left wing blocking a road normally busy with traffic. A solitary mechanic was working to release a long row of screws before a crane could lift away the offending mainplane. He tossed me a spare screwdriver. When the job was over and the road cleared, the working party packed up and headed back to the company hangar offering me a cuppa if I cared to come along. Can a duck swim! My efforts were recounted to the chief engineer, who thanked me warmly. The atmosphere seemed to me like a Nevil Shute novel. Large duck-egg green Halifaxes were crammed into the hangar around us. The smell of the cellulose and hydraulic fluid filled the air. Overalled figures were grouped on stands around uncowled engines and a dropped spanner echoed in the vast space.

I sat with my tea among these flying men, hanging on their every word. Then the chief engineer asked me if I wanted to be a pilot. I explained that I drew a bit and he invited me to come in to sketch at any time. After turning out a few drawings I tried a fairly ambitious painting of a freighter stripped for major overhaul – and he asked if he might have it! This was the pivotal moment. The education process will never end, but

this was the moment for which I had prepared so carefully. Learning had given way to producing. Someone actually wanted what I could give.

What was more, there was something in it for me. In exchange for the painting, he offered me a trip in a Halifax to take part in an air display at Leeds, another Lancashire Aircraft Corporation base. On that flight north, standing in the astrodome of that old bomber with props turning lazily and wings flexing gently, looking down on cloud just as I had seen it in thousands of photographs, my cup was full. This was the missing link, after years of watching others fly without having the experience myself. I painted as many studies as my own work at art school would allow and was rewarded with more or less unlimited flying. It was just what was needed to give authority to work with which I hoped to earn a living.

I will always be grateful for what the Lancashire Aircraft Corporation gave me over the following eighteen months. They had a fleet of eight-seater de Havilland Rapides which were used for general air-taxi charter work. During the summer months, one or two were taken each day from Bovingdon to the two civil

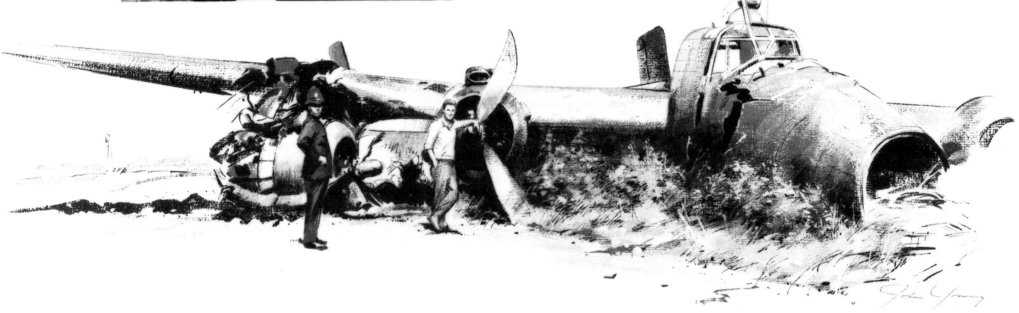

Inbound to Bovingdon from Lyons with a cargo of fruit, Halifax F-BCJX overshot the runway on 13 May 1948.

airports for London, Northolt and Heathrow, where, based beside the public viewing enclosures, they offered pleasure flights over London. For fifteen shillings (75p) you could take a turn over Hyde Park, which from about 1,500ft (457m) gave a wonderful, panoramic view of the West End. For twenty-five shillings (£1.25), the turn was made over Greenwich Observatory, offering superb views of the shipping on the River Thames, the docks and Tower Bridge. I took tickets, positioned steps, checked seat belts, disposed of sick-bags, dispensed information and generally tried to be helpful. Six paying passengers seemed to be break-even point, and so, rather than keep them waiting for further customers, the flight would go and I would get one of the empty seats. Not that operating

costs were ever mentioned, life was so easy-going. If there was a Test match at Lords, a couple of lazy circuits was no problem.

My eighteenth birthday arrived and just one more obstacle lay between art school and a job – two years in the Royal Air Force. Perversely, that was one place where I didn't come across much aviation, although I still continued the pleasure flying with Lancashire when on leave. A new feature of their programme was a package deal of dinner in the West End, car to the airport and a flight over the city after dark. It seemed that only Americans could afford this adventure and the Rapide was never full, leaving space for me to revel in the visual miracle of the lights of London. The pilots were resting from the discipline of the Berlin Airlift

and whilst 'bus driving' tourists were fairly restrained affairs we had some very exuberant trips back to base.

My last flight on the Heathrow Rapides narrowly missed being my last flight ever. On Battle of Britain Day 1949, the visibility was poor, and the commemorative fly-past over London which was a feature of the celebration in those days, had been postponed for a while. Our pleasure flight was allowed to leave the airport as usual, but over the Thames at Westminster, a single Hurricane zipped by a few feet above us and in a moment we were surrounded by formations of fighters, bombers and transport – the fly-past had not been held up for long! A shallow diving turn and we shot back to Heathrow, where an inquiry was held and my unofficial status prevented any more flying for the time being.

Can I Get a Job?

Giving aptitude tests to thousands of recruits was not what I had expected to do with my time in the Royal Air Force, but the immediate post-war period of conscription did not offer many thrills. It was a nine-to-five job, testing square-bashers for their unlikely futures in the Force – a welcome respite for them from the drill instructors. But it did mean that there was a reasonable amount of spare time for me, and the RAF encouraged off-duty craft hobbies. Painting was therefore possible in the reasonably comfortable hut known as the Education Section. My burst of activity coincided with an exhibition of work held at the headquarters of Technical Training Command. *Flight* magazine dated 12 May 1949 carried a report which included a gratifying sentence: 'Among the exhibits which were of a remarkably high standard, special mention should be made of the work of Cpl. Young (West Kirby).' I had won the art prize with a sepia wash study of an RAF York unloading on the Berlin Airlift. This seemed like tangible evidence that my work was worth something, and was the encouragement needed to pursue my plans.

At this time my parents were supportive over my work, but still sceptical that I could earn a living by it – they hoped fervently that I would turn to a 'real job' which would allow painting to take its place as a 'nice hobby'. But, far away from home, in Cheshire, there were few outside influences to dissuade me from my chosen course of action. It must be said that a liberal dose of discouragement is a good test of the inner strength and conviction required to press forward in a very competitive occupation. Such resolve is essential to cushion the blows that are part and parcel of any sort of performing in public.

One of my highly developed weaknesses shot to the fore at this time. A never-failing ability to put all my eggs in one basket paid dividends for once at this time. I set out to prepare specimens of work aimed not merely at one market, but at one particular firm, the de Havilland Aircraft Company. This enterprise had been first in the field with the Comet jet airliner, had about a dozen types or variants in production at several different factories and held a large share of the world market in piston and jet engines, propellers and, later, guided weapons. The company was also undoubtedly a patron of artists – a study of their advertising proved that. So I prepared a folio of work aimed squarely at 'D.H.'.

My artwork was sent to Hatfield before my demob and I was called for an interview on one of my very first days as a civilian. Arriving like a nervous actor at audition, I was shown into a small waiting room, bare of decoration except for one small painting – but what a picture! It was the Frank Wootton original of a small lonely Moth at height, called *Altitude Record*, which has to be judged as one of his all-time greats. In the face of such competition, the timid side of me wanted to turn tail and run, but the practical side that needed a job sat tight to see what would happen. The wait was short and a secretary showed me to the office of the Public Relations Manager, Martin Sharp. There was little informality in this meeting but to my immense, and no doubt visible, relief he announced, very quietly, that my work met with his approval. Without explanation, I was handed over to his deputy, Hugh Rice – one of nature's and aviation's gentlemen and in the years to come, one of my champions – for a leisurely tour of the factory which culminated in a look inside the holy of holies, the prototype Comet.

While this fascinating walkabout was in progress, another meeting had been arranged and within twenty minutes I found myself on a Green Line bus bound for London to show my work to R. A. 'Bob' Loader, Managing Director of the Samson Clark advertising agency which had handled the de Havilland account since the company was formed in 1920. 'R.A.L.', as he was known throughout the aviation world, had worked with Sir Geoffrey de Havilland at the old Stag Lane aerodrome in North London, before going to Toronto to establish the de Havilland Company of Canada. His office, too, had a painting of a Moth prominently displayed. This one was by Leonard Bridgman, the much respected editor of *Jane's All the World's Aircraft*. In the years that followed he became a good personal friend, more than once going out of his way to open rewarding doors for me, often by stealth, his good works only coming to light at a much later date! However, here I was before R.A.L., who examined my work very closely and stopped at one wash drawing in particular – a rear view of a Rapide in flight. One day when pleasure-flying was slack, I had sat in the cockpit of the Rapide making a drawing of another Rapide parked tail-on. Some time later I had translated this ground shot into an aerial view and, apparently, the originality of that humble offering provided evidence of some sort of potential. Bob Loader jingled his small change, as he always did for both the good news and the bad, and told

me that he had recently driven past an RAF station and a recurring thought had nagged him that somewhere in that vast organisation must be one person who could come to the agency and draw aircraft. 'I guess you're the one,' he beamed. 'Can you start on Monday, with a weekly salary of five pounds, plus luncheon vouchers, to be reviewed in six months?' I must have said 'Yes' because a desk was waiting for me in the studio on the following Monday at nine o'clock sharp. On the journey home, I hummed with indignation, mourning the three weeks demob leave that had been filched from me.

The fact that I had landed a plum job, at my first interview, took a while to sink in. Later it dawned on me that had the more usual route been followed, taking specimens of work direct to the agency, I might not have got beyond the front office, let alone to the head of the company. 16 May 1950, in my book, could be classed as a memorable day.

The Studio

With my twentieth birthday still ahead of me, sitting amongst six experienced designers quickly taught me my place, which was on the bottom rung of the ladder. From this situation, one can only look up and, most importantly, listen. The flow of work that swirled around me provided the most valuable experience on all aspects of advertising, with the accent on artwork and the processes of reproduction. The agency, founded in 1896, was one of the first in the field, and proud of the fact that all the mechanical work of engraving, typesetting and printing was concentrated under one roof. This proved inefficient in the face of rapidly advancing technology, and sweeping changes were to come, but not before I had a chance to learn all I needed to know of these mysteries. One operation not carried out on the premises however was the production of four-colour printing blocks, which were put out to specialists with a harrowing time lag. When I had my first colour work reproduced as a front cover on *Flight* magazine in 1951, there was a wait of eight weeks for the proofs to arrive.

We promoted the new jet age from a building where the accounts department was still called the Counting House. Company transport was on a par with the rest of the technology, and the material turned out by the

agency for the Fleet Street presses was delivered by a bicycle, the kind used by grocers' boys with a large tray at the front. Tension often rose as the time for the departure of 'the journey' drew near, and the unfortunate cyclist was often subject to verbal abuse. On the day he finally snapped, the poor fellow pedalled away with all the paraphernalia for printing a number of valuable ads in the next day's newspapers and took his revenge by heaving the lot into the River Thames.

From my vantage point, by this time a few rungs up the ladder, I saw many people prominent in the aviation industry come and go. We shared all the excitement and glory as the Comet broke all records and then the deep gloom when the dreadful crashes occurred and structural failure grounded the airliner. In these good and bad times, de Havilland people had a most distinctive air, like old boys of a public school or members of an exclusive club. Like most people connected with flying they relished esoteric humour, and stories culled from their worldwide travels were distilled in the 'joke pages' of the glossy and stylish house magazine, the *de Havilland Gazette*. Most of its readers would turn to the back cover before looking at anything else. Samson Clarks were responsible for the production of the *Gazette*, and in my work on it I met a

de Havilland editorial assistant, Michael Ramsden, who exercised his very individual sense of humour on this vital page. He went on to become Editor-in-Chief of *Flight International*. From that chair he has dispensed wisdom with particular reference to air safety, leavened with gentle wit, leading many to read that journal from the back too.

I met a number of the personalities of the aviation world who called at our offices near Oxford Circus, even if my part was only to rustle up a pot of tea. I remember I was asked to look after a Mr N.S. Norway from the Airspeed works at Portsmouth. He was about to set off for a signing session to promote one of his books in a nearby store, where he was better known as Nevil Shute, bestselling novelist of the day and, to me, one of the best aviation storytellers of all time. Another surprise came on arriving ridiculously early at the Farnborough Air Show and going aboard the Herald, because I was working on the press advertising at the time, to be confronted by the towering presence of Sir Frederick Handley Page, all alone, but insistent that he should give a personal briefing on his latest 'baby'. Incidents like these were high points in a routine which had settled down to a round of technical illustration, some little to do with aviation.

OPPOSITE One of the specimens of work produced by John Young at the age of nineteen, while serving in the Royal Air Force, and submitted to the de Havilland Aircraft Company.

The joy-riding Rapide flies over an SE161 Languedoc of Air France; airline and national flags flying from the flight deck were *de rigueur* in 1949.

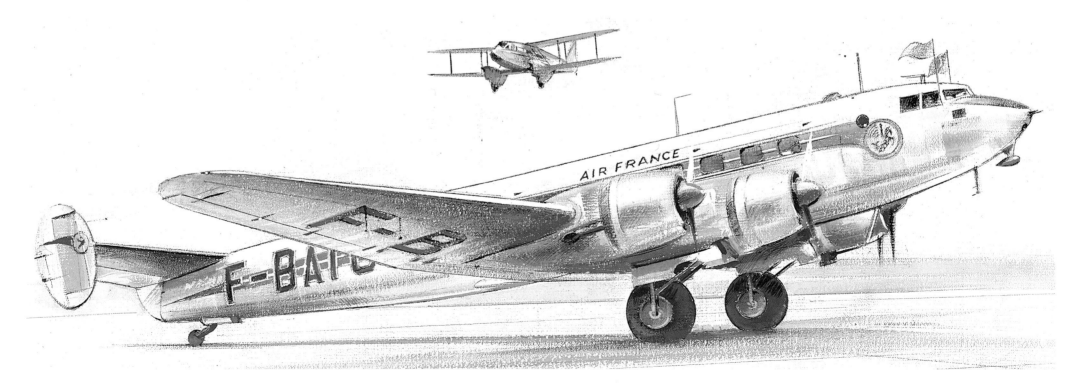

The dream of painting pictures was receding. It was time to find a way of making some visible progress. My solution was to impress everyone with my dazzling display of skill and competence, by grasping every opportunity to do increasingly detailed work with ever finer brushes. Thus I laboured on a coloured cut-away of the interior furnishing of the Comet. This apex of my career printed beautifully, but no one took a scrap of notice! I was heading in the opposite direction to the one I had dreamed of, but at least I realised the fact. The best barometer of my efforts was the reaction of colleagues in the studio, who turned out to be the best teachers I ever had. I was the baby of the outfit by some years and a couple of playful or cutting words from them carried more authority and perception than I was capable of realising at the time. Whatever my colleagues said, at least they cared – after all, they weren't obliged to make any comment at all.

Nevertheless I was frustrated and had to find a way to cut loose, but how? Literally, as it turned out! The chance came with a brief from a client who wanted a rendering of a supersonic fighter making a flat-out pass along the crowd line at Farnborough. The message to the world was to be that because this speeding bullet was equipped with his goofle-switches, Mach One at ground level presented no perils at all! I hurled paint at a piece of card for about ten minutes and slumped exhausted into my chair. I came to, aware of my mentors gathered around me, muttering. Two phrases got through to me: 'the penny's dropped' and 'at last'. Their message was underlined by the fact that this rough sketch was used as the finished artwork and, lo and behold, another pivotal moment – people began to ask me to paint pictures. Cookie, Ticker, Alan, Dick and Nick, I owe you a lot!

In that studio, we were among the first to see new pieces of artwork that arrived from Wootton, Cuneo and Nockolds to be the bases of advertisements, an experience that constantly cut me down to size but also provided inspiration. The studio ran on a great deal of perspiration as well as inspiration, and the standards were almost impossibly high. However, there was a saying in the industry that if you had worked at Samson Clarks then you could get a job in any other agency. I had been fortunate to arrive at a time when artwork played a major role in promoting British aviation products. My training had been completed on the job, along the lines of an apprenticeship, and with hindsight I would not have chosen any other course.

'Don't make it good, make it Tuesday'

It was not until the time came to go out into the world of cut and thrust that the 'Don't make it good, make it Tuesday' attitude hit me. The studio within the agency had been a very protected area. After ten years I realised that this same protection kept me from working for a large variety of clients who did not happen to bring their business to Sammy Clarks, and that the healthy fees being paid for artwork were pretty diluted by the time they reached the artist. It was also becoming clear, as marketing, PR and television were taking over the advertising industry, that the days of an 'in-house' artist were numbered and I began to think of becoming a freelance. So in 1960 I left Samson Clarks and took two of the most important things of my life from that building, a decade of invaluable experience and a wife.

Barbara had joined the agency in 1956 and dealt with matters concerning both aviation and artwork. One might think that this would have given ample warning about artistic temperament and, as in any creative field, a potentially insecure way of life. However, she did me the honour of becoming my wife in 1959, and has been the most tremendous support for more than thirty years. Her talent, among many, lies in an exceptional judgement of what is appropriate in artistic terms, and this book is dedicated to her as a mark of the influence she has had on my work. We like to recall a story concerning her mother, who, as the wedding approached, was happy to reveal to a neighbour that her daughter was to marry an artist. A consoling hand was extended with the words: 'Oh dear, try not to worry. I expect she'll be all right.'

During the 1950s another influence arrived which was to help me in the struggle to differentiate between art and illustration: the Society of Aviation Artists. The society was formed with the following objectives:

1 To promote a greater appreciation of the artistic opportunities of flight and kindred subjects, both in painters and in the general public.

2 To accept the responsibility of painting history as it is being made today.

3 To exhibit the work of painters who have chosen the interpretation of aeronautics as their special interest.

The Inaugural Exhibition was held at the Guildhall, London, in the summer of 1954. My first submission was followed by nail-biting fear of rejection, but I finally had six paintings accepted and hung beside the works of artists I held in the highest regard: Leonard Bridgman, Gerald Coulson, Terence Cuneo, Paul Nash, Roy Nockolds, Keith Shackleton, David Shepherd and Frank Wootton. The report of the exhibition in *Flight* magazine described me as 'up-and-coming', so I guess that made it official. The Society held a number of exhibitions, but so far as I was concerned, it was overtaken by a group of gliding enthusiasts who mounted regular shows in their London home, the Kronfeld Club. The atmosphere here was delightfully informal and the artists had the chance to rub shoulders in a social way that was conducive to the exchange of news and ideas. The Kronfeld Aviation Art Society was thus established and went from strength to strength, with a series of successful Annual Exhibitions. In 1971, the society was reconstituted as the Guild of Aviation Artists. Looking back over more than thirty years of exhibiting and fourteen years on the committees of these groups, I realise the advantages of like-minded artists getting together, because the life of the painter is inevitably solitary.

Painting is a Solitary Business

Solitude is not all bad; peace and quiet are essential and a motorway journey reminds me that some of my most productive times are those when my commuting friends are fighting the traffic. Self-employment is a considerable challenge – a well-known cartoonist described it as rather like entering a competition every day and having to win.

I have devised various ploys for keeping my mind moving while working without the stimulation of companions. My main companion throughout the working day is my radio and I also find that, when organising a large composition or a series of illustrations, a walk through local countryside is the most effective way of moving the various elements into place, as though the act of striding forward moves the brain along as well. Music works in the same way when I have to be painting in the studio.

No doubt there are parallels between the work of the painter and that of the musician. I admit to sheer envy on hearing music makers talking together – they have a camaraderie that can only be born of actually producing art as a team. How satisfying it would be if the artist had an equivalent, but we have to be content with the occasions when we can meet at exhibitions, lectures, seminars and sketching days. I never tire of hearing experts discussing their all-embracing yet single-minded enthusiasms. There is a favourite radio feature of mine (on Radio 4, where else?) that invites guests to talk about 'the tingle factor' in their favourite music. A similar exercise could be attempted with works of art and I have my own handful of names whose work can affect me as deeply as any piece of music. The emotion is difficult to describe and, like the deepest of feelings, should we try? It amounts to a sense of an added value to life which for me comes from seeing paintings by Monet, Pissarro, Corot, Degas, Sargent, Andrew Wyeth, Edward Seago and Ken Howard.

My education in the masters came later in life than my art-school teachers would have wished, but during the war years the treasures of the national galleries were hidden beneath Welsh mountains. My wife Barbara has a great interest in the history of art and an abiding passion for the Impressionists. In her company I have caught up on the gaps in my knowledge of the great artists, which includes being dragged around every corner of Florence! Now, when we travel, she has a list of the galleries we should visit and the treasures of Washington, New York, Leningrad and Moscow have been opened up to me.

Having chosen the freelance life, based at home, one discovers unexpected advantages – it is pleasant to visit the zoo on an uncrowded Wednesday afternoon or picnic with the family because the sun is shining. There is also the freedom to work through the night!

Living on Clouds

Is there something unique in attempting to portray an aerial subject on canvas? Primarily, the theatre in which the artist is working is very fluid, rather like being underwater as opposed to standing on the ground. It is possible to shift the horizon around in a way which would be unconventional for a traditional landscape. Aviation subjects allow the painter to slip the inhibiting bonds of gravity and occupy an arena where all viewpoints are possible. One can look in any direction, straight up or down, move the horizon around at will and manipulate cloud, water and mountains to suit the composition. An aircraft can be presented in almost any attitude, although less agile types like airliners have to be kept fairly straight and level, but can still be lit from unconventional angles.

Cloud is limitless in its scope. It can be viewed from varying altitudes in various attitudes and can be squeezed around like a landscape composed of vapour (which it is) rather than solid matter. It can be employed to impart movement, direction and mood through its varying textures, ranging from solid, towering cumulus to gentle mists. Cloud comes in layers which can convey distance, space and perspective. The background of a picture might be composed entirely of sky and cloud, or be merged with the land or sea as required, calling for further specialised knowledge of colour and lighting.

If an aeroplane is the principal subject within the picture, the artist must convey its movement, weight and speed. An airframe is bound to be balanced in that it must look capable of controlled flight, and represent the disciplines by which the structure is designed and made. The materials from which it is made give a wide selection of textures and colours. The sleek silver metal of a highly polished airliner is worlds apart from a combat type painted in camouflage and looking as though hobnailed boots have trampled across it. Moulded transparent windscreens and gun turrets give opportunities for highlights which are a gift to the skilful and a pitfall for the unwary. The meeting of art and science often leads to situations not necessarily experienced by other artists. The subject of aviation art demands technical accuracy and the engineer who has spent his career among aircraft will unerringly spot any mistake. The artist must be prepared to make corrections and, on occasion, suffer outright rejection.

Aviation art has struggled hard to take its place among more traditional forms such as marine and wildlife painting. The man in the street seems to need time to appreciate the aesthetic value of flight, which is probably why ships are acceptable in national galleries and flying machines are not. The aeroplane has been with us for less than a century and the early designs came and went very rapidly before shapes evolved into the basically similar forms flying today. By comparison with the evolution of ships, the time-scale of the de-

The artist as a young man

velopment of the aeroplane has been very rapid, spurred on by the needs of wars. The public has barely had time to appreciate any art surrounding the subject. On the other hand, because so much has been achieved in so short a time, many people involved in the industry in its early days are still alive and eager to indulge in the memories of the time when new designs were two a penny. The age produced some tremendous characters among the entrepreneurs, industrialists, designers, engineers and pilots, and their stories have provided material for thousands of books, films and specialist journals. Today, an air display featuring lovingly restored historical types can lead to traffic jams for miles around.

The thrill of flight is evoked in some who have never flown. Who will not stop in a London street to stare at a

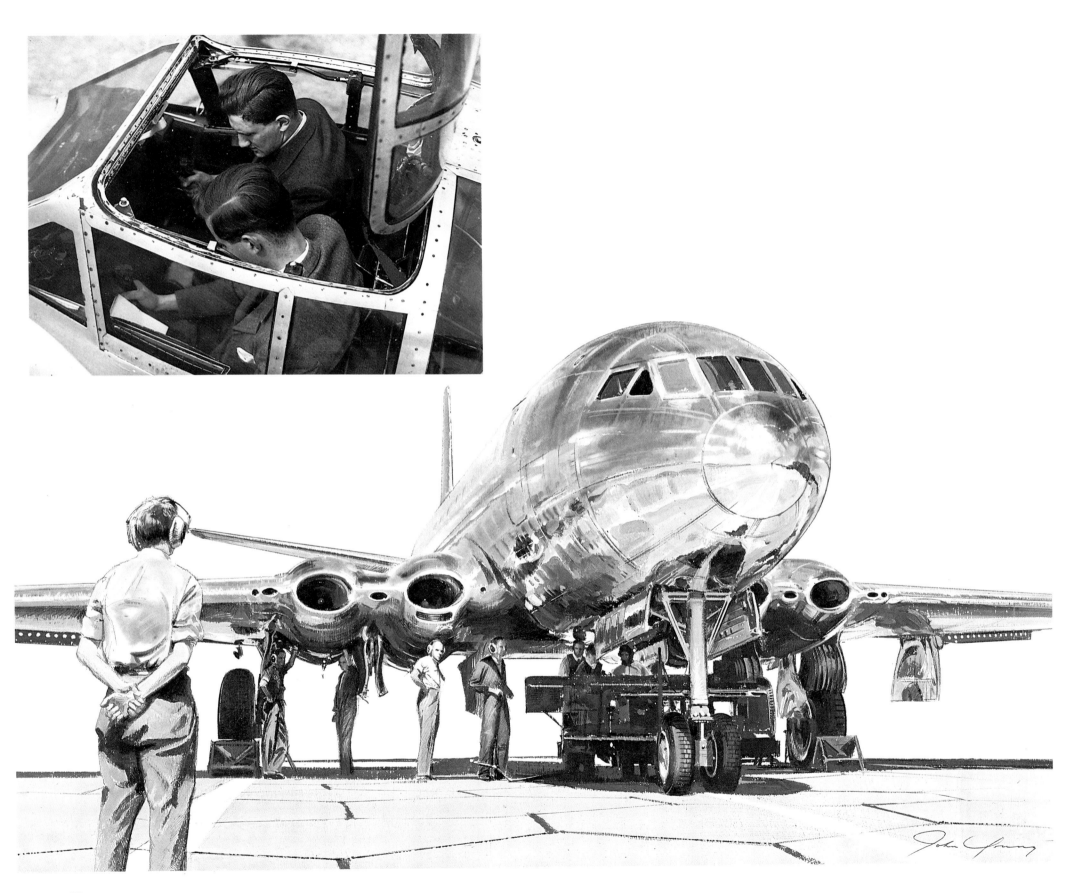

passing Concorde twenty years after its first flight? Many will go to air displays and museums simply because there is something appealing in the shape of flying machines, from balloons to spacecraft. The magic has to be in the defiance of gravity and the beauty in the shape of those vehicles, their movement and glorious backgrounds. There is a similar magic in the action of a young person learning to draw an object, and then making it cast a shadow, breathing on it an air of depth and reality. The artist is conjuring three dimensions from two, and his imagination and intuition when properly nourished can create something inspired. In my case, that achievement is reached by observation, by looking at everyday objects as exercises in perspective, light and form, and less frequently by going into the air to store information in the world's best computer, the one the Good Lord put between our ears.

Having assembled a wealth of knowledge, the trick is to know what to put in and what to leave out. A virtuoso showing-off of sheer information and technique will not impress anyone. A discreet space into which the viewer's imagination can enter will enhance the work and evoke a response. The dissolving of form by light, a touch of understatement, will invite participation and invoke another magic moment: real contact with an audience. Creative tension is thus achieved between picture and viewer; the artist's message has been received and, with luck, will stir the viewer's imagination and some 'added value' will be retained.

Like any other occupation, painting a specialist subject boils down to problem solving. The problem is matched by knowledge, obtainable from many sources – books, films and museums, but nothing can beat first-hand experience.

OPPOSITE Being a professional artist brought opportunities for some high performance flying. Jets were a novelty in 1951 when I flew in the prototypes of the Vampire Trainer and on a five-hour de-icing trial in the Comet. In the photograph, I am sitting in the right-hand seat of the Vampire having just landed from a flight to 40,000ft in a city suit! At the time, service as a part-time member of the Royal Observer Corps enabled me to gain experience in RAF jets. One of these trips was a prize for winning an aircraft recognition contest against one of Fighter Command's front-line squadrons. There happened to be two of my old school pals serving on the squadron and they made sure that the resulting wringing-out in a Meteor was interesting to say the least.

Pictures, Pictures

The camera, said my drawing tutor, is a good servant, but a bad master. I would say it is a damned good friend! Working in the advertising agency, I was fortunate to fly in some of the first jets which, in the early 1950s, was quite an unusual and exciting experience. But it was also quite rare, and I often waited a year or more for the opportunity. One of the pleasures of working in the studio was to see the high-quality prints of first class air-to-air photographers. I dreamed of being there, alongside the camera, seeing these shiny prototypes live in their fairyland cloudscapes. Then, on a glorious morning in 1955, I *was* there, on board a Varsity from the Empire Test Pilots' School orbiting the Isle of Wight in formation with the prototype Folland Gnat. The tiny fighter hung motionless on the wing tip while the great photographers Charles E. Brown, C.A. Sims, John Yoxall and Cyril Peckham did their stuff. I shot off a modest roll on my vest-pocket Kodak and realised that another of life's great pleasures had come along disguised as work.

More sorties came with the years and I have a total admiration for the dedication of these cameramen. They would use rolls of brown paper, taped across windows and cockpits to keep out unwanted reflections and fly hundreds of miles to find photogenic backgrounds. All this was pure gold for the artist. Listening to the professional talk of such people was also of tremendous value to me. We did have examples of Murphy's law stepping in to thwart the best-laid plans. One session stretched to more than four days at a time when prints of a production Comet were urgently needed. On a bright Monday morning, the Comet was not cleared to fly, on Tuesday the photographer 'went unserviceable', on Wednesday it was the Dove camera platform. Everything *had* to be right for the next day. It was, until the photographers saw the Comet. During the night, a six-foot-wide black band had been painted across the polished metal wing and then liberally dotted with wool-tufts for some aerodynamic tests!

Had I not pursued a painting career, my need to record events in pictures and compose various elements into scenes might well have found fulfilment in a film studio. During the war the cinema was my second home and I would often imagine myself in the future directing a camera, or in charge of the special effects department. Occasionally a film unit would come to

the local airfield which was conveniently near the studios at Denham and Elstree, so that familiar territory sometimes appeared in the background of a feature film.

In the early 1960s I was trying to recall the days of the Fortresses in order to paint authentic scenes, but twenty years had slipped by and the memories of a youngster were not all that reliable. Imagine my feelings when three B-17s flew into Bovingdon to recreate wartime scenes for a film version of John Hersey's novel *The War Lover*. Actors were kitted out with period uniforms and flying gear. Jeeps and other vehicles fussed around as the Forts were fuelled and 'armed'. Some of the guns looked a little like broomsticks, but on the whole the effect was well above the film makers' average and the flying was a joy to watch. I was allowed to roam freely with camera and notebook, with none of the wartime restrictions, watching this uncanny re-run of my childhood. Twenty years' additional maturity also ensured that this time I knew what to do with the sketchbook.

Steve McQueen and Robert Wagner were the star names of the production, and during the inevitable periods of hanging about, while McQueen tore around punishing a trials motorbike, I talked to a young actor playing a youthful gunner in 'Buzz Marrows' crew. His name, which I confessed I hadn't seen in lights, was Michael Crawford.

Within a couple of years I too was working on a film. My agent heard that artists with experience of aviation subjects were needed for an epic to be made at MGM Studios, Borehamwood. It was a science-fiction story about astronauts to be called *2001 – A Space Odyssey*. My CV had preceded me, together with – unknown to me – a bid for a fee that my agent thought the film-maker's bottomless purses would consider a trifle. The interview went well and the Art Director indicated that he would like to use my services. 'However,' he asked, 'is there some particular reason why you want to earn more than I do on this job?' With my remuneration suitably scaled down, that picture still paid for the building of a studio at home, together with a new kitchen and a garage thrown in!

The huge Art Department worked closely with NASA and the American space industry, as Stanley Kubrick wanted this film to be as authentic as possible and not just a flight of fancy. Bearing in mind that in 1965 no manned space vehicle had left earth orbit, one of my tasks was to imagine the view of earth as a whole

planet from various distances in space. It was interesting to discover in 1968 that I didn't get it far wrong! I also designed shoulder patches for space suits and, my largest project, posters depicting fanciful holiday resorts on earth for use in the space station foyer. Stanley Kubrick briefed me on a number of ideas – a solar-powered city on the slopes of Mount Kilimanjaro, a hotel built as a hovercraft cruising the Amazon and another built within a vast glass bubble under the sea in the Bahamas.

In my new purpose-built studio, life was busy with book illustration and work for the RAF, and the bedroom I had vacated became a nursery for our son Robert. Among the books was a series for children of the pre-teen years calling for colour sketches of aircraft, ships, cars, trains and working and fighting vehicles. Called *All Sorts of . . .*, they traced the history of each subject which involved a large amount of research. Authors had already been found for *Aircraft* and *Trains*, but I felt that Barbara might enjoy writing the text of *Ships* and *Cars* as she had already been involved in the research and she needed a break from the world of a toddler. It was a very successful series and stayed in print for nearly fifteen years. This period in the early seventies saw work in the plastic kit boxes market, and the poster market also blossomed, enabling me to produce a long series of aircraft Fact Sheets, based almost entirely on what I would most like to have had on my own wall as a boy. This steady flow of illustration work gave me the solid base I needed to be able to strike out on painting for exhibitions.

Go West, Young Man

Having paintings exhibited was stimulating, being presented with awards was gratifying but having to make a living – winning the accolade of the customer who puts his hand in his pocket – was the most important. My past experience led me to paint a high proportion of American subjects, and an encouraging number went to US buyers which led me to plan a trip to spy out this market. I went to New York in 1975 and, having established contacts, began to paint a stock of speculative subjects. The first pictures were nearing completion when I heard that the agent Virginia Bader was about to take the work of several artists to the USA and had room for just one more picture. My submission

was her only aviation subject, which I think was taken along with some trepidation. To her amazement it sold immediately to a doctor who had no connection with flying.

I am grateful to many folk, whose patience was sorely tried as ploys were devised to transport canvases across the Atlantic at minimal cost; not least, to some long-suffering stewardesses who stowed large flat parcels in wardrobes, galleys, and less accessible corners of their jumbos.

Slowly pictures began to sell and, as time passed, a steady demand for original paintings led to the reproduction of selected subjects as limited edition prints, for which there is a large following among American collectors. I met some of the great names of aviation, General Jimmy Doolittle and General Ira Eaker, the fighter aces Francis Gabreski and 'Pappy' Boyington. I visited the States several times on fact-finding missions, as the choice of treatment of subjects proved to be extremely important. It was on these rounds of airshows, symposiums and trade fairs that I managed to visit three of the shrines associated with aviation which had long been on my list. The waiting was worthwhile and each location had a character of its own. The first was a pilgrimage to Kitty Hawk, North Carolina, to the sacred sand dunes where the Wright Brothers had made the world's first powered flight. The second was to the home of the Confederate Air Force at Harlingen and the third was to Old Rhinebeck Aerodrome where Cole Palen kept his collection of restored First World War aircraft.

OPPOSITE **Mosquitoes Bomb Amiens Prison**
de Havilland D.H.98 Mosquito F.B.VI
Acrylic, 20ins x 32ins, 1967
On 18 February 1944, a formation of Mosquitoes of the 2nd Tactical Air Force, led by the late Group-Captain P.C. Pickard, DSO DFC, attacked the prison at Amiens, in enemy-occupied France. More than a hundred Frenchmen under sentence of death for aiding the Allied cause were being held in the building. The walls were breached by the bombs allowing more than seventy of the patriots to escape.

The painting was hung in the 1967 Annual Exhibition of the Kronfeld Aviation Art Society, winning the *Flight International* Trophy. The editor of that journal, Michael Ramsden, was on the panel of judges and wrote the report for that year:

First was John Young's *Mosquitoes Bomb Amiens Prison*. It's a splendid portrayal of a moment, an instant of action – you can really feel the 'g' as the pilot pulls away from the target and although the subject, which is a prison in the snow, isn't one which would inspire many painters and which in fact in this painting occupies quite a large part of the picture, nevertheless the eye goes straight to the Mosquito. When you try to sort out why it does, I think it's because of the very clever way in which the artist has got the road and the horizon – the triangle on the right taking the eye straight to the Mosquito, the angle of the following Mosquito and the clouds behind helping too. Even the propeller blades help in this important illusion of taking the eye to that triumphant aeroplane.
It's a very famous and heroic subject and of course although the actual subject is fairly low on the list of criteria in judging a painting, it does I think help. Somebody did say she wouldn't be very happy to have a picture of a bomb going off in her living room – I think that's quite a good point – the only thing I would say about it is that if there was such a thing as a cheerful bomb dropping during the war, that's probably it. Incidentally the speed which he has achieved is probably due to the very bold and vigorous treatment of those buildings in the foreground. I suppose the artist was tempted to put figures in – without them the effect of total surprise which the story tells is complete.

The remark about the bomb going off in the living room is very pertinent and is the reason why many of my pictures avoid smoke, flames, blood and guts, because I know they are destined to hang in domestic settings. The reason for painting this subject escapes me now; it could have been a recollection of the RAF display held at Farnborough in 1950, a one-off attempt to recapture the pre-war Hendon displays. This was the first flying show I attended as a professional (on a free ticket provided for me!), and was quite the most memorable display I had seen. The show featured a thrilling set piece – a re-enactment of the Amiens raid, the kind of spectacle which leaves an indelible image and one which surfaced to good effect seventeen years later. A poignant question ended Michael Ramsden's critique in *Flight* magazine: 'The artist's role is surely to reflect and interpret the contemporary scene; who will do for the age of aviation what J.M.W. Turner did for the age of steam?'

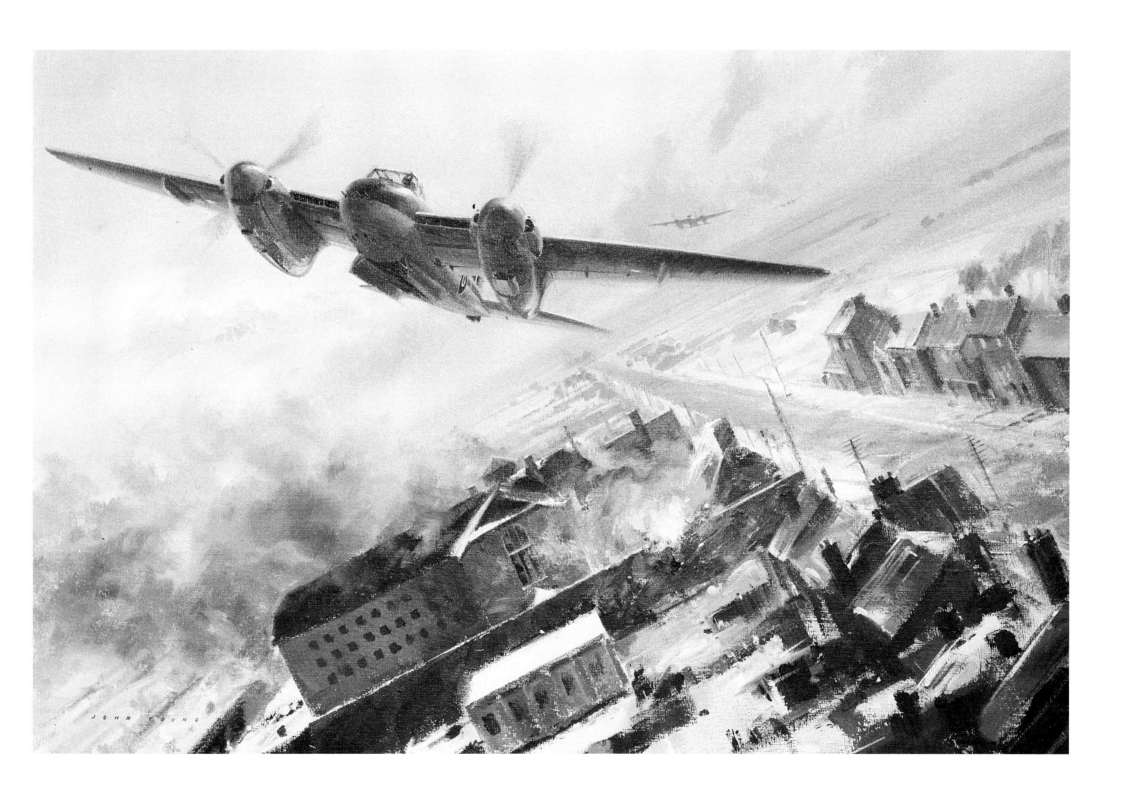

Pilgrimage

Climbing the Kill Devil sandhills at Kitty Hawk to reach the tall memorial to the Wright Brothers I felt a keen sense of presence. Below were the markers showing the length of the first powered flight, less than that of a 747 fuselage. Nearby was the shed where the 'Flyer' had been assembled, and across the way a museum displaying a replica of the machine. I had painted the scene countless times for book illustrations and sensed that every attempt had fallen short of the feeling that I was experiencing in this place. Pacing the ground where it all began, I felt released at last from the longing to 'be there' and felt I now had gained the ability to treat the subject with more authority next time. It was worth the hire of the aircraft from Richmond, Virginia, and the good offices of Jeff Ethell to fly me down there. A moment I shall never forget.

In 1977, I had the opportunity to go to Harlingen in the Rio Grande Valley of Texas. Ever since my first acquaintance with the B-17 in 1942, I had wanted to ride in one. The Confederate Air Force at Harlingen offered me a trip in *Sentimental Journey* during their annual display which features the largest gathering of warbirds anywhere. The following are notes I made at the time:

I found a place by the right waist gunner's window. Looking up the sloping fuselage I could see the pilots juggling the levers for engine starting. The old bomber shuddered into life with resounding pops and bangs, smoke whipping away from the exhausts. Chocks away, brakes off, lurch forward, turn and wait, what a huge crowd, taxi past the grandstand, flags everywhere. With brakes squealing the Fort made its way to the active runway, paused for final checks and then lumbered along the concrete, engines roaring and vibrating, wheels whacking the expansion joints, until daylight showed under the tyres, the movement felt smoother and we were airborne. More drift off than lift off. The old girl dug her nose into the wind and yawed into a shallow climb. The wheels disappeared from sight as they retracted and a gentle turn brought us back across the field just as a second B-17, *Texas Raiders*, took off and climbed across the flat brown landscape.

Making my way forward I stuck my head out into the slipstream from the open hatch in the roof of the radio compartment, welcoming the rush of fresh air as the ground temperature was more than 100°F. There, riding on the wingtip, was the most beautiful sight. *Texas Raiders* had tucked in really close, pristine, shining, bucking in the rough, hot air. Aft of the radio room, everyone seemed to be sick, so I braved the narrow catwalk across the shuddering bomb doors with their ripping draughts – lesson number one in how the real thing differs from all the photographs!

The space behind the pilots was vacant. Clinging to the backs of their seats, I swigged from the water bottle they offered. The two Fortresses stayed close together for the benefit of photographers, until it was our turn to join the display. The first re-enactment was of the attack on Pearl Harbour. As we approached the field, the grass beside the runway erupted with fiery mushrooms, their detonations clearly audible inside the thundering B-17. On the next pass, *Texas Raiders* performed its party trick of landing on one wheel for a touch and go, our speed cut right back as we stayed with him until airborne again. Throughout the sequence we were under attack from replica Japanese fighters, as used in the film *Tora! Tora!*

What an experience! My notes conclude with a long list of the warplanes that flew formation with the Fort during that two-and-a-half-hour trip. I learned more about those planes that day than years of study had taught me – hot, uncomfortable, thrilling, fun, and totally satisfying!

While in Texas, I was given an insight into the effort which goes into tracking down old warbirds for possible resuscitation to flying condition for display with the Confederate Air Force. I was invited to join a prospecting trip into the boondocks of West Texas, the grapevine having brought rumours of a clutch of Venturas and C-46s which might yield a specimen worth working on for restoration and eventual exhibition. My transport was the fabulous Lear Jet – two pilots, two passengers and a climb to 41,000ft in fourteen minutes. The air at a lower level was obscured by choking dust storms which we entered, on let-down, at 11,000ft. The landing strip was pure desert and the aeroplanes we had come to see were real enough. The locals showed a lukewarm interest in our mission, but invited us to inspect the old hulks with a matter-of-fact warning about snakes living in the cabins. Visually this was a fascinating episode. We scuffed through the sand, overtaken by blowing tumbleweed, with the mercury hitting 104°F,

The artist at work during an SBAC Flying Display at Farnborough. The subject is a D.H.110 Sea Vixen.

a September record. The desert air had preserved the structures remarkably well, but the broiling sun had ruined the tyres, windows and other transparencies. The proud lines of the old tail-wheel types pointed their noses into the air with a forlorn dignity. But beneath their surfaces they were in very poor condition. It seemed that their value had escalated during our visit so after some brief and abortive bargaining, we left empty-handed and headed away and up, the co-pilot giving me his seat for the thrill of the climb.

At Rhinebeck, in upstate New York, they re-enact the First World War in a mixture of fun and panache on summer weekends. A report of my visit there, written for the Guild of Aviation Artists' newsletter, brings it all back:

We were greeted by Dick King, constructor and pilot of a Sopwith Pup, built around an engine found in the basement of a London pub. Following a few circuits in his Piper Cub, for orientation, we took a bite of lunch during which T-shirts gave way to RFC and German uniforms. The younger members of the families appeared as mini-Wermacht as vintage cars and armoured vehicles took their places on this hillside pasture which Cole Palen has chosen to call an aerodrome.

In superb sunshine, a large crowd enjoyed crazy-flying, dog fights and all the fun of the circus. Then it was my turn to strap into a Tiger Moth with three large 'bombs' filled with soot across my knees, to be aimed at the armoured car careering drunkenly down the field. I scored three direct misses, which didn't seem to matter as the war appeared to end in a draw. It must have done, for in the evening we all met together in Dick's garden beside the field, sipping a little mountain dew, to the scent of the barbecue, reliving the afternoon's show. Barbara was out looking for the Catskill Mountains in the Cub while Rob swam in the pool with the remnants of the German Army.

A brief and very happy episode, a counterbalance to many solitary hours in the studio.

One other place of pilgrimage is closer to home. No matter how frequently I visit Old Warden, there is a sensation of walking into a Constable landscape where the painter has swopped the haywain for vintage aeroplanes. The Shuttleworth Collection which is

based here has a fascinating fleet of old-timers, all kept in immaculate condition. The sight, sound and smell of a Bleriot or Boxkite, airborne on a summer evening, is one of the golden moments which makes it easy to understand why such a moment should be captured and held.

'How would you like to come up country?'

For me, this question is redolent of the last days of Empire and sums up the best part of working with the Royal Air Force before its withdrawal from the parts of the map that used to be coloured pink. Routine 'showing the flag' trips could provide the most exciting visual material. Besides wielding my camera, I found that brief word pictures could be valuable. For example, this diary extract takes me straight back to 1963, recalling details of one of these journeys:

John Young met artist and astronaut Alan Bean in Houston, Texas. As lunar module pilot on the Apollo XII mission Alan landed and walked on the moon in November 1969. He later spent 1,600 hours in space aboard the second Skylab mission in 1973.

Aircraft – Twin Pioneer XM 291, No 21 Squadron RAF Eastleigh, Nairobi, Kenya, 30.8.63. Pilot Fl. Lt. Arthur Pullen. Navigator Fl. Lt. Idris Heavers. Airborne 0710 GMT. Cargo plus two RAF passengers. One large game rifle. We cross Nairobi suburbs just below flat grey stratus. Fort Hall 0738. Overtaken by 30 Squadron Beverley. (Not many people can say that!) Cross White Highlands. Farmlands. 124kt at 500ft. Formated on an eagle over the lower slopes of Mt. Kenya. Paddy fields worked by Mau Mau prisoners. 0750 Embu. 0810 Mitungugu airstrip. Cloud breaking. Coffee. 0830 arrive Isiolo, low pass to inspect strip before landing. Isiolo is known as the settlement made famous by the story of Elsa, the lioness.

27

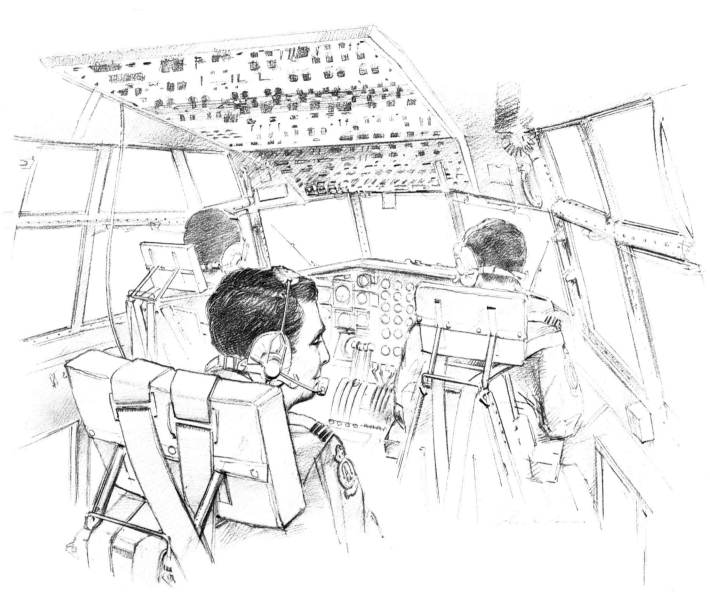

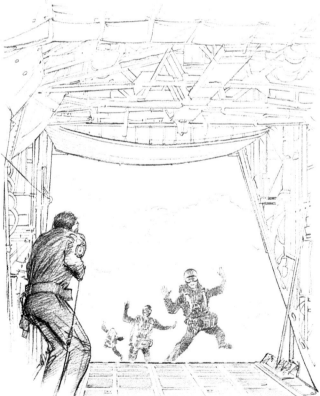

The Lockheed Hercules has been the transport workhorse of the Royal Air Force since 1967. Famous for its load-carrying capabilities it broke endurance records when air-refuelling equipment was hurriedly devised and fitted during the South Atlantic campaign in 1982. One Hercules flew from Ascension Island to drop supplies to the Task Force in the Falklands, a non-stop round trip which took more than twenty-eight hours. In all, the squadrons flew their C-130s for 13,000 hours in support of the British forces.

Take off delayed by the loss of extractor for starter cartridges. Airborne 0935. Follow Uaso Nyiro river to rock where Elsa's family was reared. The flight then passed through some of the most awe-inspiring scenery on earth. Words are not enough. No camera could take in these vistas. Low flying to find herds of giraffe, elephant, gazelles and zebra. The Twin Pin flies like a brick and hot air on the Equator is not comfortable. Never been airsick but this beast tried to get me. Cross desert area and land on lush green strip at huge cattle ranch. Danish owner drives us to bungalow for coffee and promises carcase for squadron barbecue next week.

Arthur pulled starting handle which produced a large amount of wire which should not have appeared. Prop swung by hand using leather strop on a pole. Much sweat, swearing and cries of: 'Back to Biggles'. Success. Take off 1150. Passed some craters of extinct volcanoes, lakes covered with pink flamingoes. Passed Nanyuki 1200. Weather closed in. Rain. Crept under cloud between Mt. Kenya and Aberdare Mts. More game – ostriches. Nyeri, Fort Hall, Eastleigh. Land 1250.

Needless to say I did take some photos, but staccato word pictures like these can be a very useful element in the *aide memoire* jigsaw.

'Do you mind if I sketch?'

Sketching is the most rewarding form of information-gathering. It impresses the general scene upon the mind and enables the artist to be selective about the amount of detail that he chooses to include. For example, the pencil sketch of the crew of an RAF Hercules was developed from an on-the-spot drawing made with a ballpoint pen. This first stage was covered with worded notes on light and colours and would have provided sufficient information to build up work into a painting. The rendering in pen was made on a flight between Hong Kong and the RAF base at Changi, Singapore.

Leaving Kai-Tak in the old Transport Command tradition of 'Wheels up, tea up', I was invited to climb up to the flight deck, leaving a troop of Gurkhas who had blindfolded themselves and settled down to sleep on crates of helicopter parts. Time, or lack of it, is usually against drawing such a scene from life. But this trip was scheduled for four hours. Drawing the structure of the cockpit was easy, but the crew seemed to be moving around, and when the captain offered me a spell in his seat, how could I refuse? The Charlie 130 droned southward checking its course on waypoints with exciting code-names like Tarpon, Thresher and Trumpeter. The coast of Vietnam came up and we were abeam Cam Ranh Bay. Tense exchanges were overheard on the radio giving clues to the nasty scrap that was going on down below. This was 1971, and who could concentrate on sketching at a time like this? I could pick out the flashing discs of helicopter rotors darting in and out the defoliated forests. Columns of smoke and great marching footprints of bomb craters were the only signs of conflict visible from our cruising altitude. The radio calls from aircraft working the tower at Tan Son Nhut airbase, Saigon, faded as the beautiful south coast receded and the South China Sea lay between us and peaceful Malaysia. A stupendous sunset must have been exceptional because the crew all reached for their cameras! The final circuit of Singapore Island was made in darkness, broken by a million pinpoints of scattered lights. Aviation has a way of treating our eyes with mind-boggling sights, and the creative urge has been nurtured once again.

The smaller drawing was made after a trip with the Falcons RAF Parachute Display team. I travelled as far as the open ramp at the rear of the 'Herc', where one moment I was jockeying for a space to take photographs then suddenly it was a very lonely place indeed. I had been fitted with a parachute, to be used only in dire circumstances, but on hearing of this my five-year-old son disowned me for not availing myself of the opportunity!

Over the years I have had the good fortune to observe the Royal Air Force at first hand. Here are a couple of accounts penned at the time, the first from 1967:

The Belvedere helicopter beat its way across the Johore Strait, beside the causeway linking Singapore Island with the mainland. Built up areas gave way to agriculture, mostly neat rubber plantations and then to wild jungle as the hillsides became steeper. Another No 66 Squadron Belvedere kept station beside us, and as usual the crewman seemed to assume that passengers would prefer to sit on the door sill, desert boots trailing in the slipstream, rather than travel 'indoors'. This chopper was cunningly designed so that the exhaust from the forward turbine blew straight into the doorway, increasing the air temperature which was already around 90°F and smelling strongly of burnt kerosene. Condensation rose from the jungle and steamy tip vortices traced circles around the rotor blades. On the crest of a ridge lay LZ944, a raft of logs made from trees felled in the immediate vicinity and lashed together to form a landing pad just large enough to take one Belvedere.

We dropped slowly and carefully into the space bounded by 200ft trees, the crewman using the intercom to call clearances to the pilot. A couple of practice landings were made before it was left to me to disconnect my safety strap, jump down and stand among the sawn-off trees. There I took photographs and generally observed this rather weird exercise as the two machines, like dragonflies, danced around taking turns to dart down for a landing on the logs. I tried to keep my mind off the consequences of these two helicopters dancing into each other and leaving me deep in jungle, with the two hundred species of snake I had heard about at the Jungle Survival School and a wife and three-month-old baby at home. It was with some relief that a Belvedere finally landed and picked me up.

The Far East was hot but I will never forget the baking heat of Aden, or my arrival there in an Argosy, the 'Whistling Wheelbarrow' as the RAF called it.

The aircraft – which had flown non-stop from Nairobi – found a parking space, the door opened and a cascade of ground crew poured in. It was their one chance to have a few moments of cool air on the flight line before the airframe became almost untouchable. A Belvedere was my transport for a sortie up-country from RAF Khormaksar. We were taking a party of men from No 45 (Royal Marine) Commando who were to be lowered by rope to a hill-top at Dhala, eighty miles to the north in the Radfan where dissident tribesmen were causing trouble. It was the first time No 26 Squadron had used this roping technique for landing troops. Positioning myself in the doorway to take some close-ups of the Marines going down

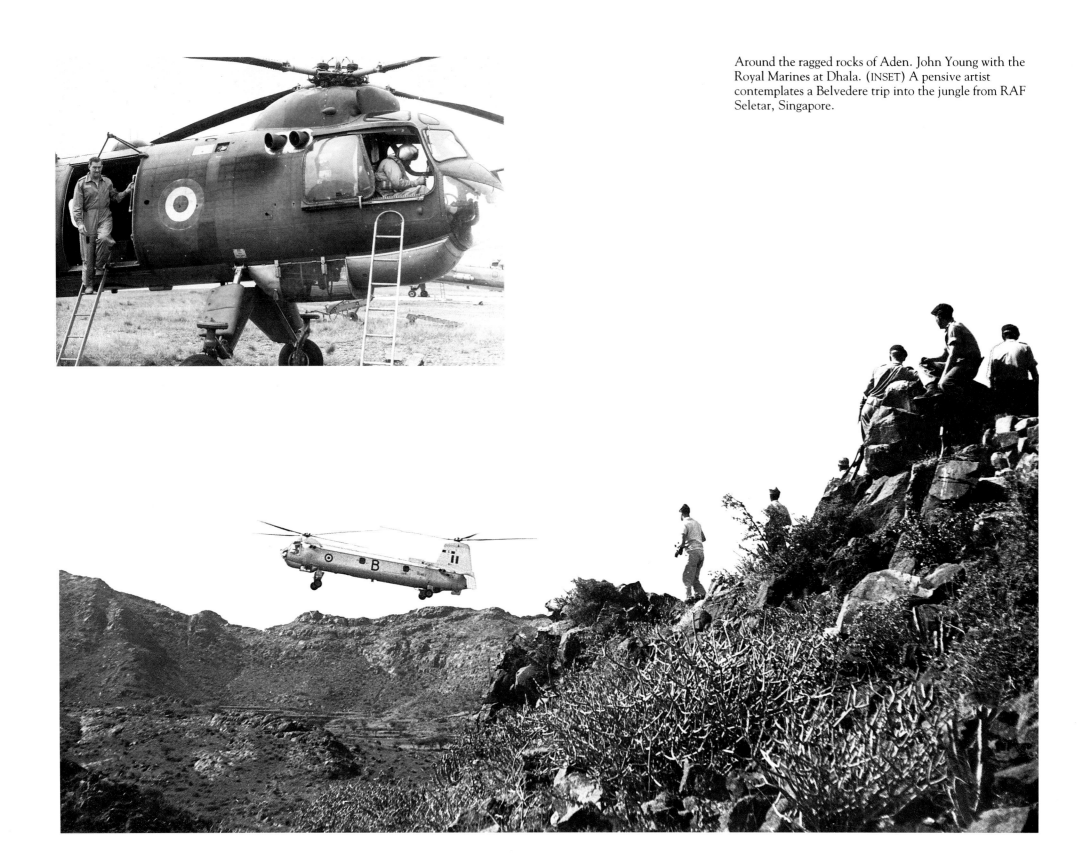

Around the ragged rocks of Aden. John Young with the Royal Marines at Dhala. (INSET) A pensive artist contemplates a Belvedere trip into the jungle from RAF Seletar, Singapore.

the static-line, I felt a tap on the shoulder and gained the definite impression that I should go down the rope first and take pictures of the men coming down. I had not climbed a fifteen foot rope since the school gym, let alone the forty-five feet below me, and I wasn't wearing fatigues, but down I had to go.

I regained the use of both arms shortly after my return to the UK!

The helicopter is a dream machine for observing from the air, which is one of its *raisons d'être,* enabling the artist to travel slowly and really have time to study a subject. I had a memorable trip around the North Sea gas production platforms, making a dozen landings in one long sortie which extended from a base in Suffolk half way to the Dutch coast and back.

For sheer romance and quiet, peaceful observation from above, the hot air balloon is unbeatable. My first trip consisted of wafting up into a sunset, in dinner jacket and bone-dome helmet, Barbara in a gownless evening strap (and bone-dome) and a military orchestra playing on the lawn from which we had risen. Apart from the ear-splitting bursts on the burner, the only sounds came from barking dogs and a few ribald comments from passing barbecues. A brush with a tree was followed by a smooth landing in a cornfield and the arrival of the retrieve with a bottle of champagne. Some flying is boring, much is uncomfortable, but a trip in a balloon is one of life's great experiences.

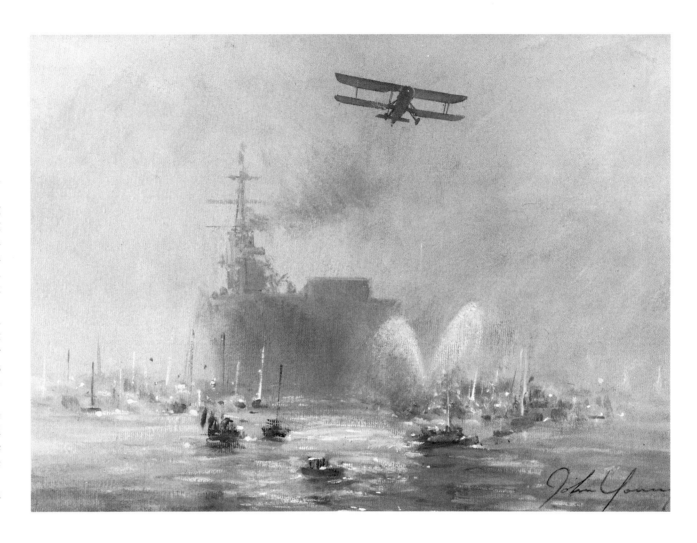

Occupational Hazards

Asked to cope with a new challenge, the freelance often accepts the job and then sets out to learn the necessary technique. When commissioned to paint a mural, I had some experience behind me. An aspect of wartime life which had an effect on the younger generation was the considerable number of families who moved into the district as refugees from the London blitz. As opposed to the evacuees who went to the country without their parents, the boys I came to know arrived with their families to live in well-equipped comfort. We eyed each other curiously mainly to find out what new possessions had moved into our neighbourhood. My greatest surprise was to discover that one of my new friends, a Czech, had painted large

pictures of aircraft on the wall of his room. My own room was still pungent with new distemper and ideas of murals seemed doomed to disappointment. I bravely mentioned the subject at a convenient mealtime, and was quite flabbergasted at the parental encouragement to have a go at my pristine walls.

Quite soon, a Wellington (landing, of course) and a Mustang became subject to visits from parties, like archaeologists flocking to ancient cave paintings, and eventually my Czech friend arrived with a miniature bottle of precious luminous paint and proceeded to anoint all the wingtip navvy lights, landing lamps and other excrescences which needed no lights at all. My cup ran over and sleep was delayed for many nights – how many people had a Wimpey on finals in the bedroom?

The important legacy of this story for me is the element of ice-breaking. There could never again be a first

The Return of HMS Hermes
Oil, 16ins x 20ins, 1982
Reproduced by courtesy of Mr & Mrs J. Warburton.
The task force flagship returned from the South Atlantic to an emotional welcome at Portsmouth. She loomed through early morning sunshine and mist accompanied by the Swordfish and a host of the south coast's fireboats and I had to paint the scene immediately. The picture was completed within hours and proved so successful that I had to paint the subject nine times.

time for a mural. I designed several murals at art school, but was unable to take them to fruition. My next work on a wall was a world map in a RAF library during National Service, and in professional life, one or two opportunities arose to complete panels in my studio and see them installed in their final sites. Apart from a little more practice on stage scenery, which seemed to

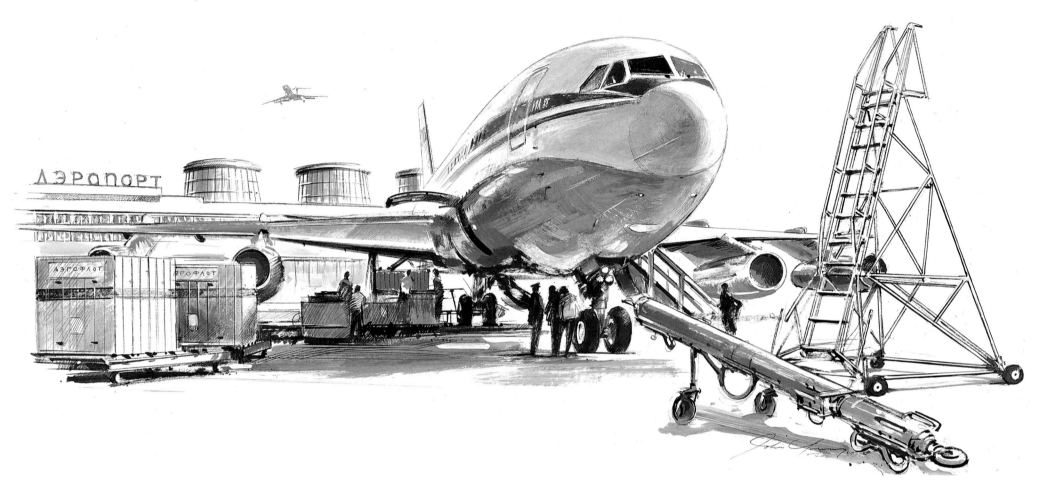

consist of acres of canvas, my first solo taste of ladders and gymnastics came in Nairobi in 1963 when I painted a mural eighteen feet wide in the booking office of British United Airways. To be accurate, I took the wall with me as a series of blank panels but, as is always the way with these things, they did not leave the aircraft with me at Nairobi but got shipped on to Johannesburg. A golden opportunity presented itself while the paperwork was sorted and the panels were retrieved. I went sightseeing in the Ngong Hills and the game parks, wondering if painting elephants might prove profitable – and decided against it!

Two years later, the airline took over the BOAC route to South America and asked me to design and execute murals for a trio of offices in Santiago, Buenos Aires and Rio de Janiero. With a schedule of one wall per week, I felt that the task could use another pair of hands and so Barbara came along.

Travel-weary, twenty-two hours out from Gatwick,

we were welcomed by the BUA Station Manager and driven into Santiago in a Ford which by rights should have been in a museum. It was good to find that the wall was prepared, and there were no worries about materials as I had brought my own with me. A good weekend's rest was all we needed.

Sunday morning was quite beautiful, the late summer sun (in March) warmed a sky of startling clarity and the Andes looked close enough to touch. Flowers filled the streets and parks, people strolled and we listened to a band playing in a square. Then, like a rumbling subway train, a violent movement began and our whole world began to shake. In the following eighty-five seconds we learned an awful lot about earthquakes. As we stood in the street, clutching each other, because there isn't much else you can do, a succession of shock waves rippled through a glass-fronted building from top to bottom. No panes of glass broke, but the window catches sprang open as they are de-

Ilyushin Il-62 of Aeroflot at Pulkovo Airport, Leningrad, 1986.

signed to do in these circumstances. A few chunks of masonry arrived in the street, mostly from older buildings, and book and shoe shops were a sight to see. The capital of Chile had in fact suffered its worst earthquake of the century. Just out of town, five hundred people lost their lives in a shanty town near a dam. We witnessed the most livid sunset of our lives and I also had to think of starting a mural in the morning – if the wall hadn't cracked! It was intact and, aided by an atmosphere reminiscent of the blitz, the work went well. We also enjoyed wonderful hospitality in the homes of some of the staff. The work in the other cities in Argentina and Brazil seemed dull by comparison, but by then ladders seemed to be the least dangerous part of murals.

Foreground

Having exhibited for years with groups of artists, the natural progression was to go solo, and, in the early eighties, a number of one-man shows proved enjoyable and rewarding. The subject matter of these exhibitions does not fall within the scope of this volume, but in attempting to keep a balance in my personal narrative, I have included three pages of non-aviation subjects at the end of the collection of plates which follows. There is nothing like a steady flow of aviation work to make one long to indulge in landscape, and my one-man shows, mostly of landscape subjects, proved that the public liked my non-aviation work too.

I probably spent as much time on the nearest main-line railway embankment as on the airfield in my young days. Coupled with the fact that the railway ran parallel to the Grand Union Canal which in wartime was crammed with heavily laden narrow-boats, I probably richly deserved my reputation with the proprietor of the local newspaper. He was moved to report to my father that his son led 'an aimless existence'. Unabashed, I still say to anyone who will listen that the basis of successful painting is to 'observe and then observe again'. I thoroughly enjoy all the work I do on railway paintings, although I sometimes rely on the good offices of some enthusiast friends for the finer points of technical detail. Marine painting is also a great love, and I do not get nearly enough time to spend on it. Painting the sea is one of the great challenges and there are precious few artists who get it right. It is another fluid element, like cloud, that must be observed at great length if any truth about it is to be captured.

Of course, my aviation paintings have relied heavily on their backgrounds, not only because of the affection that I feel for my native countryside, but also due to the variety of places I have been lucky enough to see across the world – there is a very special frustration in having enough material to fill two painting lifetimes!

One entirely unexpected aspect of my one-man shows was the chance it gave me to meet the public who came to view. I was able to talk to them, and listen to individual preferences which gave me valuable feedback, providing more ideas for the next show. At the same time, the exhibitions of the Guild of Aviation Artists were growing in stature, attracting visitors from overseas and showing the best of the genre. As an inveterate member of both the Selection and Hanging Committees, I have a ringside seat for every phase of the game, being confronted by every level of expertise that a mixed professional and amateur membership can offer. It is a privilege to be asked to evaluate work that is obviously fired by such keenly felt emotion. A healthy increase in sales over recent years has been important for the survival of the Guild, and it is good to see the swelling number of visitors who make a point of coming to the Annual Exhibition.

For those unable to purchase or commission an original work, the most popular form of aviation art is the limited edition print. Buyers are assured of a certain amount of individuality by the size of the edition, usually limited to 850 copies, and the fact that every one is personally signed by the artist. Subject matter is decided in a number of ways, sometimes because of an important anniversary of an historical event or victory or a first flight or special celebration, or because a particular deed of derring-do has never been recorded in paint! In fact, the most popular prints are simple portraits of the most beloved aircraft – the Spitfire, the Lancaster and the B-17. Prints are made from an original oil work which I paint in the same way as any other original. The publisher may well be very involved in the composition stage of the painting, but generally much is left to my judgement.

The first stage of a major composition is research. If the subject is a particular aircraft, then I try to find out everything I possibly can about it – in particular to make it sit in its period, by using contemporary photographic sources wherever possible. I have seen instances of post-war and even modern modifications showing up in wartime scenes, because the artist has used preserved aircraft references, instead of going back to the real thing. Next I research the day – if it is a particular historical date then I try to find out what the weather was like. Time of day is naturally important because of the position of the light – how and where the light falls can say more about a scene than anything else.

Finally, it is necessary to research the background, whether it be cloud to fit in with the weather conditions, an aerial view of a city or terrain anywhere in the world. I had fun with *Cockney Sparrows* (page 50) because the date is September 1940, before the blitz largely devastated this part of London. There are lots of photographs of the blitz damage but not so many of the time just before! All Hallows By The Tower, the Toc H church in the left hand foreground of the picture, was gutted in those winter raids when some incendiaries fell through the roof, followed by a much larger bomb which did not explode. Firemen could not then go in to extinguish the fires because of the danger and most of the church, except the walls and tower, was lost. All Hallows was subsequently rebuilt, but I had to find a picture of it before this damage. When I went to visit it, I found it has a beautiful seventeenth-century spire. I thought this had been on the church pre-war, but my research showed that the original had been destroyed in a gunpowder accident in a local chandler's in 1650 and only replaced in 1958. It is so important to follow up the trails in research and not make assumptions, as I nearly had over the spire.

When I arrive at the final stage of composition, the construction of the picture, I play a kind of 'pin the tail on the donkey' game. I sketch a general feeling of the setting on paper and keep it near my desk. Then I position the sketches and tracings of the various elements, and move them around from day to day until I feel really satisfied that they are grouped in their most comfortable positions. In the case of *Salute to the Queen* (page 87) I think this process took nine days, as it was vital to achieve a balance between the ship, the aircraft and the statue. Once these decisions are made, the first paint goes on to the canvas. This is obviously the background, and if it is a sky then Barbara knows my door will be shut and interruptions are taboo until that first wash of paint is on. It may take a day or two for the background to dry sufficiently for the foreground elements to be traced down from my working drawings and then the remainder of the picture is executed over days, weeks or even months depending on its complexity and, sometimes, my own feelings.

As I have related, I learned to draw at art school, but my painting was self-taught and I have no regrets on that score. One doesn't play truant or waste time while learning this way. A tutor could probably save a great deal of time with hints on avoiding mistakes, but lessons learned by dropping one's own clangers are the best. It seems strange now, but I do remember being very miserable about the whole process of learning to deal with oil paint, so it follows that I must really have wanted to win through to some sort of acceptable standard. Seeing students copying the work of Old Masters led me to try, and I found it a very rewarding experience.

My preference is to paint by daylight in my studio

Aviation art has a strong following in the United States. The artists have formed the American Society of Aviation Artists. John Young tries another mode of transport at Sedona, Arizona, on a visit to meet ASAA members.

where there is a dusty easel and a traditional palette in the corner. These are rarely used because my choice is to sit at a sloping drawing board with a large meat dish for mixing colours. To get going I prefer a minimum of colours, say three or four for ease of control. I can begin to enjoy myself once the canvas is covered. Most artists know how daunting the great white space can be. I am often asked what gives me the impetus to 'get going' every day. The bank statement is as honest a reply as any. I am also frequently asked about north light, as though there was some magic distillation supplied by the Aurora Borealis, whereas the practical reason for

studios facing north is that there are no shadows cast by the sun from that direction!

A topic which troubles leisure painters is perspective, a subject which I relish because I happen to be able to cope with it and can take pleasure from hours of applying geometry which would scare me rigid if anyone described it as mathematics! Teaching the subject to art groups over the years, I have tried to convey a skill which I have used by instinct, rarely using names or terms for the various parts of the jigsaw. Having to apply a discipline in this way, the artist invariably learns as much as his pupils.

A fine-toothed, smooth canvas is my favourite for most purposes, imparting a sympathetic feel to the brush as the paint is applied, the tooth contributing but not intruding a disturbing pattern in the finished artwork. My usual medium for mixing paint makes one concession to the pace of commercial life. A quick-drying agent is introduced alongside pure turpentine because I feel that a picture is under control if the day's work is reasonably dry the following morning. Even so, to the merriment of some of my fellow artists, my trademark is a giant Mahl stick, which rarely leaves my left hand. So much time can be wasted on the repair of smudges, and this weapon helps to keep that problem at bay.

Once the painting is in progress, an analogy with the orchestral conductor is not inappropriate. Balance has to be achieved in many departments – between light and shade, between colours, lines versus mass, hard and soft-edged surfaces, or boldness versus sensitivity. The consistency of the paint itself can vary by infinite degrees from impasto to a fine transparent wash. Control is my watchword which suggests keeping to the rules, but of course brilliance comes from judging the moment to break from conventional constraints and get away with it. The moment comes when the picture is judged to be complete – and this is a fine judgement, sometimes missed by artists.

If a print is being made, the original painting is scanned by an electronic device which separates the colours and measures the tonal values by breaking the picture into a series of minute dots not visible to the naked eye. They can be seen by looking at the colour plates in this book through a powerful magnifying glass.

The colours into which the image is separated are blue, light blue, red, pink, yellow and black. The resulting six positives are each transferred to the light-sensitive surface of a separate sheet of aluminium. This

is a process which uses the rule that oil and water will not mix, an appropriately coloured ink, which is oil-based, adheres only to each of the dotted areas, and is 'printed' like a finger or footprint onto a rubber roller which in turn 'prints' the image onto a sheet of white paper. The intermediate operation with the roller gives the whole process its name, 'off-set'. When each coloured image has been printed progressively in precisely the same position on the paper, a faithful reproduction of the original painting emerges.

In very high quality reproduction work, a dozen or more separate colours are used and, together with a top grade paper, a quality print that collectors will seek out will result. The judgement of a highly skilled printer is as important as any other element in this process. When printing is complete, the artist inspects each print and, if satisfied, adds his signature. When every detail has been covered and the new edition passed for release, the printing plates are destroyed along with any blemished copies which didn't make the grade. I have been fortunate in that some of my publishers have invited me to be present at the beginning of a run, which can be a very emotional moment as hundreds of reproductions of your work appear before your eyes.

In the second half of the 1980s, I had the good fortune to meet Greg and Kathleen Weber who had established the Heritage Aviation Art gallery on the perimeter of Boeing Field in Seattle. They decided to publish their own editions and created the Aerodrome Press. I am grateful to them for being able to reproduce a number of their subjects in this book. The Webers have established a reputation for their friendly welcome to all who call at the gallery. It has become a 'talk shop' where collectors of aviation art from all over the world call in to browse around the walls and buy. It was here that we had a hilarious signing session with Col. John Mitchell and the P-38 pilots seen in the photograph on page 72. The fighter pilot talk bubbled as though the events of 1943 were only a year away. As they signed, they fascinated us with accounts of life in the Southwest Pacific, tales of tropical downpours, snakes and foxholes, of combat and comradeship and of their subsequent flying careers in some of the first jets.

Later in the gallery I face the small mountain of paper as it is my turn to sign each copy of *Search for the Needle*. At around five hundred sheets I am on automatic pilot having mislaid my name. A monstrous Union Pacific loco growls past on the main line from Seattle that runs south along here, shaking the timbers of the

gallery. On the tarmac beneath the window someone tinkers with a helicopter, Mount Rainier begins to blush and the building rumbles again as a mighty AWACS thunders into the air. When the noise dies away, a lone hawk harrasses more peaceful birds who feed by the runway. Eight hundred prints and two coffees later, I am in fine fettle. I have remembered my name again and the pile of completed prints is comfortingly high. I sweep through the last dozen sheets with a flourish and a sigh of relief. No duds, all signatures readable and spelt correctly. Barbara removes the last sheet and I wring my hand having signed nearly nine hundred prints.

My gaze refocuses through the window. The mountain is now quite pink, steam billows from the Boeing No 2 plant where my old Fortresses were built half a century ago. Puget Sound turns to crinkled gold as the sun slants down behind Hurricane Ridge on the Olympic Mountains. A private owner guns the Merlin of his Mustang for one more circuit, reluctant to land.

In the gallery, a couple of late visitors pause in front of VIP (page 55), one of my Fortress paintings. I sense their approval and as I pass them I hear: 'That ain't any old tool box, that's a *Kennedy* tool box'! I have to look out of the window – the sunset is now beyond the reach of any artist in its sheer magnificence, and look, what's this, winking its way down the approach? An old DC-3, the 'Gooney Bird', rumbles down the glide-slope into SeaTac Airport.

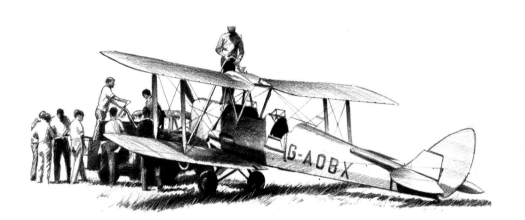

'All I have seen teaches me
to trust the Creator for all that
I have not seen.'

RALPH WALDO EMERSON

THE PLATES

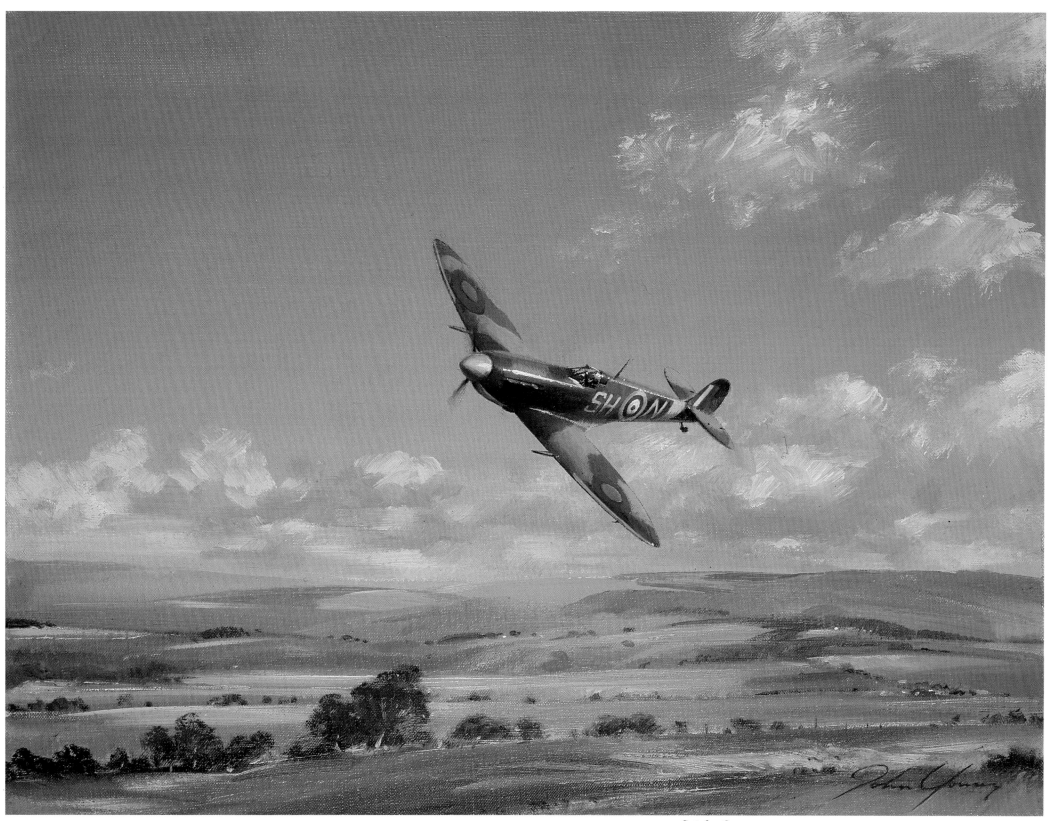

Spitfire Supreme
Supermarine Spitfire Vb
Oil, 16ins x 20ins, 1988
Reproduced by courtesy of the Vancouver Oral Centre for
Deaf Children.

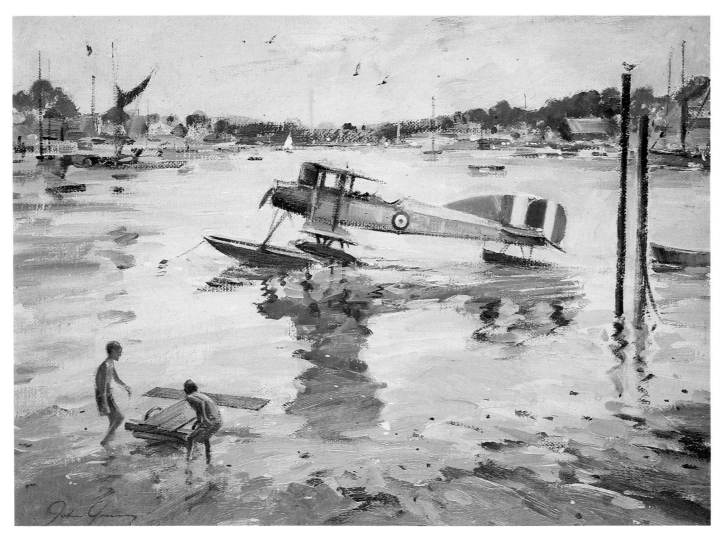

ABOVE **Launching the Seaplane**
Short 184
Oil, 15ins x 19ins, 1987
An example of a loose treatment of brushwork. The First
World War scene is enlivened by the two boys launching
their own seaplane.

BELOW **The Visitor**
BE2a
Oil, 16ins x 20ins, 1988
The Visitor was a flight of fancy. I knew that a BE2 came to
the Rothschild Estate at Wendover in the Chilterns during
army manoeuvres in the summer of 1913. A forced landing
would have been more than likely, the farm labourers
would no doubt have been most curious and, for me, here
was another chance to paint my local landscape.

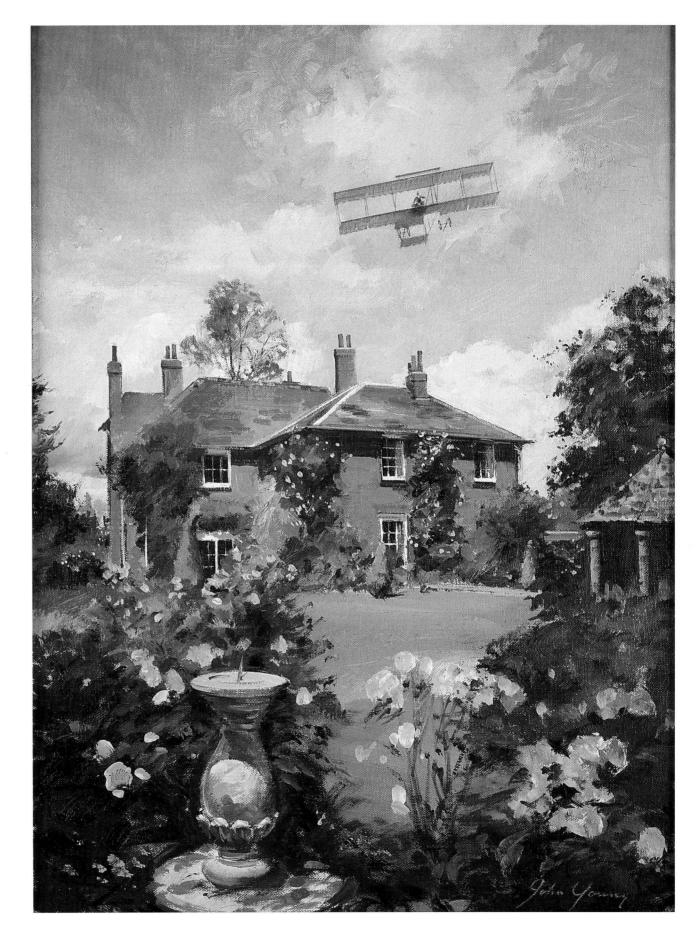

Listen, the Flying Machine
Henri Farman Biplane
Oil, 20ins x 16ins, 1985
Reproduced by courtesy of Mr & Mrs J.H. Batchelor.
The house appeared in a magazine property advertisement that I found in my dentist's waiting room. I had the idea for the picture there and then – and I did ask him if I might take the ad!

There is a special atmosphere about the days of the early aeronauts which borders on the romantic, and I find such inspiration irresistible. Coming across an old photograph of a stick-and-string biplane cruising above a regatta in the last carefree days before the First World War, a small series of paintings ensued. The scene became more idyllic with each attempt. Years later I learned that the actual flight had been treated as a grave misdemeanour and the bold aviator was brought to book for flying too low, endangering life and limb and frightening the ladies! It is likely, therefore, that my idea of the downstairs maid calling the young master into the garden to see the flying machine was just about 180 degrees out. She had probably dragged him indoors and was even now covering his ears while attempting to deal with her own fit of the vapours.

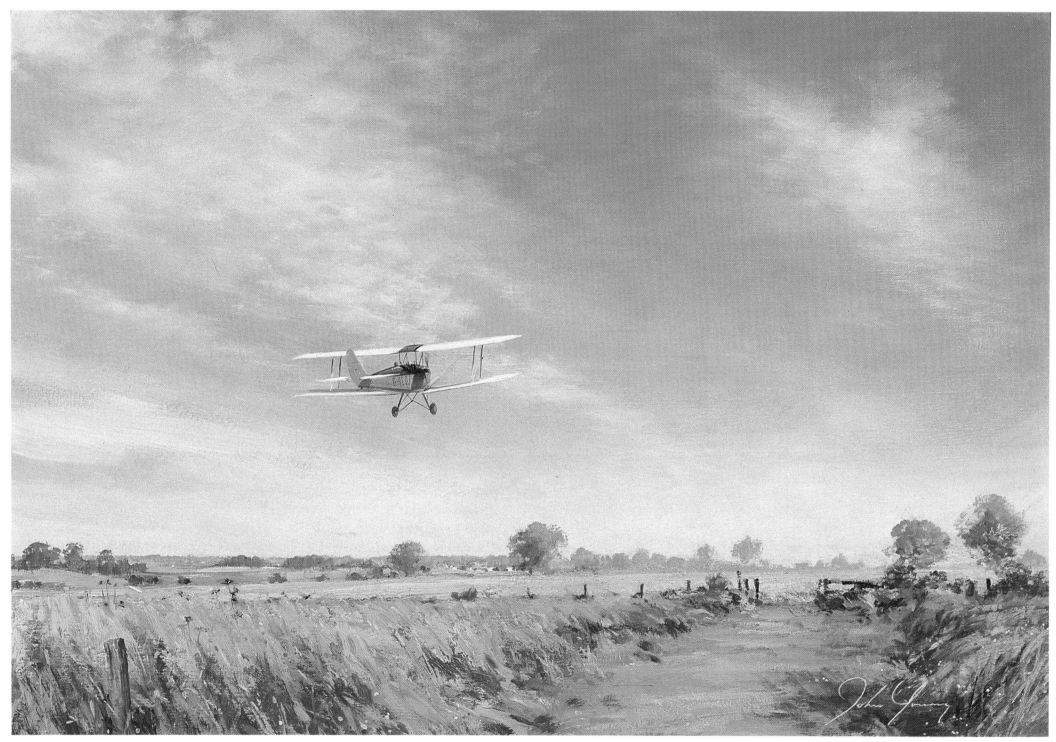

Gone Flying
de Havilland D.H. 82A Tiger Moth
Oil, 20ins x 30ins, 1981
Reproduced by courtesy of Mr & Mrs A.S. Crumpton.
This subject was developed from a day's painting on a farm
strip, and the title suggests going nowhere in particular,
just 'gone flying' – pure pleasure!

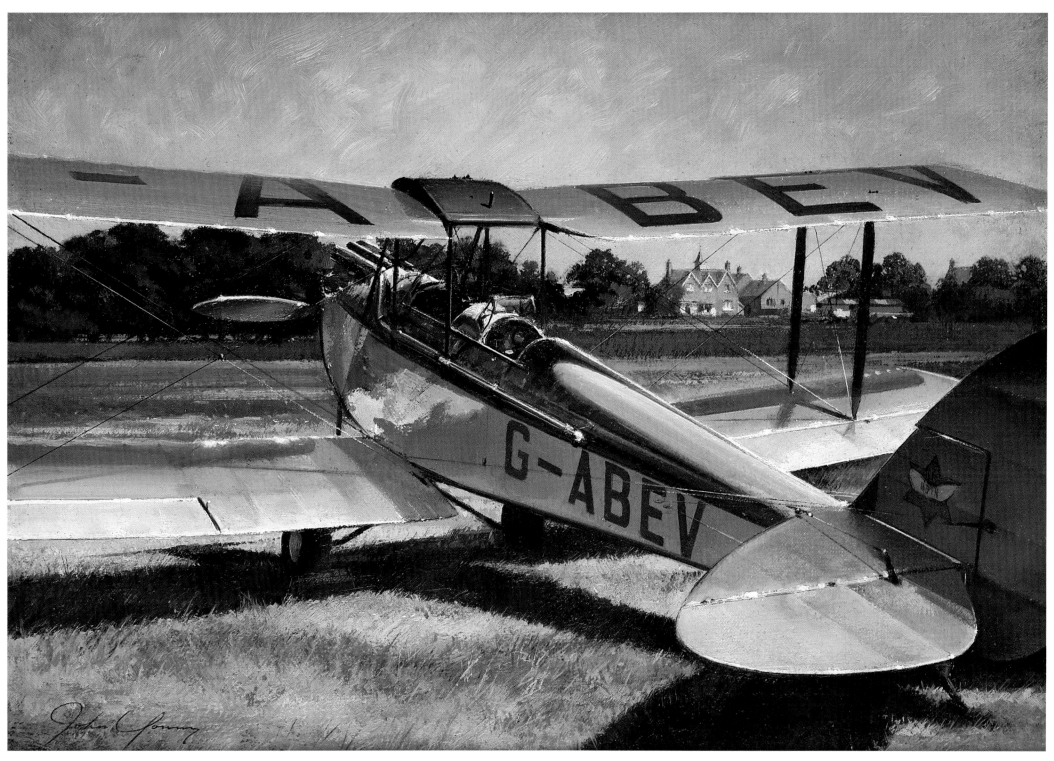

Moth in Sunlight
de Havilland D.H.60 Moth
Oil, 10ins x 14ins, 1987
Reproduced by courtesy of Mr & Mrs J.H. Batchelor.
I was struck by the interesting collection of textures on this
brightly-lit Moth at Old Warden, and set out to capture
the feel of the doped fabric, the polished plywood and the
magnificent burnished copper exhaust pipe.

41

THE AFGHAN HIND

Job satisfaction rates highly among rewards for the artist, and few occasions have given me more satisfaction than the events which surrounded the painting of a Hawker Hind in Royal Afghan Air Force colours. In 1970, a few Hinds were found junked behind a hangar on a military airfield in Afghanistan. Mountain air had preserved the structure remarkably well, and after negotiation, the RAAF agreed to present a complete aircraft to the Shuttleworth Collection at Old Warden, Bedfordshire. The British Ambassador in Kabul suggested to the Shuttleworth Trustees that a graceful gesture might be made for the gift. A solid silver model of a Hind was financially out of sight and so I was asked to paint a portrait of the aeroplane, to be presented to the RAAF when the Hind was handed over.

The Ford Motor Company sponsored and undertook an expedition overland to Kabul to fetch the dismantled aircraft and, after a 12,000-mile round trip, the thirty-five-year old Hind came home to England. A further eleven years of restoration followed, but now she is flying again. A visit to Old Warden on a summer day to see her in the air could be described as very positive job satisfaction, and that is putting it mildly!

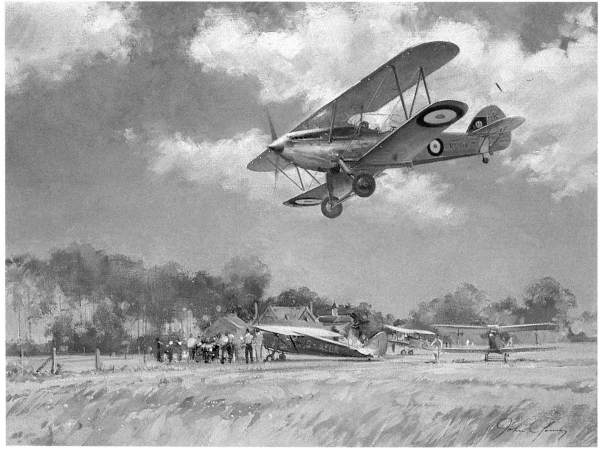

ABOVE **Sunday at Old Warden**
Hawker Hind
Oil, 14ins x 18ins, 1985
Reproduced by courtesy of J.R. Burns Esq.

LEFT John Young's painting of the Afghan Hind about to leave London on the journey to Kabul.

OPPOSITE **Hawkers over the Rock, 1933**
Hawker Osprey, Hawker Nimrods
Oil, 20ins x 24ins, 1981
Reproduced by courtesy of Mr & Mrs D.D. Unwin.
The Fleet Air Arm was composed of RAF aircraft normally embarked in Royal Navy ships, flown largely by naval crews. The Osprey seen near Gibraltar was the naval equivalent of the Hart, and the Nimrods were the counterparts of the RAF's Fury.

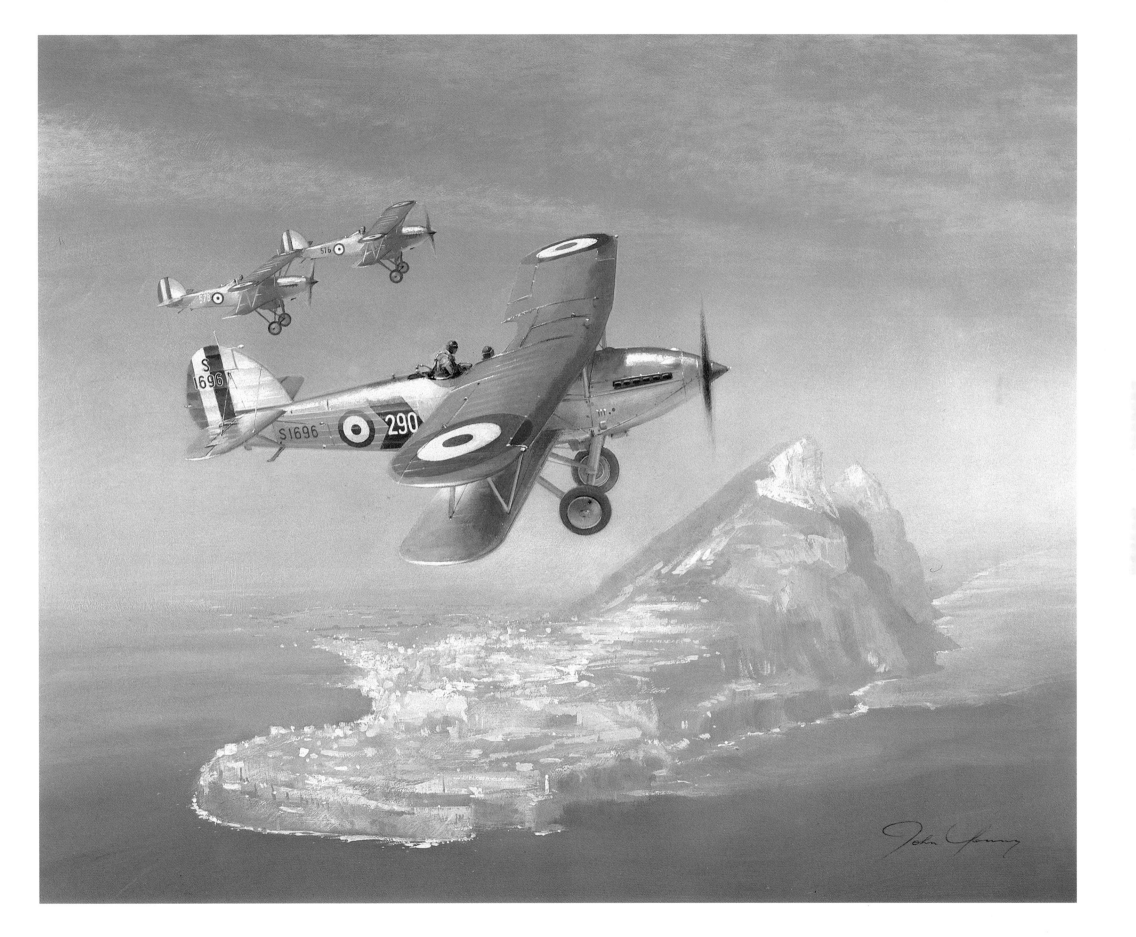

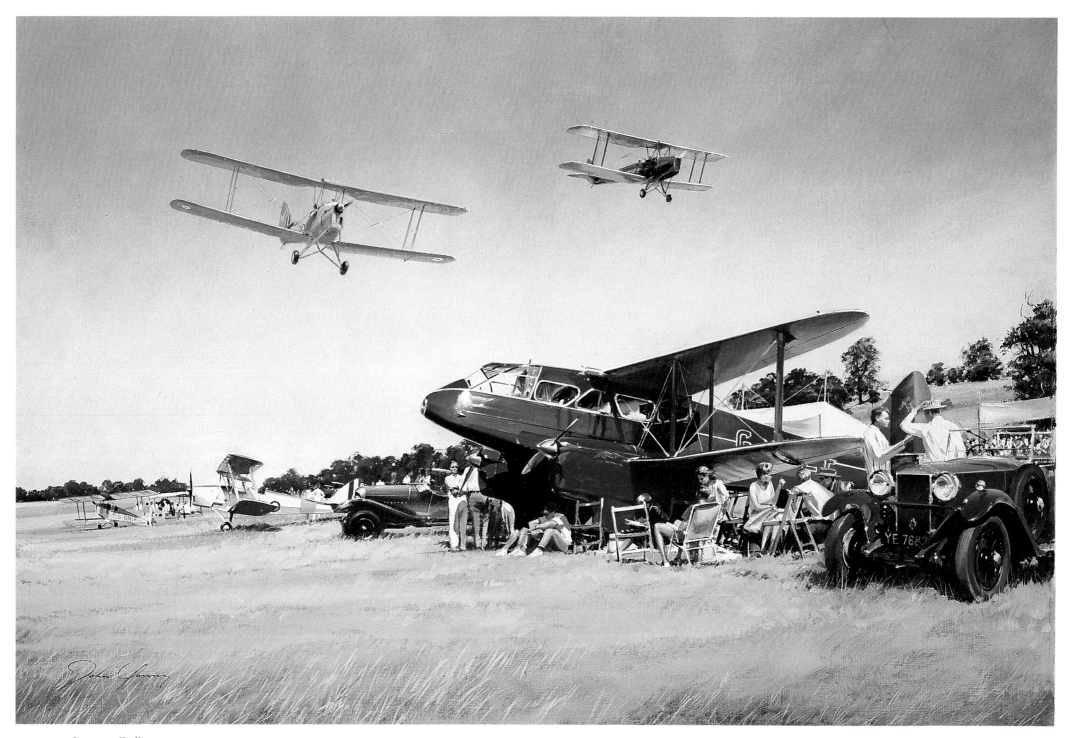

Summer Rally
de Havilland D.H. 89A Dragon Rapide
Oil, 20ins x 30ins, 1987
Reproduced by courtesy of Brian Woodford, Esq.
Winner of the Airtour Sword, 1988.
This scene was painted following a D.H. Moth Club
Meeting at Woburn Abbey. The sky was gin clear and I
decided that it made a very suitable background for a
complex composition.

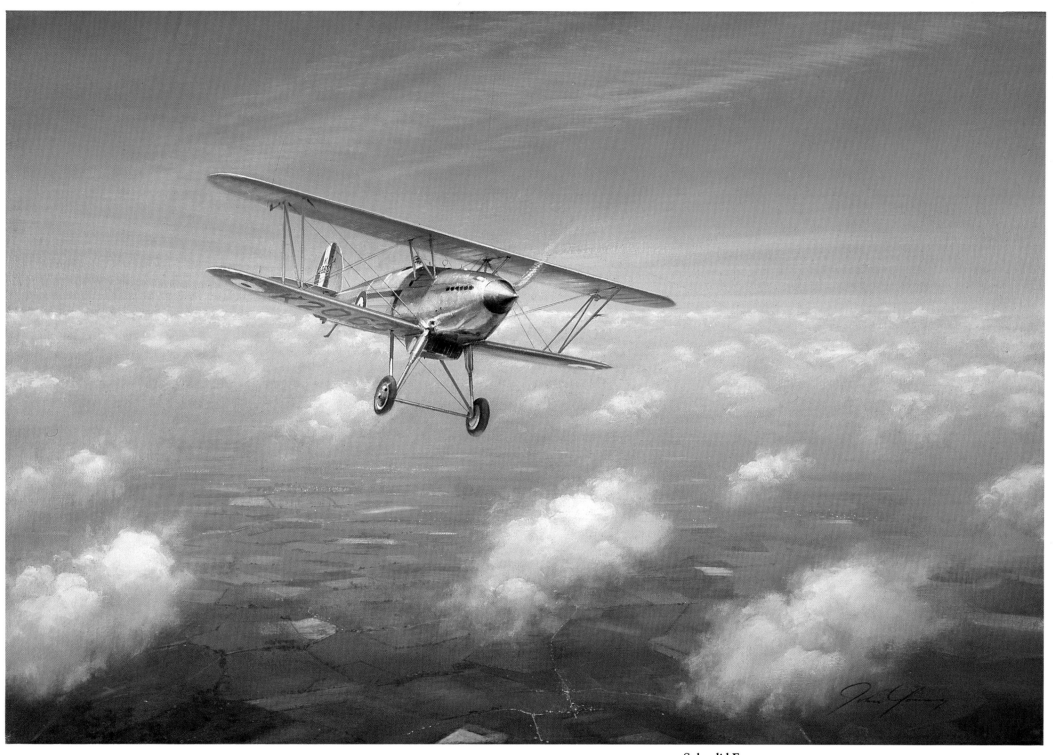

Splendid Fury
Hawker Fury I
Oil, 20ins x 30ins, 1989
A Fury of No. 1 Squadron, RAF up from Tangmere in the
1930s. This machine illustrates the evolution of a fighter
aircraft. Its First World War origins are plain to see and,
with half-closed eyes, the removal of the wheels and top
wing reveal an embryo Hurricane!

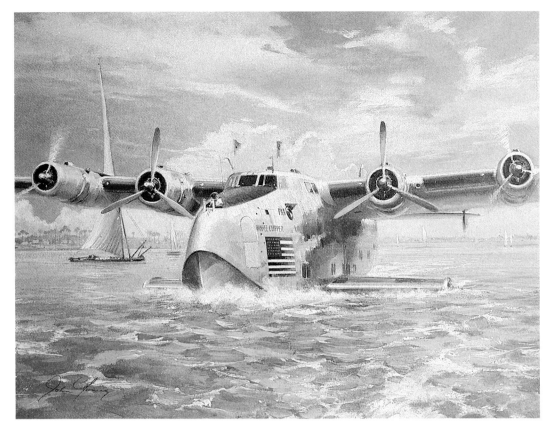

The Epic Flight of the Pacific Clipper
Boeing 314A NC18603 'Yankee Clipper' of Pan American Airways
Oil, 12ins x 16ins, 1981
Reproduced by courtesy of the Royal Air Force Museum. Overtaken by events at Pearl Harbour while on a flight from San Francisco to Auckland in December, 1941, Capt. Bob Ford was told to proceed to New York 'the long way round'. The epic flight that followed crossed the Equator six times and broke a number of records. *Yankee Clipper* made the first round-the-world flight by a commercial airliner, spending 209 hours in the air over a route of 31,500 miles. The painting shows the Boeing on the waters of the Nile at Khartoum. In the years before the war it seemed to a young schoolboy observer that all long-distance air travel was to be by flying boat. Our periodicals showed cutaways of spacious cabins with passengers relaxing in the splendour typical of an ocean liner. The 'C' Class flying boats of Imperial Airways bore stately names like *Canopus*, *Cassiopeia*, *Capricornus* and *Caledonia*. When war came, the military version of the Empire boats known as the Sunderland made an enormous contribution, as it watched over the lifeline of shipping which kept Britain alive.

When the war ended, *The Aeroplane* held a competition for the design of a new airport for London. From what I recall of the entries, several took it for granted that it would be in the area of the present Heathrow terminals, but would take the form of a vast lake full of bobbing flying boats! The history of water-borne aircraft has left the artist a rich store of subject-matter with the chance to manipulate the effects of light and flying spray on the water.

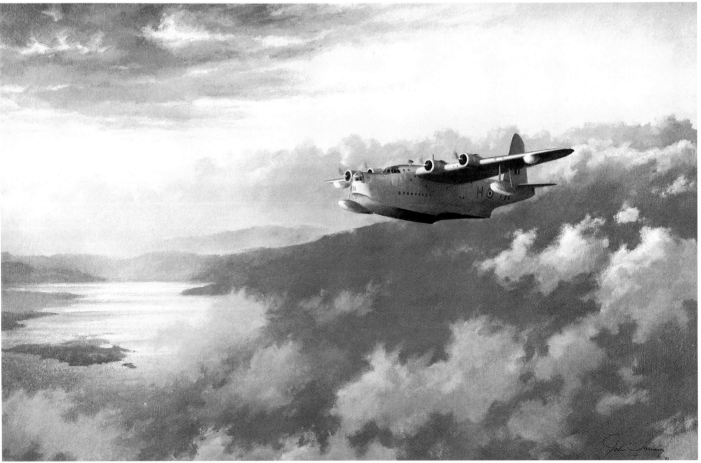

Evening Patrol
Short Sunderland M.R.5.
Oil, 24ins x 36ins, 1973

46

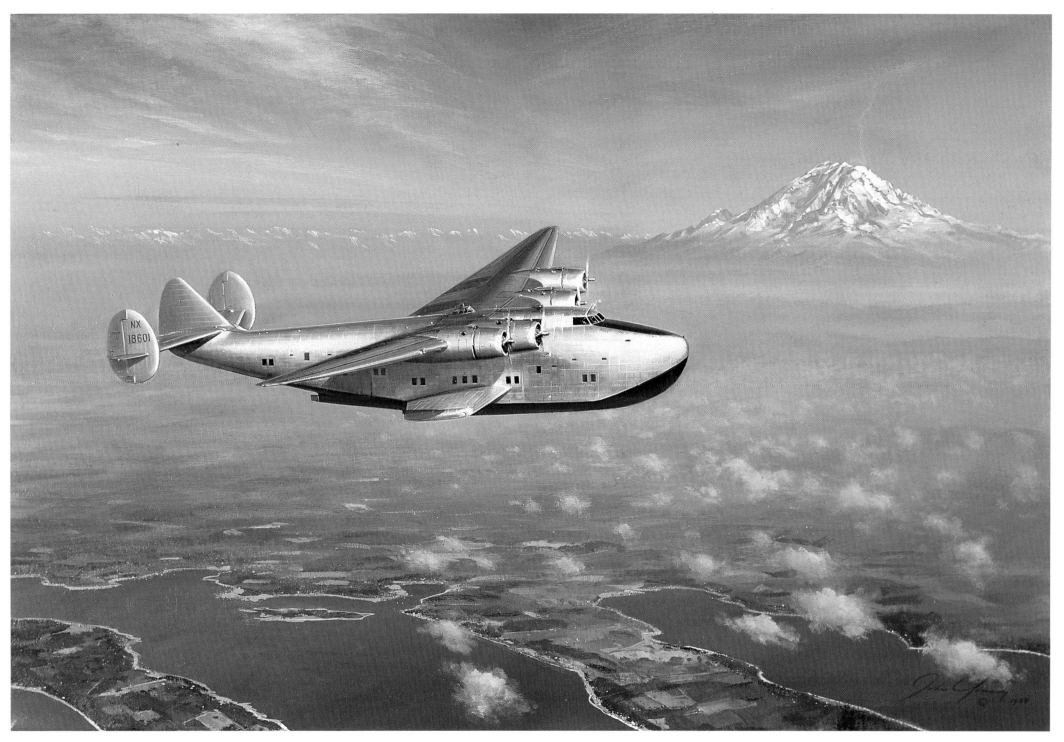

Two Majesties
Boeing 314A
Oil, 20ins x 30ins, 1988
Reproduced by courtesy of Airport Travel Center,
Memphis, Tennessee.
Painted to celebrate the 50th Anniversary of the first flight
of the 314 from Lake Washington in 1938. Mount Rainier
dominates the skyline.

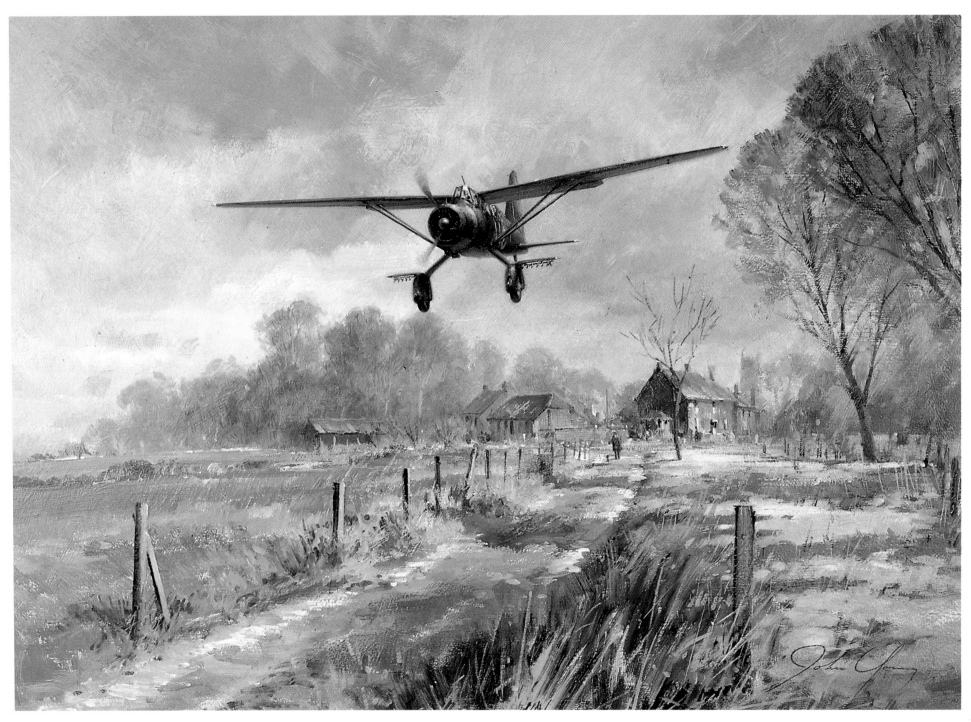

Landing Practice
Westland Lysander
Oil. 24ins x 32ins, 1983
Reproduced by courtesy of Mr & Mrs P.W. Ashworth.
Winner of the Roy Nockolds Trophy, 1983. Lysanders
equipped the army-cooperation squadrons at the outbreak
of war. Here a pilot makes a landing in a confined space on
agricultural land.

The Lysander was an aeroplane apart, borne out by a
favourite saying of wartime aircraft recognition instructors:
'There is a difference between an aeroplane, a barrage
balloon and a Lysander – the aeroplane can't stand still in
the air, making it difficult to identify!' It was very special to
me as it was the first type to be 'brought home' by an elder
brother of one of my school pals. I had been warned to be
around at midday for a surprise and the 'Lizzie' was flown
slowly around the neighbourhood at tree-top height in a
dazzling display of the kind that the Air Ministry spent the
rest of the war trying to stamp out.

I treasure a couple of quotations regarding my Lysander
pictures. One from Harald Penrose: 'I must congratulate
you on the *superb* painting of the Lysander exhibited at
Westland's Open Day (page 49). Mine was the job of
testing the Lizzie prototype (among others) as I was Chief

Test Pilot for twenty-two years. You make the Lysander
really *fly*, a rare quality with many an artist.' The second
was from Roger Bacon in the 'Straight and Level' column
in *Flight International*: 'Never have I seen so many RFC ties
so proudly worn, or such a collection of historic
aeroplanes. Some of them were flown in 30-knot gusts.
Quite enough for the old dears, especially for landings in
front of the Queen. Twice I went back to the static park to
feast my eyes on the Lysander. I had not seen one before,
except in pictures; it was like a John Young painting come
to life. I am quite sure that I have never enjoyed an
airshow so much.'

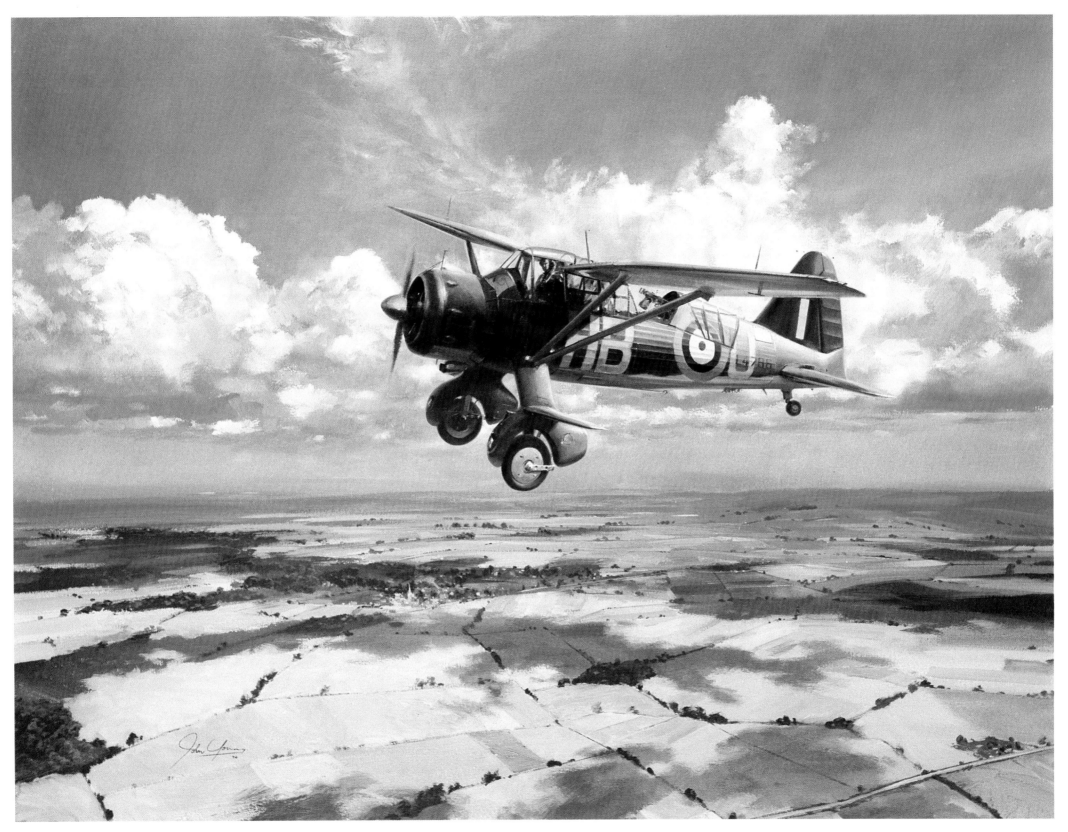

Such Great Names as These
Westland Lysander
Oil, 30ins x 40ins, 1974
Reproduced by courtesy of the Royal Air Force Museum.

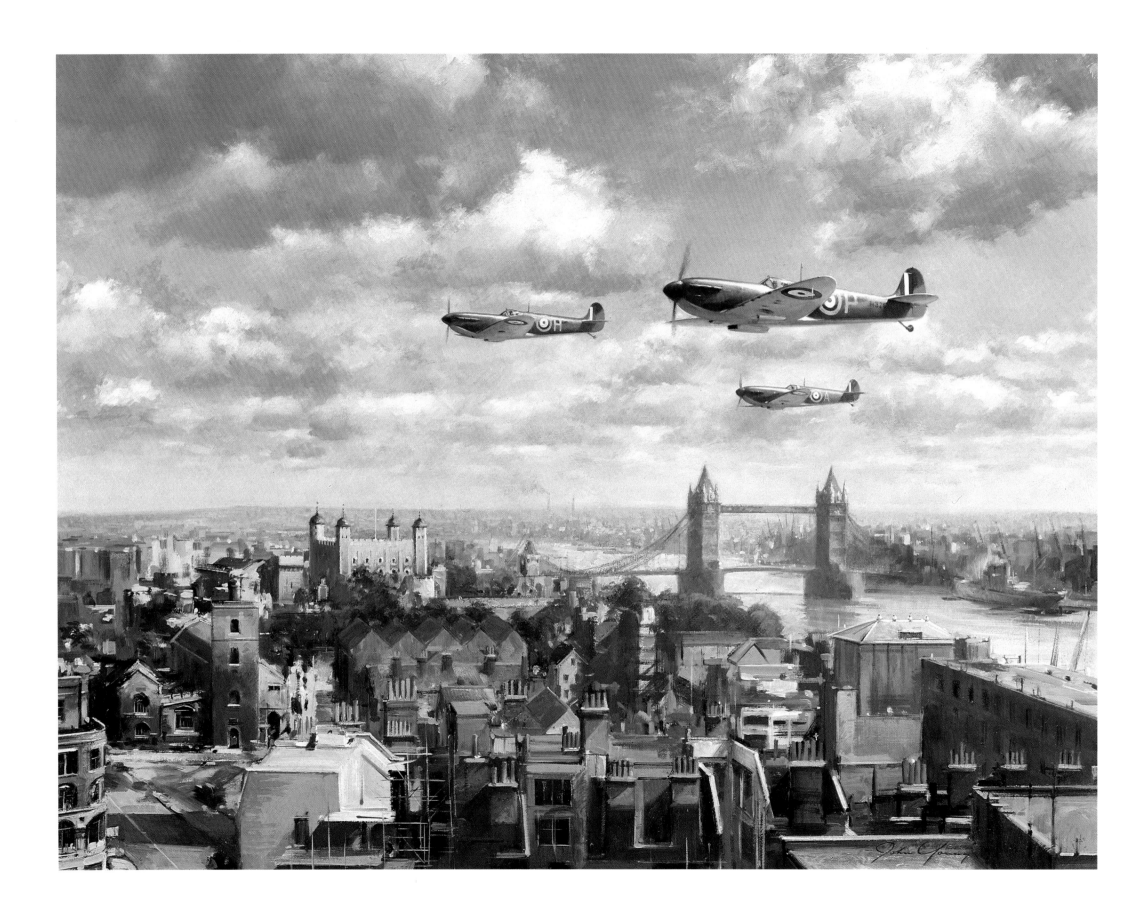

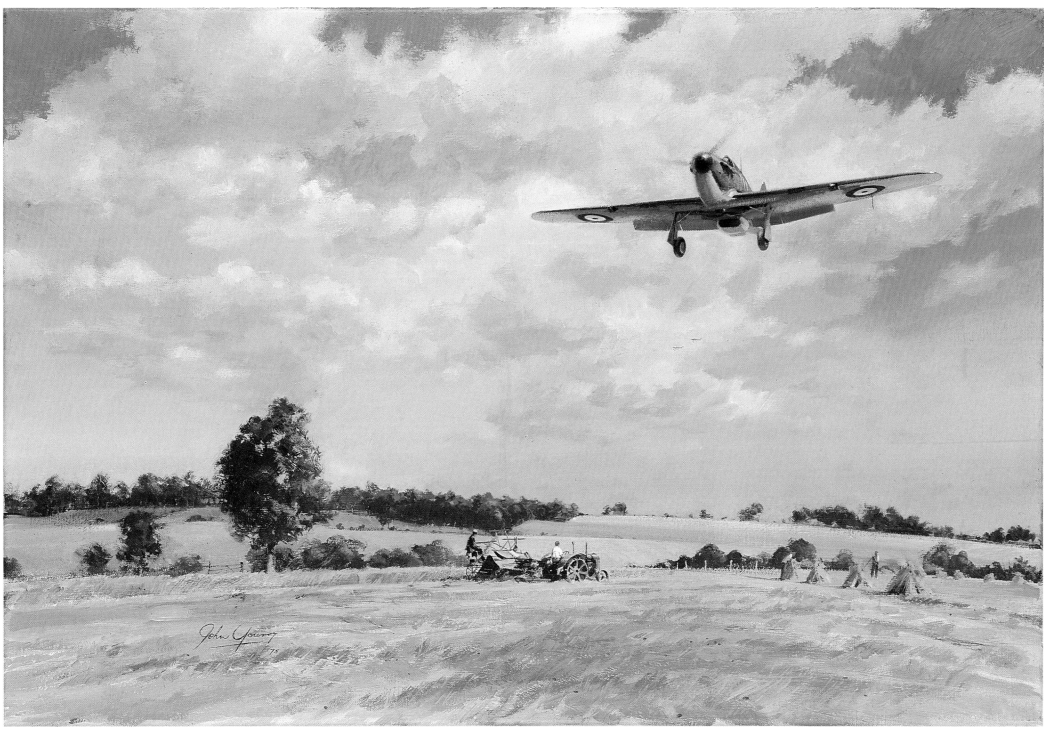

OPPOSITE **Cockney Sparrows**
Spitfires over London, 1940
Oil, 27ins x 34ins, 1986
Reproduced by courtesy of V.A.T. Watkins, Esq.
This composition was created to celebrate the 50th
Anniversary of the first flight of the Spitfire in 1936. A
simple portrait of the aeroplane seemed inappropriate for
such an important event. I wanted to link it with a readily
recognised part of the national heritage which the Spitfire
had fought to preserve in the Battle of Britain. The title
did not come so easily, but when the painting was well
under way, my wife was rehearsing the Noel Coward song
'London Pride', and the 'Cockney Sparrows' line of the
lyric stuck and became the name of this picture.

September, 1940
Hawker Hurricane I
Acrylic, 20ins x 24ins, 1970

BATTLE OF BRITAIN

The Battle of France is over. I expect that the Battle of Britain is about to begin. Upon this battle depends the survival of Christian civilisation. Let us therefore brace ourselves to our duties, and so bear ourselves that, if the British Empire and its Commonwealth last for a thousand years, men will still say: 'This was their finest hour.'

WINSTON CHURCHILL, 18 JUNE, 1940

The battle did commence in June and lasted for sixteen weeks. Fought mainly in daylight, until a series of night attacks by the Luftwaffe started in mid-August, the German air fleets were based on fields spread across Northern France and the Low Countries. Their initial targets were the fighter airfields of the Royal Air Force spaced along the south coast counties of England and around the capital.

The Prime Minister referred to the fighter pilots drawn from the United Kingdom and Commonwealth, with men from occupied Europe and the United

We never forgot or figured out the reason for the strange smell of the German fighter.

States, as 'The Few'. Their numbers totalled just under 3,000, five hundred of whom lost their lives, with a similar number wounded. The Luftwaffe was able to call upon 2,500 aircraft for the assault on England, which reached a climax in mid-September, when raids by more than 1,000 aircraft were launched against London. I remember the evening news bulletin on 15 September, claiming '185 destroyed'. This number was actually vastly inflated and it eventually transpired that the score was 56. Nevertheless the Luftwaffe had not achieved the superiority required to cover an invasion by the German Army. October brought shorter days and deteriorating weather, leaving RAF Fighter Command badly battered and weary, but undefeated.

One of the RAF's well-kept secrets was its possession of early-warning radar. The system in those days was technically crude, but provided sufficient information for Lord Dowding and his commanders to deploy the slender number of aircraft and pilots to the best advantage. The sheer bravery of those young, unknown pilots, their skill and determination, held the line until the battle was won, and Germany was never able to bring sufficient forces to bear for another attempt to overcome and occupy the United Kingdom.

Fifty years have passed, recall is far from perfect,

but personal memories of this period are quite real. I can remember being very, very frightened. This was usually for short periods and for irrational reasons. I remember being woken one night from very deep sleep by the air-raid siren. Abject terror adequately describes my state, but on reaching wakefulness I realised that the piercing note was the 'All Clear' and I had slept through whatever activity had caused the 'Alert' in the first place.

I sensed agonising anxiety in my parents and their friends. The air-raid drill at school ruled that we should make our way downhill to the cellars beneath the massively built brewery next to the school. However, my family insisted that I should take off in the opposite direction, up the hill, to my home where, I suppose, if we were due to go anywhere, we would all go together. The bombs which frightened me most of all were the 'screamers' which had a sort of eerie whistle attached to their fins.

When really heavy raids caused widespread destruction in the City of London, my mother set aside her fears and, without explanation, took me on a walking tour of the awful devastation. I have often wondered why we made this journey – she had worked in the City before her marriage and maybe she could not believe the reports she was hearing and had to see for herself. As a ten-year-old, it was a sight that was to stay with me for the rest of my life.

Paintings of crashed aeroplanes are few and far between, so a word on the genesis of the picture opposite is appropriate. At the home of our church treasurer, a parish meeting had ground on way beyond my boredom threshold, and I found myself staring at a broken model of a Hurricane abandoned on a shelf, at my eye level . . . and my imagination took over.

OPPOSITE **'He weren't no more than a boy'**
Hawker Hurricane I
Oil, 18ins x 24ins, 1984
Reproduced by courtesy of J.A.N. Gardner, Esq.
The subject of this picture is absent. The young pilot who crash landed his Hurricane in a Kentish field may have survived – unscathed or perhaps wounded – or may have lost his life. The simple agricultural folk are drawn into the Battle of Britain which, for most of the summer of 1940, went on above them.

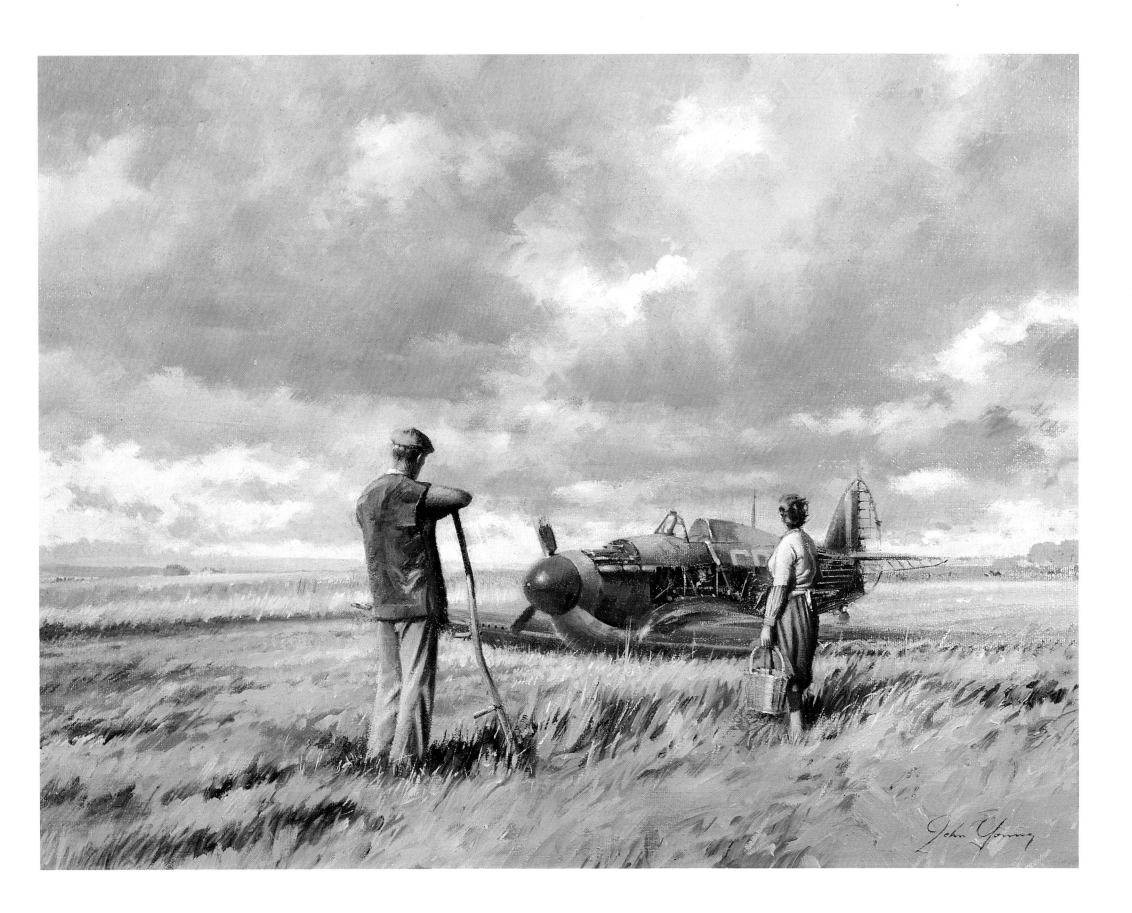

John Young at a signing ceremony in Washington D.C.,
1978, with two of the wartime commanders of the 8th Air
Force. Left, Lt. General Ira C. Eaker, who flew on the first
8th Air Force B-17 mission, and right, Lt. General James
H. Doolittle, who led the famous raid on Tokyo by B-25
Mitchells flying from the aircraft carrier, U.S.S. Hornet.

To Mr. John Young:

 Hoping you will find this account of the
early operations of the U. S. 8th Air Force out of
UK of interest. Without the complete cooperation
of the Royal Air Force, as well as the government
and people of Britain, the historical experiences
recounted in this book would not have been possible.

 Congratulations to you for the brilliantly
conceived and executed paintings of war-time planes,
British and American, which have been a constant
source of pleasure to all veterans of the "Mighty
Eighth."

Ira Eaker

Ira C. Eaker
Lt. Gen., USAF (Ret.)

The pictures were magnificent and were appreciated not only
by Ira and me, but by the excellent turn out that came to see
them.

I look forward to the next time our paths cross and I'll have the
pleasure of again seeing you and your lovely lady.

As ever,

Jim

J. H. Doolittle

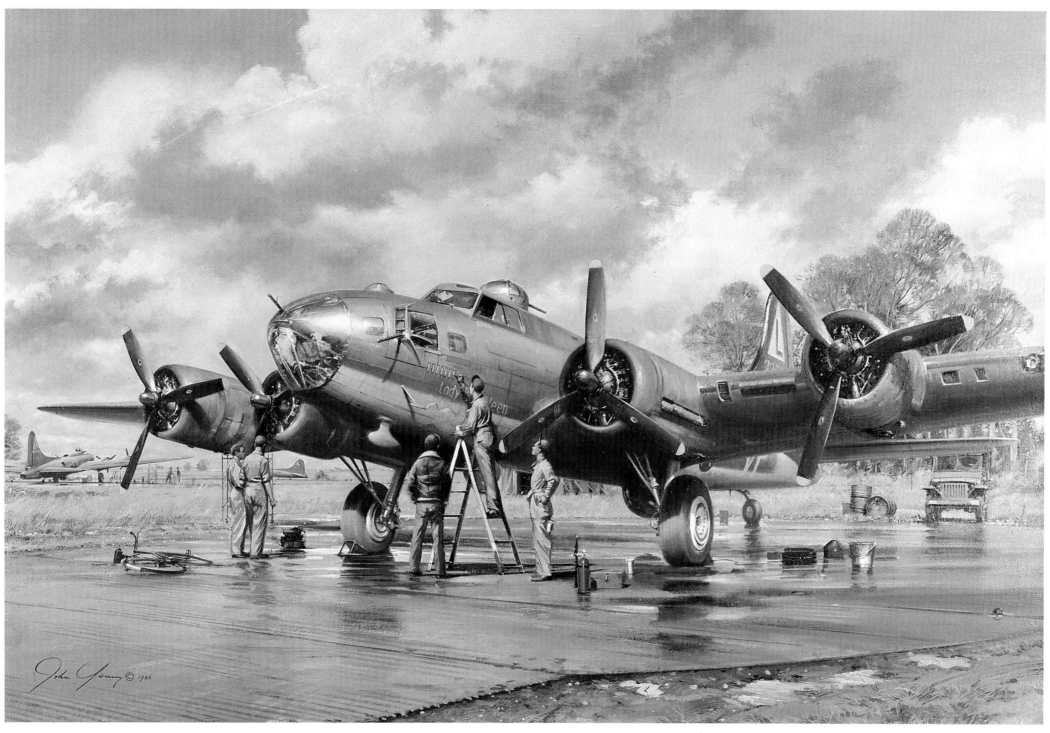

Very Important Painting
Boeing B-17F Fortress
Oil, 24ins x 36ins, 1988
Reproduced by courtesy of Mr and Mrs Greg Weber.
In the dark days of 1943 when the 8th Air Force lost sixty
bombers in one day, the crew's thoughts dwelt on their
chances of surviving the twenty-five sorties needed to
complete a tour of duty. The painting of the mission tally
on the nose of the aircraft was vitally important.

OVER THE HUMP (Walt Glover)

Upon graduation from flying school, I was transitioned in B-25 medium bombers before being assigned to General 'Hap' Arnold's Combat Cargo operation composed of sixteen squadrons in four groups. Our mission was to support front-line combat units by bringing supplies with newly developed air-drop techniques, or by landing on improvised airstrips. We were furnished with brand new C-47s and launched ourselves to the China – Burma – India theater in mid-1944.

Our squadron supported General Slim and General Stillwell in their battles from the Imphal Valley to Rangoon. We were then assigned to the Chenkung airbase near Kunming in south-west China for two months in an effort to support forward fighter aircraft with parts and fuel, evacuating casualties on the return flights. This was Japan's last push to the west.

On our first mission in China, weather conditions got the best of us, and myself and three crew members bailed out at night, at an altitude of 10,500ft, about 100 miles south-west of Chunking in mountainous terrain. We were reported missing in action for two weeks before finding our way back to the squadron. The weather was just as much our enemy as the Japanese ground fire, and navigational aids were poor.

After 1,500 hours in C-47s, I finished my tour in C-46 Commandos, but it is the C-47 which has a very special place in my heart, as it carried us through some very difficult flying situations and mostly brought us home without a scratch! It was not one of the glamour aircraft of World War II, but has since been recognised from an equipment standpoint as a major success factor in the European theater and it certainly kept the Chinese in business when the Burma Road was closed. The 'Hump' pilots lifted 650,000 tons of cargo over the 15,000ft Himalayas in the most perilous conditions between 1942 and 1945.

One can find any number of outstanding paintings of Spits, Mustangs, Corsairs and Jugs, but extremely few of the 'Gooney Bird'. *Skytrain from Kunming* is the only painting I have ever seen which portrays the machine as it was, seen in a setting so very reminiscent of the area where we flew. What makes it a 'painting' adorning my wall, rather than just another airplane picture, is the excellent three-dimensional quality. Thank you for this lasting memory of our flights through the Himalayas.

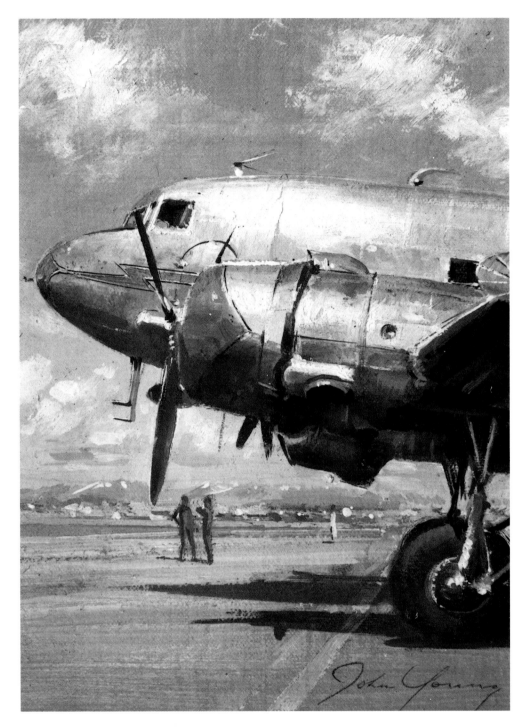

Walt Glover is one of 5,000 members of the Hump Pilots Association, the name sticking after an American newsman named them 'Humpsters' during the war. For his work in this combat zone he was awarded the Distinguished Flying Cross with two Clusters, and the Air Medal with three Clusters. He is now President of Ipeco Inc., producing aircrew seats in California. Walt Glover recently returned to Kunming with his co-pilot Don Solberg to meet the Chinese people who had aided them when they parachuted from the C-47 and made their escape in December, 1944.

DC-3
Oil, 7½ins x 5½ins, 1983
Reproduced by courtesy of Mr and Rev. Mrs B.O. Hall.
The DC-3 was the civil version of the C-47 Skytrain which equipped a USAF unit at my local airfield for many years. I intended this small original to be painterly rather than an exercise in rivet counting.

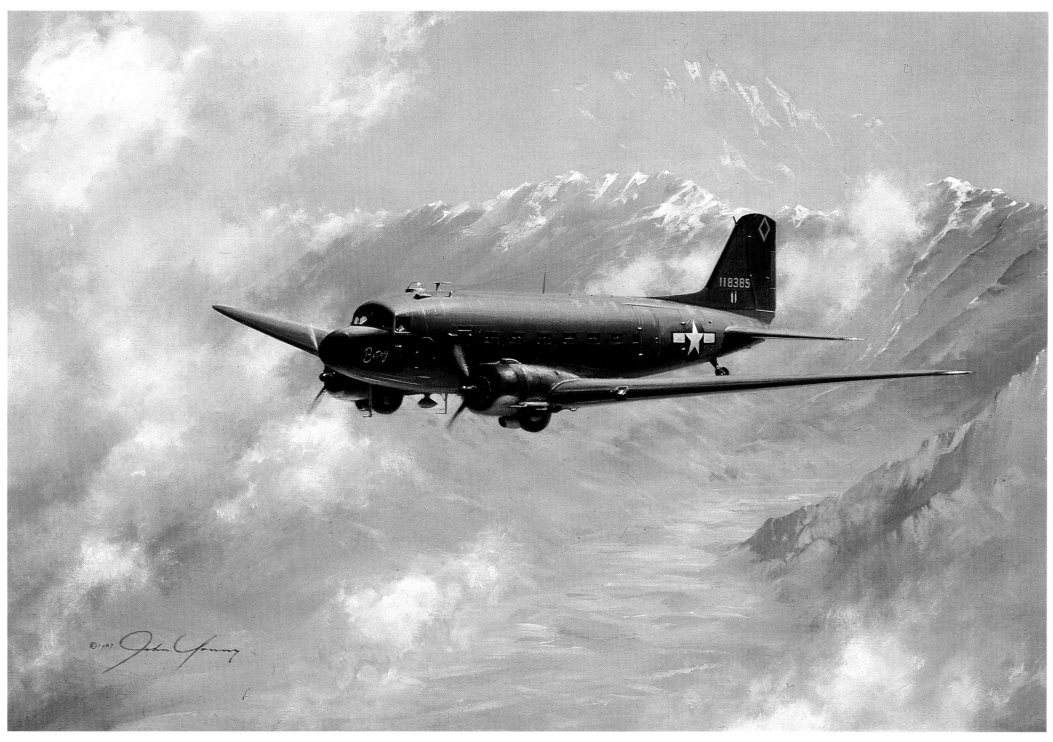

Skytrain from Kunming
Douglas C-47 Skytrain
Oil, 20ins x 30ins, 1987
Reproduced by courtesy of Casey Law Esq.
In British service this aircraft was known as the Dakota.

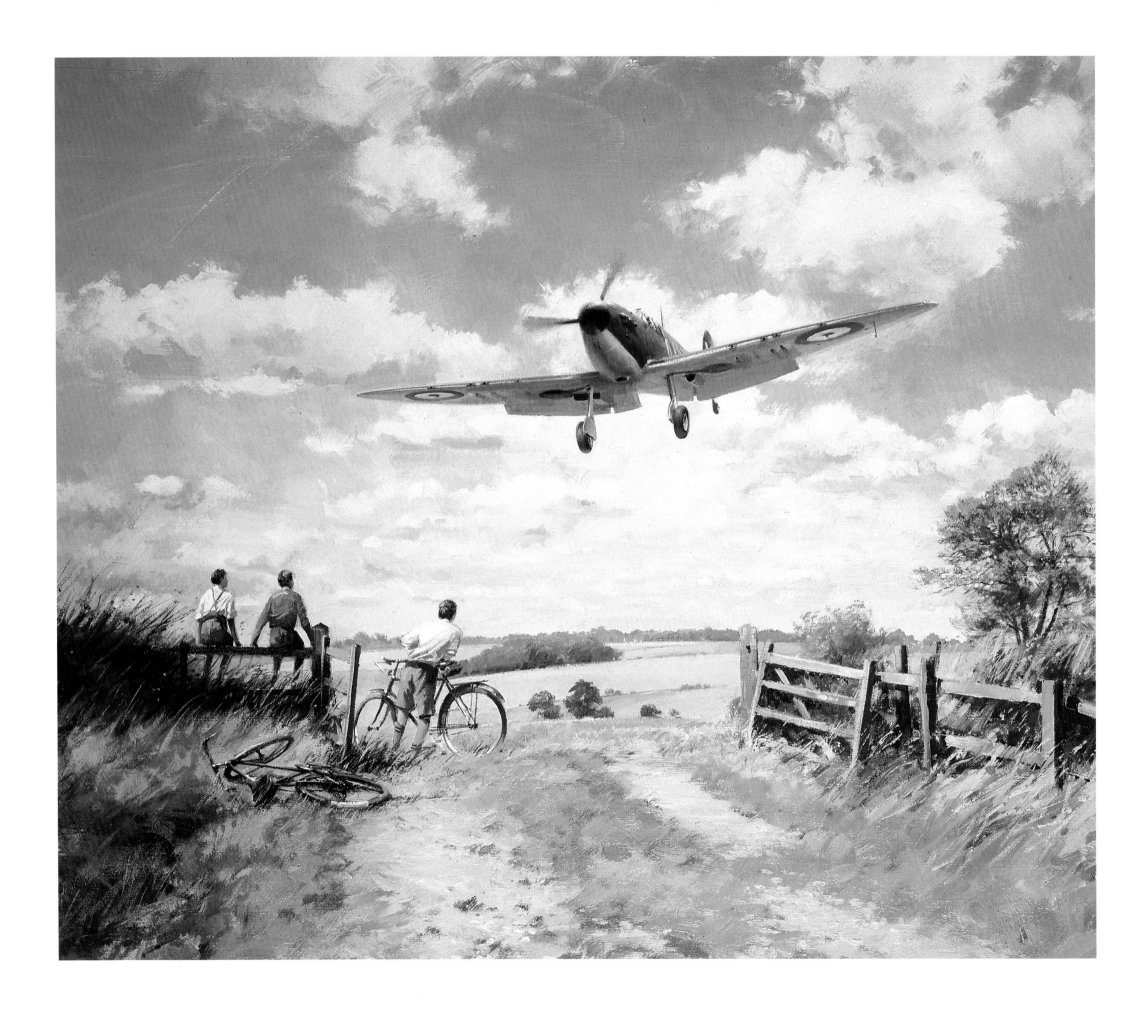

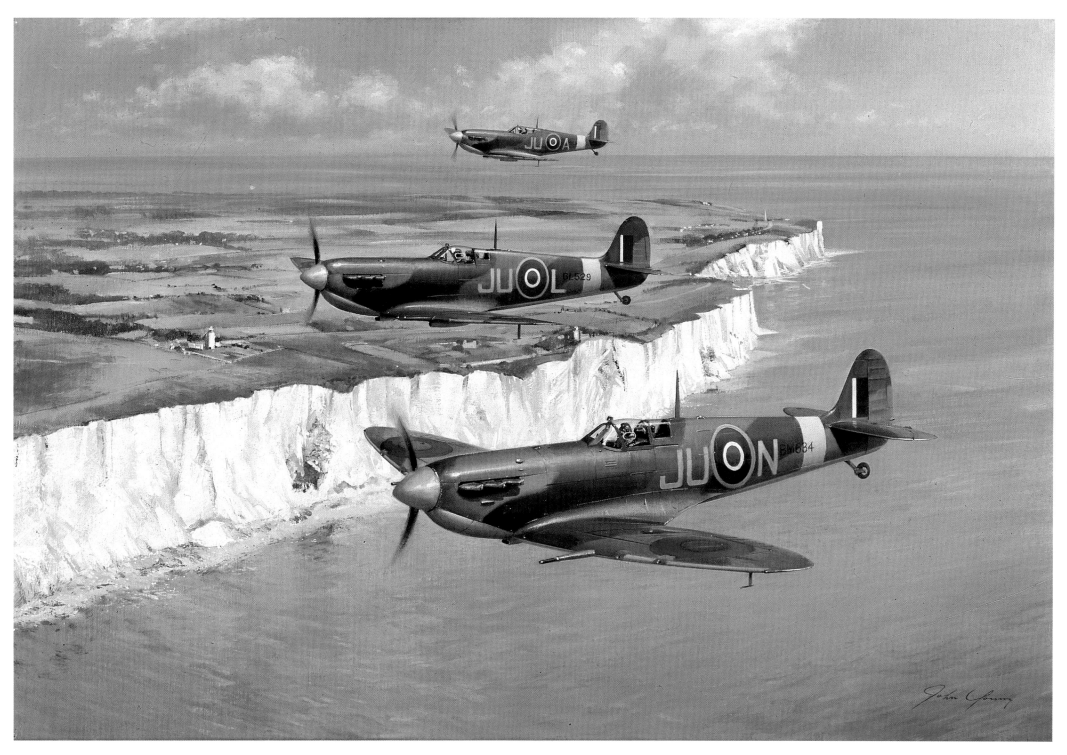

After Noon
Supermarine Spitfire I
Oil, 20ins x 30ins, 1985
Reproduced by courtesy of F. Manning Esq.
Winner of the Roy Nockolds Trophy, 1986.
A Battle of Britain pilot returns from an engagement at the height of the day to fill his tanks while the armourers load fresh belts of ammunition. The school holiday of the summer of 1940 was a stirring time for anyone who could walk or cycle to the local aerodrome.

Dover Patrol
Supermarine Spitfire Vb
Oil, 24ins x 36ins, 1988
Reproduced by courtesy of Dr C. Barber.
There is a double meaning in this title, as the memorial to the Dover Patrol is shown in the background above the famous white cliffs on the south-easterly tip of England. The Spitfires are from No 111 Squadron, RAF Fighter Command.

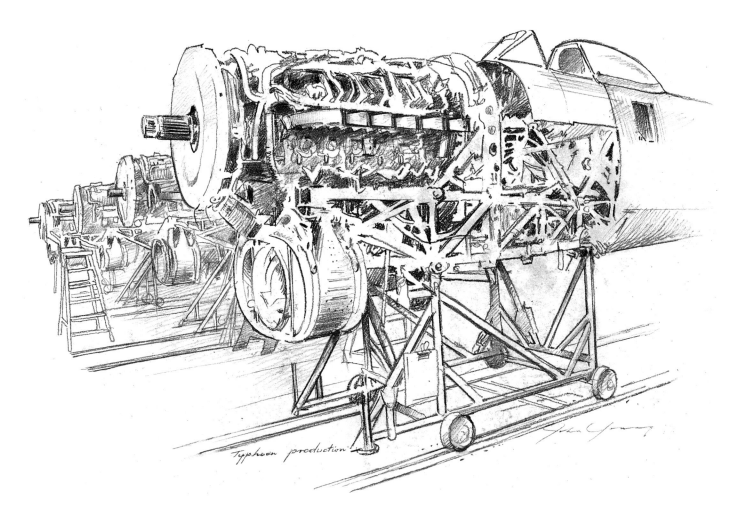

Typhoon production

By then, it seemed, I had become familiar with every nut, rivet and component part of the Typhoon. As a member of the three-man Defects Department, formed to sort out problems that marred the aircraft's entry into service, I had crawled inside the cramped rear fuselage, via a small radio access door, to discover why tailwheels sometimes refused to retract or extend, and had spent time in the cockpit to work out why a pilot had lost his life by apparently jettisoning all his fuel and diving into the Channel after shooting up targets in occupied France.

By the summer of 1944, the de-bugged Typhoons had proved themselves unrivalled as fighter-bombers, sinking enemy ships in the Channel, attacking key German radar stations along the invasion coast before D-Day, bombing transport targets and V-1 launch sites in France, and then sending enemy troops scuttling from their tanks in critical battle areas like the Falaise Gap. This painting has great meaning for me in that it recaptures something of the tensions, excitement and terror of those days. Rocket-laden Typhoons take off in a cloud of dust from a forward airstrip, Sabres roaring at full power, one wheel characteristically retracting before the other, to clear a path for Allied armies on the ground. This was *their* finest hour.

John W.R. Taylor, FRAeS. FRHistS. AFAIAA.
Editor in Chief, Jane's All The World's Aircraft.

TYPHOONS IN NORMANDIE, SUMMER 1944 *(John Taylor)*

My first encounter with the Typhoon was unforgettable. Within hours of starting work in Sydney Camm's design office at Kingston-upon-Thames, the great man himself invited me to accompany him to Hawker's experimental department on the other side of Canbury Park Road. Just inside the door of this 'holy of holies' stood prototypes of the Tornado and Typhoon, like giants impatient to be unleashed. It was a sight to inspire any airminded eighteen-year-old. Six months earlier their predecessor, the Hurricane, had been the main contributor to victory in the Battle of Britain. Here, amid still-visible signs of a Luftwaffe attempt to destroy them, were mighty weapons with which to strike back.

The Tornado remained a prototype, condemned by its underdeveloped Vulture engine. The big 24-cylinder Sabre engine of the Typhoon, although making it the RAF's first over-400mph fighter, was almost as troublesome. There were other, even worse, problems. More than twenty Typhoons were lost when their rear fuselage tore away in flight, usually in a high-speed dive. The quick solution was to attach the tail end so rigidly that it could not separate. The ultimate answer was the more refined, thin-wing, Hawker Tempest.

In the heat of combat, Allied pilots sometimes mistook the heavy-nosed Typhoons for German Focke-Wulf 190s, and several were shot down in error. As a temporary measure, the whole front fuselage of each aircraft, forward of the wings, was painted white, prior to adoption of black and white wingroot stripes for all Allied combat aircraft.

OPPOSITE **Typhoons in Normandie, Summer 1944**
Hawker Typhoon
Oil, 16ins x 20ins, 1985
Reproduced by courtesy of J.W.R. Taylor Esq.

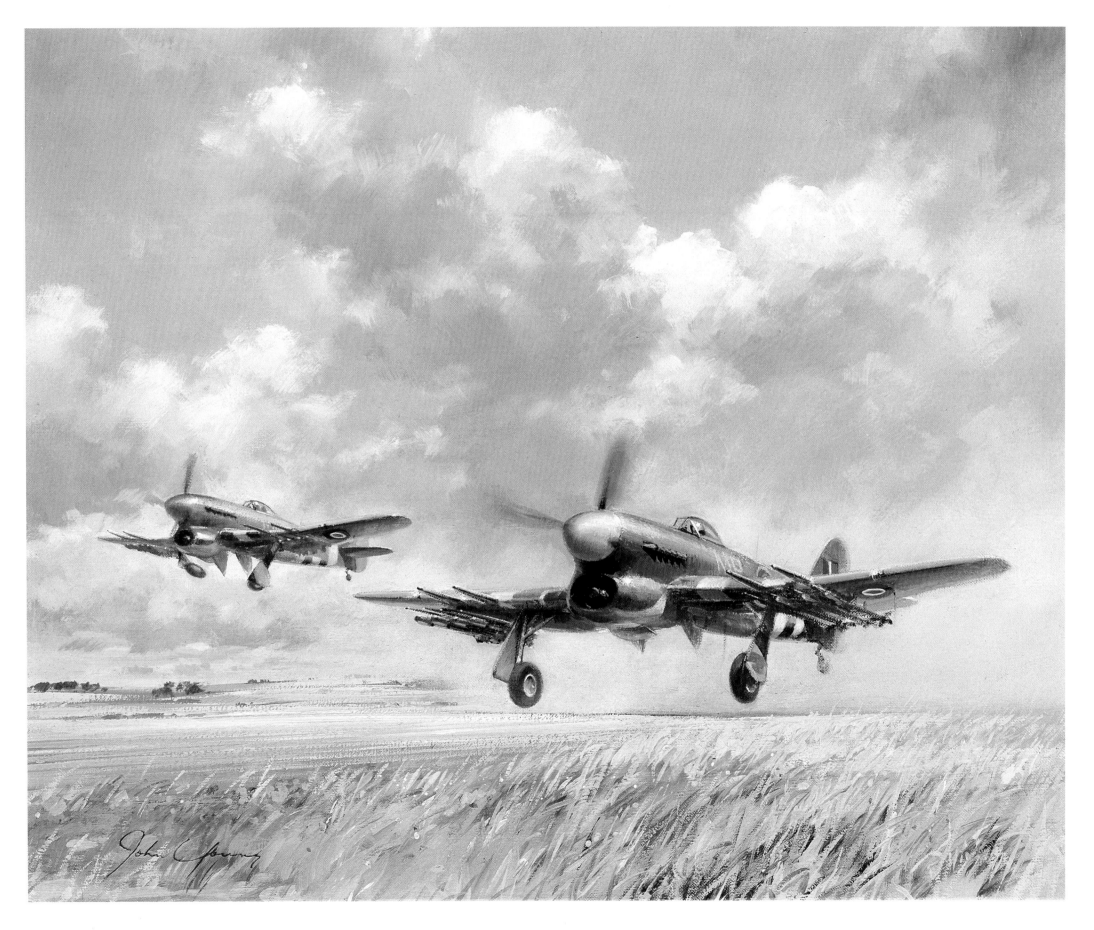

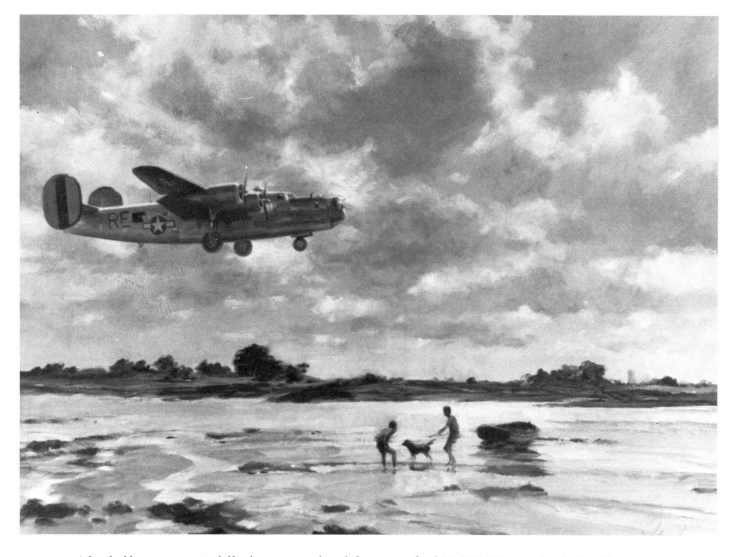

Liberator
Consolidated B-24 Liberator
Oil, 20ins x 30ins, 1976
Private collection.

After half a century it is difficult to comprehend the prodigious effort of the 8th Air Force operations from bases in East Anglia between August 1942 and May 1945. A few statistics can begin to convey some idea of the logistics involved in daylight bombing on 459 days of those 34 months. The 8th aimed to have 2,800 four-engined bombers at its peak strength. The attrition rate was such that 5,982 Fortresses and Liberators were lost at a cost of 46,456 lives. The production totals for these two aircraft types reached 12,731 for the B-17 Fortress and 18,482 for the B-24 Liberator.

The aircraft which served in the 8th Air Force dropped 732,231 tons of bombs. They flew 4,590,391 hours, using 867,564,117 gallons of fuel. The gunners fired 72,339,729 rounds of .50 calibre ammunition which they claimed shot down 6,259 enemy aircraft. The farmland of Norfolk and Suffolk was invaded by an army of construction workers who built 68 airfields and accommodation for 200,000 men. Bearing in mind the scarcity of machinery and depleted work force available in 1942, the amazing amount of concrete laid was the equivalent of 4,000 miles of present-day motorway. It should also be remembered that this area of England was peppered with numerous RAF stations mounting the night-bombing offensive. Few signs of the 8th Air Force's stay remain today, but many Americans continue to make their pilgrimages to reawaken memories and relive those fateful days.

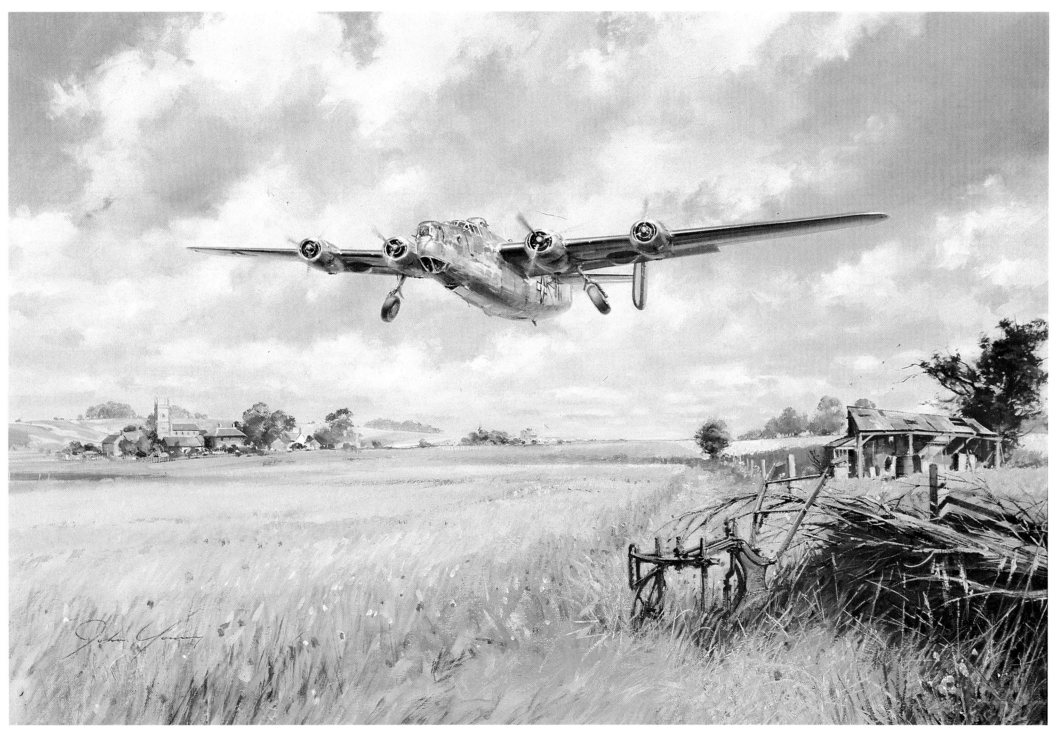

The Sword and the Ploughshare
Consolidated B-24J Liberator
Oil, 20ins x 30ins, 1987
Private collection.
This aircraft belonged to the 93rd Bomb group 'The Travelling Circus', the oldest B-24 group in the 8th Air Force. The group flew more missions (396) than any other 8th AF B.G., and was the most travelled group assigned to that Air Force.

EASY SKIP, SPARKS IS BAD
(Sir Michael Beetham)

When I took over as chief of the Air Staff in 1977 and first sat at my desk, I found myself looking at a blank wall in front of me where my predecessor had taken his favourite painting to his new office down the corridor as Chief of the Defence Staff. I contacted the Royal Air Force Museum to see what they might be able to lend me to fill the gap. They arranged me a splendid collection of paintings of aircraft from which I could select but, as soon as I saw John Young's painting of the Lancaster, I knew that that was the one I wanted.

I have a special attachment to the Lancaster as my first operational aircraft, the one that carried me safely through my part in the Bomber Offensive in World War II and the one that I flew in squadrons for several years after. The raids against Germany were almost invariably at night but we were frequently landing back at base shortly after dawn. The losses were heavy and many aircraft returned damaged either by flak or fighters. John Young's Lancaster, with its shrapnel damage and the port inner engine feathered certainly evoked memories for me of landing similarly after a raid over Augsburg in the winter of 1943/44. He has captured the atmosphere just before touch-down perfectly, with the menacing clouds in the background and the next Lancaster to land just thirty seconds behind. The airfield and the surroundings are bleak but welcoming, as is the green light clearance to land a few seconds earlier from the chequered caravan to the side of the runway at touchdown point. One can almost sense the relief of the crew to be safely home once again, a relief heightened on any occasion when returning not quite in one piece.

The painting lived with me on the wall throughout my five years in office. I would love to have taken it with me, but I am glad to say that to this day my successors, whilst not personally attached to the Lancaster, have kept it hanging there. This is really no surprise to me, for not only is it a very fine painting, but it also portrays an important part of the Royal Air Force's history.

Marshal of the Royal Air Force, Sir Michael Beetham, GCB,CBE,DFC,AFC, was Chief of the Air Staff from August 1977 to October, 1982.

Bombing Up
Handley Page Halifax BIII
Oil, 20ins x 30ins, 1984
Reproduced by courtesy of R.B. Collins, Esq.
The Halifax shared the burden of the night Battle of Germany with the Lancaster. This is 'O-Oboe' of No 78 Squadron.

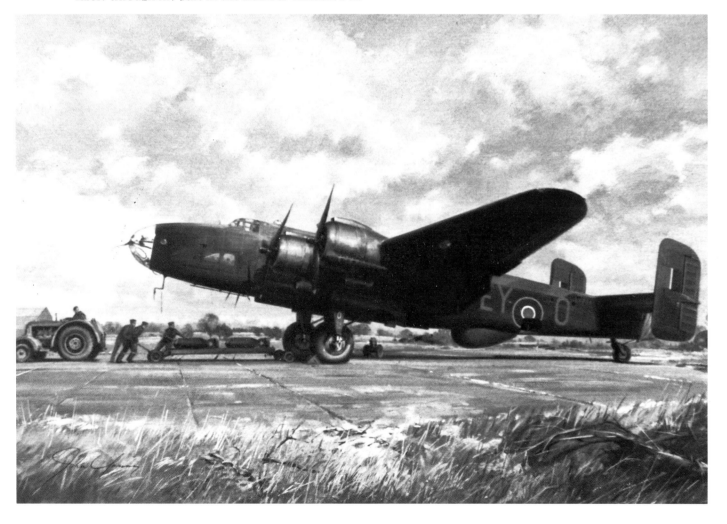

OPPOSITE **'Easy Skip, Sparks is bad'**
Avro Lancaster
Oil, 30ins x 40ins, 1975
Reproduced by courtesy of the Royal Air Force Museum.
The title represents the emotion of a flight engineer or gunner who is holding a tourniquet on the radio operator, trying to save his life, as the skipper brings in his damaged bomber. The stationary propeller with a large chunk missing tells its own story.

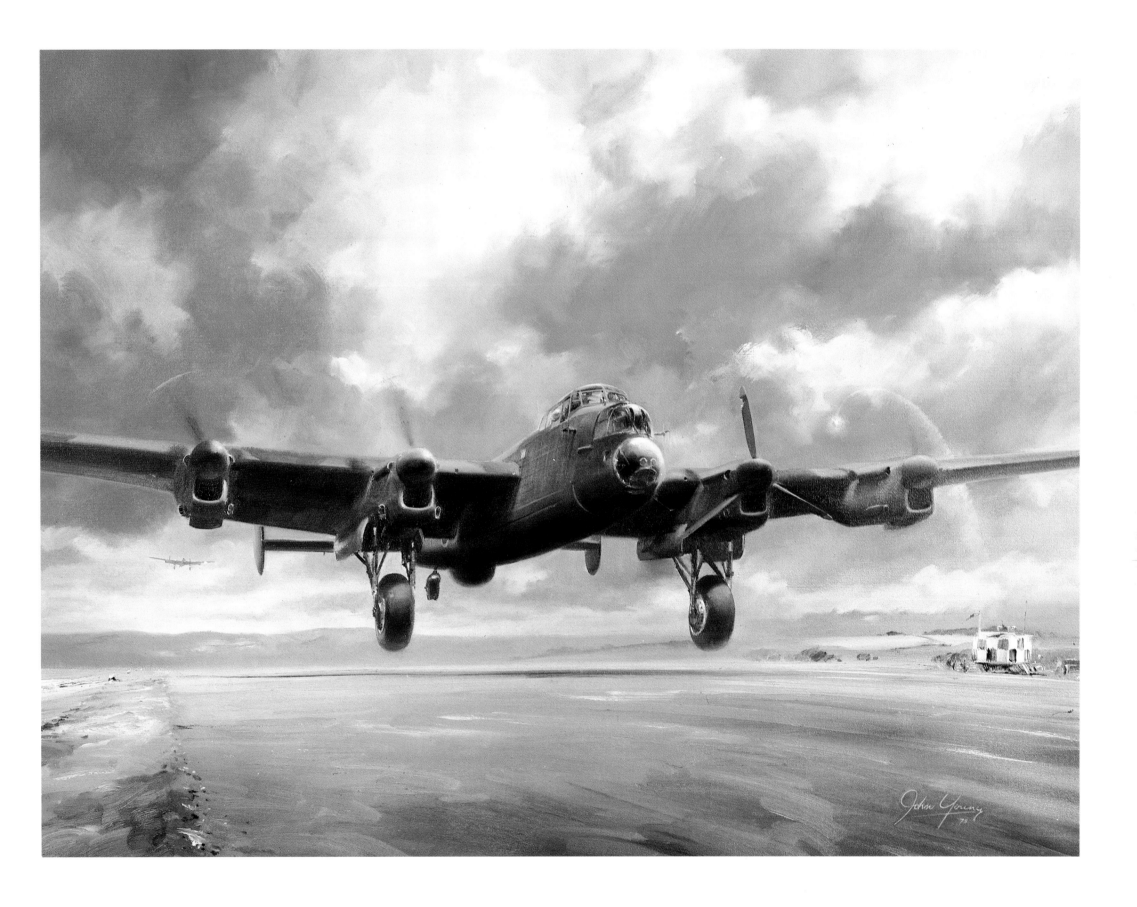

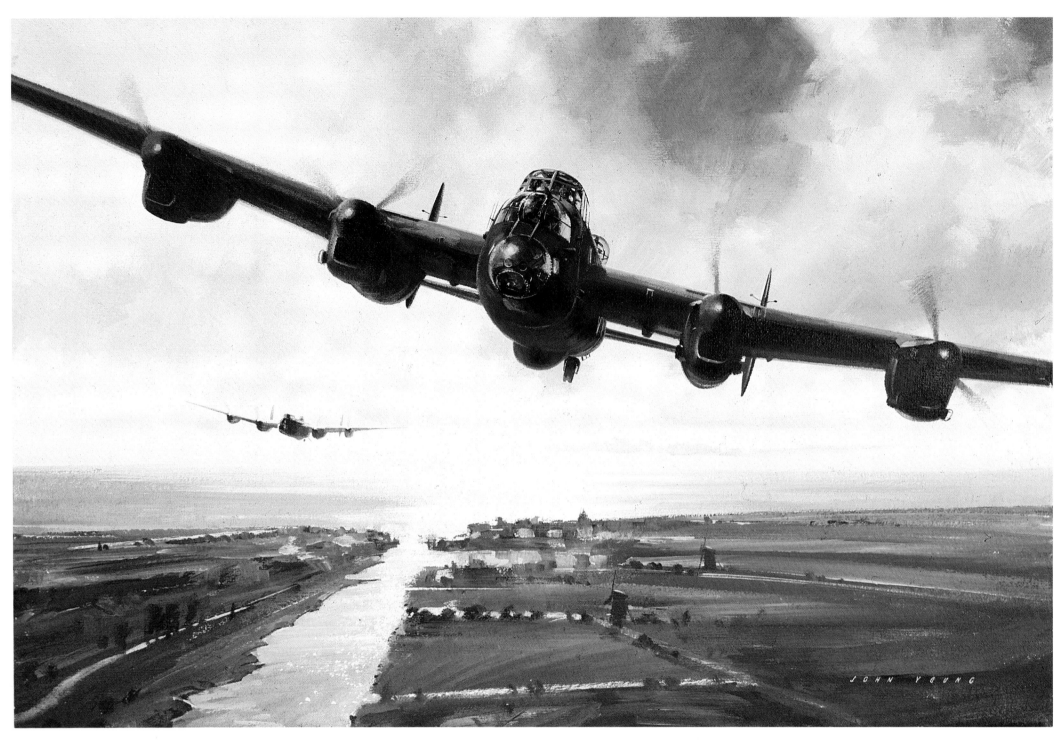

Lancasters over Holland
Avro Lancaster
Oil, 20ins x 32ins, 1968
Reproduced by courtesy of the Royal Air Force Club.

The Golden Cloud
Avro Lancaster BIII
Oil, 33ins x 44ins, 1982
ED 860 'N-Nan' flew on 129 operational sorties. For six of
these the pilot was Air Vice-Marshal Norman Hoad, a
founder member of the Guild of Aviation Artists. On
29 August 1944 he took 'Nan' to Konigsberg in East
Prussia, a mission lasting 10 hours 45 minutes, all of which
had to be flown manually. The aircraft was hit in the port
wing root by cannon shells from a Junkers 88, damaging
the Lancaster so severely that it never flew again.

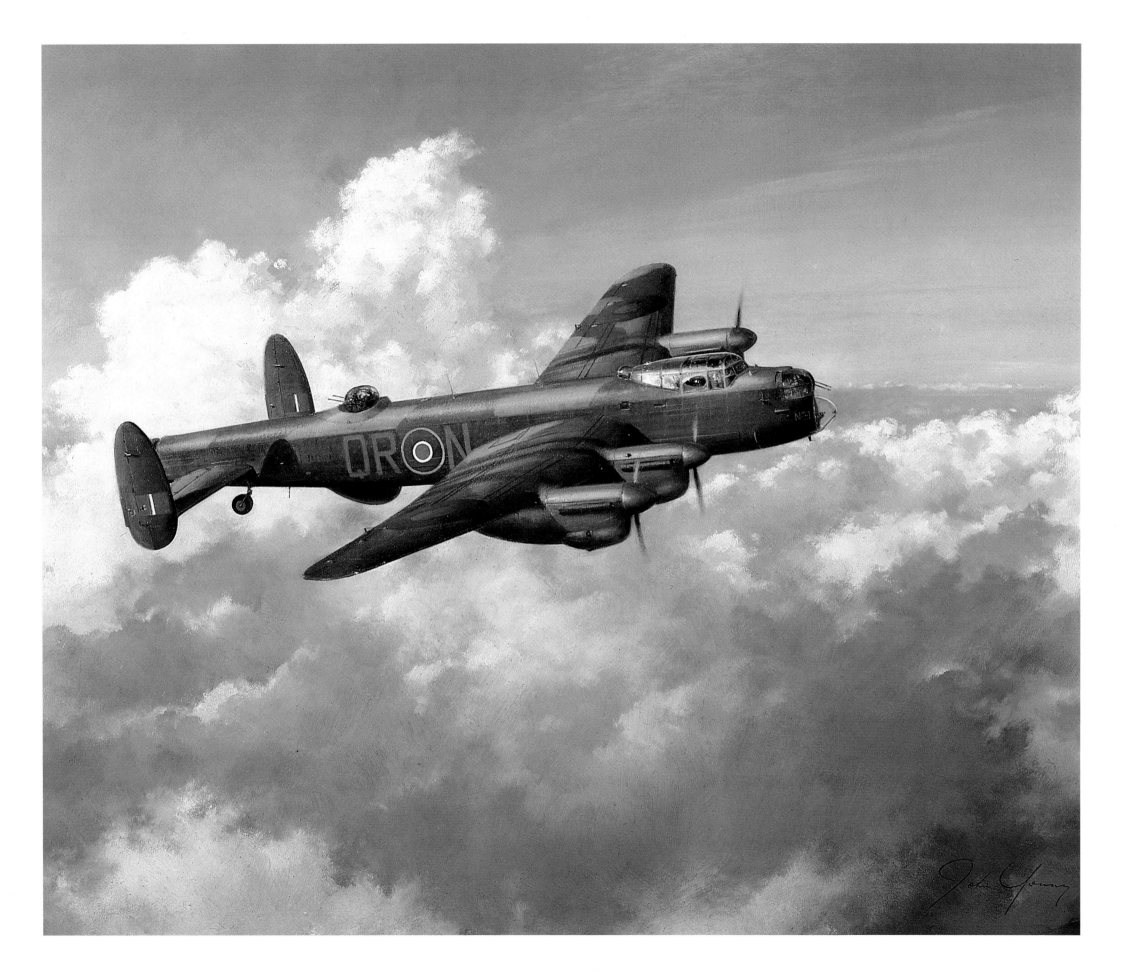

LOADING A TALLBOY (*Mick Maguire*)

I have been asked, not for the first time, what this painting means to me. What indeed, when it is loaded with many memories? The fact that it portrays the three loves of my young life, to wit: LACW Karina Temkin, Lancaster J-Johnny of IX Squadron and my old Matchless G3L motorbike is one thing, but it also speaks vividly of wartime in the Lincolnshire fens, of life and death, of which there was more than enough at the sharp end of Bomber Command, and of my arrival at Bardney in the winter of '43 – if arrival is the correct word.

Newly commissioned from flight sergeant, I'd had two days' leave in Ireland before making the trek to HQ 5 Group at Grantham, to be diverted straight to HQ 53 Base Waddington and, almost without stopping, to Bardney in the company of the base armament officer who left me at the deserted armoury with instructions to contact the C.O. after takeoff. It was pitch black and the noise of some twenty-odd Lancasters on pre-takeoff checks was appalling. Throwing my kit into a corner, I sat on the desk as the telephone erupted. 'I won't answer it' I thought, but picked it up – before I could speak, a voice said 'Get over here right away' and the line went dead. I figured that only the C.O. could speak with such authority but where was he in the black and noisy bomber station? The control tower surely. I went outside, picked up the dark shape of the tower and climbed the back stairs, opened the control-room door and saluted smartly to a small and obviously agitated Group Captain who looked at me in surprise and asked coldly who I was and where I had come from. I could tell he didn't want to know where I was born.

'Pilot Officer Maguire, armament, from Fighter Command,' I said. Looking even more fiercely at me, he snapped: 'OK Fighter Command, there's a Lancaster out there with an unserviceable rear turret. You've got forty-five minutes to fix it.' Stunned, I saluted again and rushed down the stairs to return to my only other point of reference, the armoury, where, in the dark, I collided with a rather weary looking individual who introduced himself as

Sergeant Gallant, armourer. I told him I'd only been on the station five minutes, been lumbered with an unserviceable aircraft with some forty minutes to go and what the hell could we do about it.

The next half hour was an education. I found myself on dispersal watching a high speed turret change as the rest of the squadron rolled past, engines blaring, brakes squealing, aldis lamps up in the nose picking out the tail of the aircraft in front as the awe-inspiring procession made its way to the takeoff point. With the replacement turret not quite bolted down, 'O' Oboe revved up, rolled out to join the queue and, as the last but one aircraft roared off into the night, swung onto the runway and lined up for takeoff. A bunch of armourers tumbled out of the rear door with Sgt Gallant shouting instructions to the gunner. Anticipating my queries, Gallant said: 'It's OK, the gunner is an armourer and he'll bleed the hydraulics on the climb.'

Back in the office around midnight, listening to the armourers' smalltalk, I was surprised when the C.O. came in and offered me a lift to the mess. 'Is it always like this?' I asked. 'Worse, usually', he replied. I looked at him and there was nothing more to say. A few weeks later, he was a prisoner of war.

Somehow John's painting, with the subtle glow of new concrete picking out the highlights of the aircraft undercarriage and giving shape, weight and menace to the 12,000lb Tallboy bomb, conjures up another day. A day, not much different from others in its hard and unrelenting work, which ended with an almost theatrical twist. A day when the squadron, returning from ops, beat the fog and came home to Bardney, all but one, who found it prudent to land at Waddington, our base station, where the visibility was a little better.

In the evening, with the squadron bombed up and ready to go at first light, the base armament officer telephoned to ask what, since there were no Tallboys at Waddington, we proposed to do about our stray bird still fogged in there. Being a bit short of alternatives, I said that we would bring the mountain to Mohammed and would, he, Robby, please arrange for some lighting and a policy of non-interference, thank you. There was no reason why we should not

transport the big bomb over the dozen or so miles to Waddington. After all, the roads of Lincolnshire were full of bomb convoys in those days but this one was going to look different, that's all, and I hoped we could take cover in the fog. So, an hour or so later, our small convoy of one motor cycle and a David Brown tractor hauling a big 'H' type trolley loaded with a gleaming wet Tallboy and draped with sundry armourers, slipped through a dark and fog-bound Bardney village to Potterhanworth. There we parked by the pub and went in for half a pint of mild – to the consternation of an elderly local who came in, eyes popping and shouting about a ruddy great rocket parked outside.

We departed in a hurry and came into Waddington base through the back entrance and into the bomb dump where we fused the bomb before making our way to the perimeter track. I went ahead on the bike to check up on facilities at the dispersal pad where our stray bird was and found, to my surprise, that not only was there more illumination than I had expected or required, but that a large audience of HQ base staff had gathered to catch their first sight of a Tallboy. I also suspected that Robby, singing our praises too loudly, had turned this affair into a circus.

I intercepted the armourers on the perimeter track and warned them of this new development, but need not have worried. My small team, rising to the occasion, completed their safety checks and did a very slick bombing-up operation in twenty minutes, with Corporal Spencer adding the last dramatic flourish by checking the lower bomb fin and bomb door clearance with a cigarette card, before leading the team out into the glare of the floodlights to take a cheeky bow to the audience. They clapped and cheered and filled Robby's service cap with a little something to buy the boys a drink on the way back. Another day and night to add weight to IX Squadron's unofficial motto: 'There's always bloody something'.

Squadron Leader Maguire was Armaments Officer of No IX Squadron from 1943 to the end of the war in Europe and of No 617 Squadron (the Dam Busters) in preparation for deployment in the Far East.

68

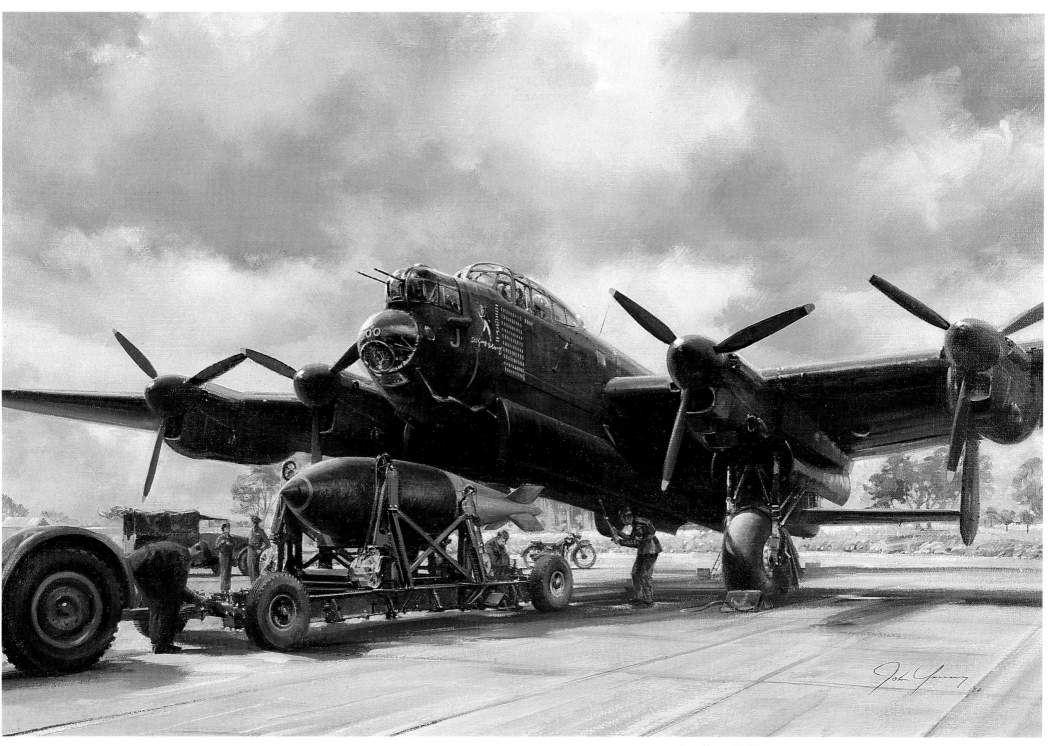

Loading a Tallboy
Avro Lancaster BI
Oil, 20ins x 30ins, 1984
Reproduced by courtesy of Squadron Leader J. Maguire, MBE.
Lancaster W4964 'J-Johnnie Walker' of No IX Squadron
was another aircraft to complete more than a century of
operational sorties with a final score of 106. The
scoreboard on the nose includes a searchlight shot out by
'Mick' Maguire.

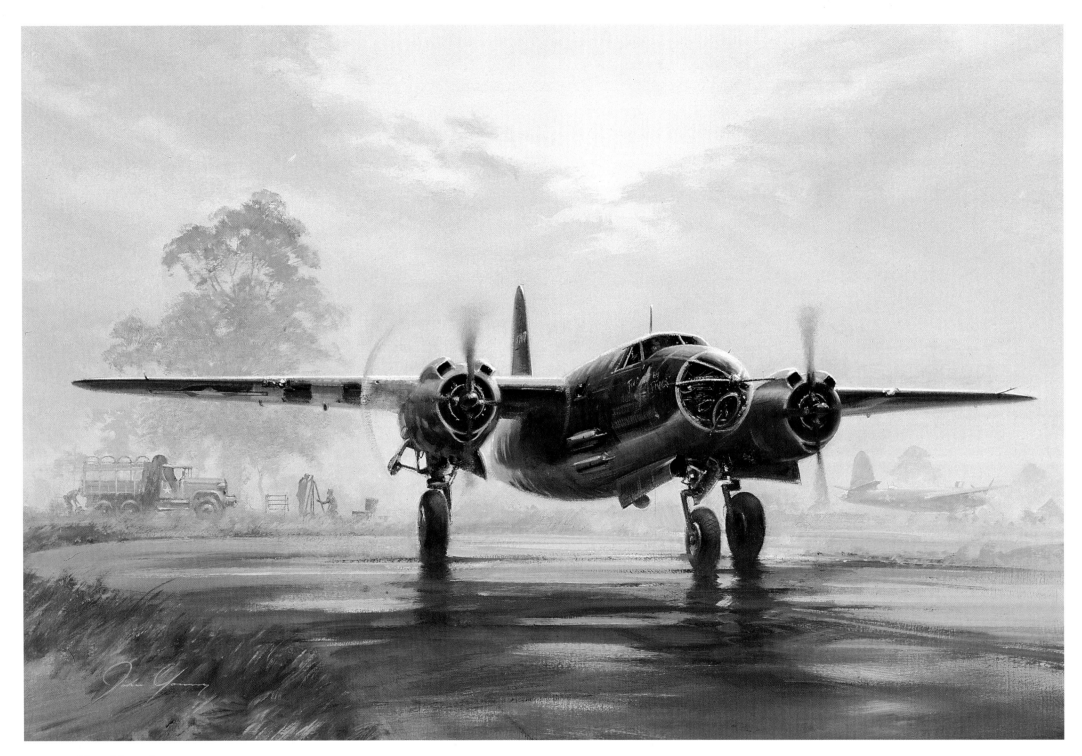

Misty Marauder
Martin B-26 Marauder
Oil, 20ins x 30ins, 1987
Reproduced by courtesy of Gale Wergeland Esq.
A B-26 of the 9th Air Force which operated from East
Anglian bases, alongside the 8th. 'Five by Fives' of the
387th Bomb Group flew 188 combat missions, the second
highest by a USAAF bomber in the European theatre.

70

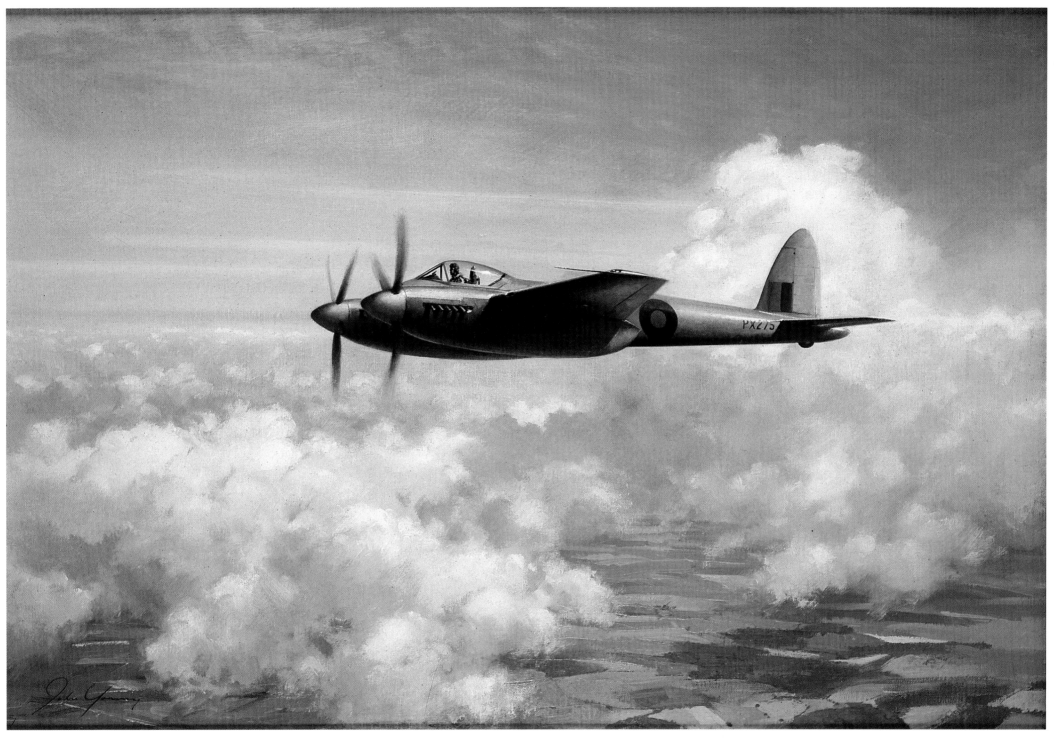

Ah! de Havilland
de Havilland D.H. 103 Hornet
Oil, 20ins x 30ins, 1987
Reproduced by courtesy of J. Harris, Esq.
The sleek lines of the Hornet single-seat fighter epitomised the shapeliness for which de Havilland designs were renowned. Like its ancestor, the Mosquito, the Hornet was of wooden construction, using a ply-balsa-ply sandwich. One of the fastest piston-engined machines ever made, it arrived too late to see service in World War II, but did fly operationally during the Malayan Emergency.

To arrive at our selected interception point too soon would prove embarrassing and possibly fatal as the Japanese had seventy-five additional fighter aircraft sitting on the airfield where Yamamoto was to land. Also, fuel amounts were critical. A late arrival would mean we would miss our quarry. We had no radars, radio beams or drift meters to guide us, and from take-off to rendezvous we would not have a single checkpoint. The airspeed indicator, clock and compass were our sole means of navigation.

As planned intercept time got down to only one minute away, Lt. Doug Canning, number-three man in our flight, broke radio silence with 'Bogeys, 11 o'clock, high'. There, shimmering in the morning sunlight, were two 'Betty' type bombers, soon to be destroyed, along with Admiral Yamamoto and his staff. Also to be seriously impaired would be the capability of the Japanese to carry on the war they had commenced on 7 December 1941 at Pearl Harbour, Hawaii.

John Young's painting captures the infinite vastness of the ocean and the sky, both of which were uppermost in my mind during the two hours we flew to accomplish our impossible mission to 'Search for the Needle'.

Col. John W. Mitchell, USAF (Retd.). During his service career, Colonel Mitchell was awarded the Distinguished Service Cross, Navy Cross, Legion of Merit, Bronze Star, Distinguished Flying Cross with four Clusters and the Air Medal with nine Clusters.

LEFT Four of the P-38 pilots meet in Seattle to sign prints of *Search for the Needle*. Left to right Col. John W. Mitchell USAF Retd., Barbara Young, Julius 'Jack' Jacobson, Delton Goerke, Kathleen Weber of Aerodrome Press, John Young and (seated) Lt. Col. Doug Canning USAF Retd.

SEARCH FOR THE NEEDLE
(John Mitchell)

This great painting, *Search for the Needle,* brings back many distant memories. As the planner and leader of the mission which was to take off from Guadalcanal and which looked for and destroyed Japanese Admiral Isoroku Yamamoto, I was much impressed with the feeling of isolation on the outbound journey.

After establishing the circuitous route which it would be necessary for us to fly to avoid detection by enemy coast watchers and/or radar, it was also necessary that an altitude of 50ft above the water be maintained. Meticulous timing was an absolute requirement as we would have to fly some 415 miles to make an interception of a Japanese bomber (converted to transport) and accompanied by six fighter aircraft (Zeros). This group would be flying from Rabaul to the southern tip of Bougainville, a distance of some 325 miles, ground speed and exact route unknown. This was, indeed, a 'Search for the Needle'.

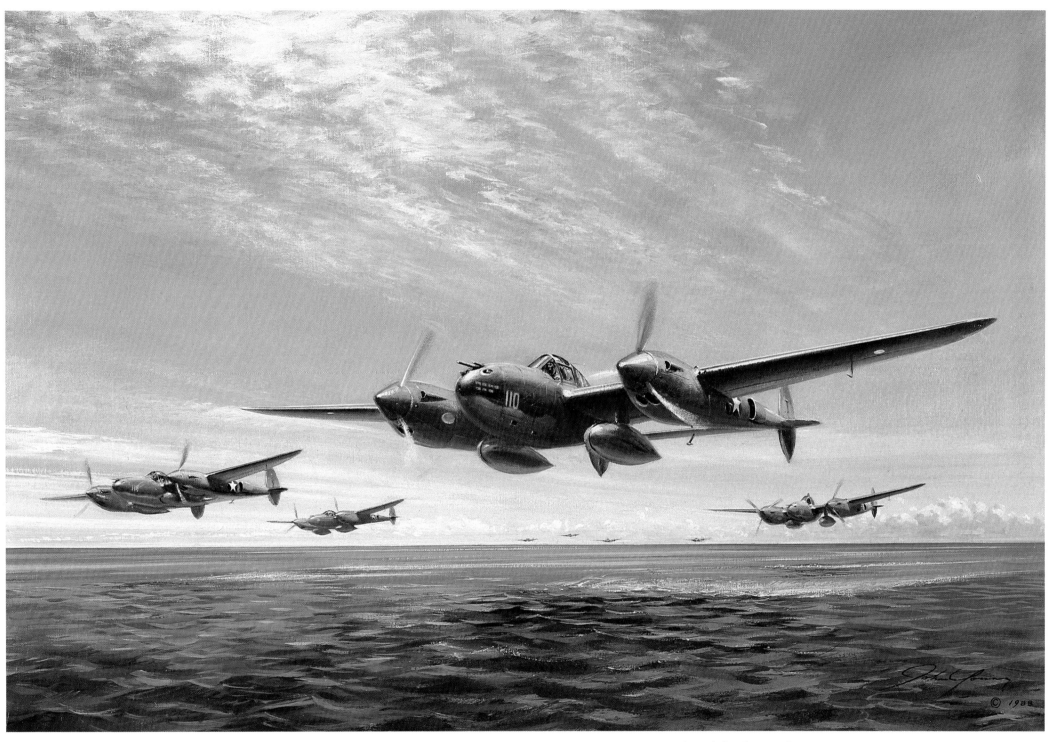

Search for the Needle
Lockheed P-38 Lightning
Oil, 20ins x 30ins, 1988

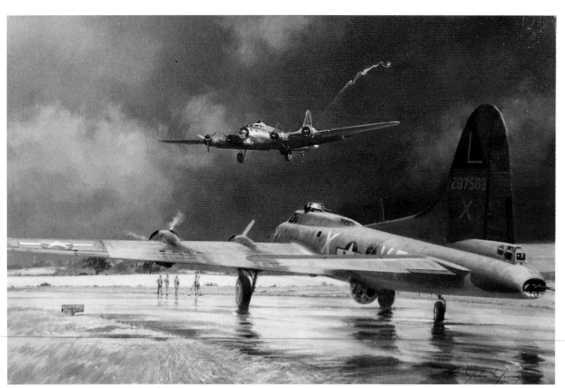

After the Storm
Boeing B-17G Fortress
Oil, 20ins x 30ins, 1985
Private collection.
Two B-17s arrive back at base through stormy conditions after another hard mission. A camouflaged aircraft pauses at the runway threshold on its way back to dispersal. The newer, natural metal aircraft is on final approach with an engine out, and fires a flare to warn the medics that there are wounded aboard. The taxying Fortress has the inner engines stopped for better pilot visibility. I enjoyed working on a dark sky for a change, giving opportunities for some unusual effects.

A prerequisite for a successful painting of a B-17, or any other type seen at rest, is the appropriate choice of support vehicles. In *After the Storm* one ground crewman has a bicycle, the most common mode of transport on the airfield. I recall the sight of hundreds of bikes abandoned on the ground like dead insects around the vast mess hall while their riders took 'chow'.

In the early 1940s, the motor vehicles clustered around the Forts were new and unfamiliar shapes, an added attraction for young spotters. The name Ford was familiar to us, but it took time for us to twist our tongues around Chevrolet, Studebaker and Willys.

Willys - Overland ¼ ton 4x4 Jeep

Bomb Truck

Mobile Snack-bar.

Runway Control Van with B-17 nosepiece as observation cupola.

Cletrac aircraft tug

Dodge ½ ton ambulance

Sedan Staff Car

Harley-Davidson motor cycle

Tractor with two 2000-gallon trailers

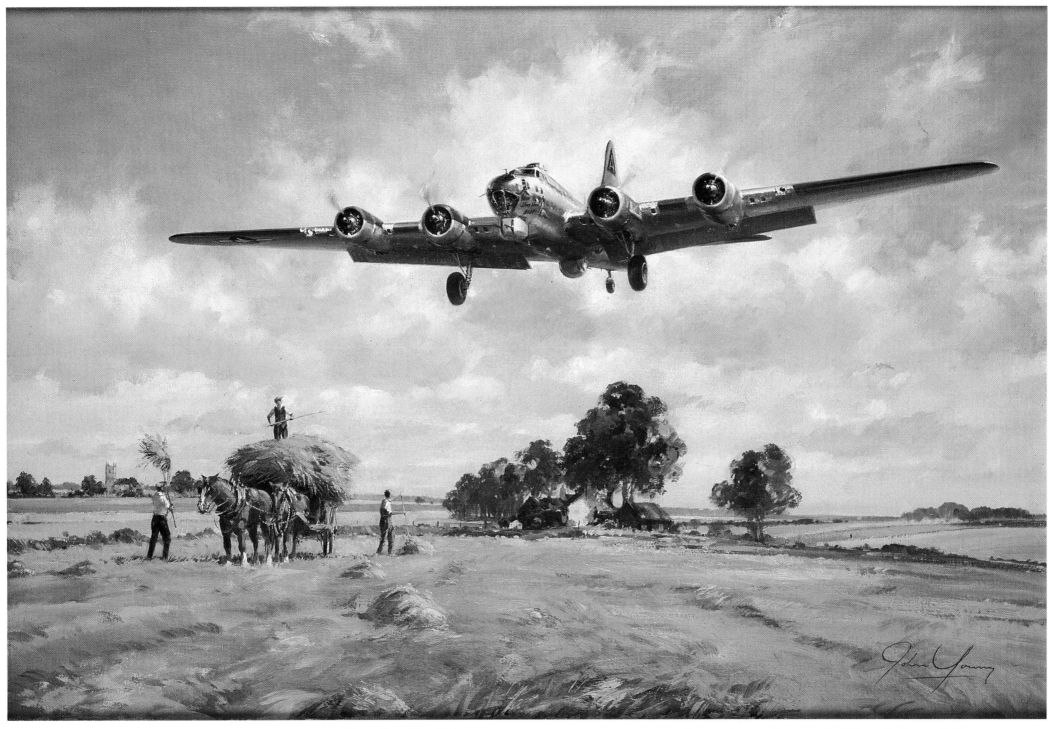

Shoo-Shoo-Shoo Baby
Boeing B-17G Fortress
Oil, 20ins x 30ins, 1979
Reproduced by courtesy of Mr & Mrs J.H. Batchelor.
A Flying Fortress returns from a mission. This bomber ended its career with the USAAF when it force-landed in Sweden having been shot up over Poland. After several careers as airliner, coastal patrol and photo survey aircraft, the remains went home to the US as a 'basket case'. She was painstakingly rebuilt at Dover AFB, made airworthy and, flying for the first time in seventeen years, was delivered to the United States Air Force Museum at Wright Patterson AFB, Ohio, in 1988. This Fortress is on permanent display as a memorial to the men of the 8th Air Force who died in the Second World War.

MUSTANG WONDER (*Jeff Ethell*)

Looking at Don Gentile's P-51B *Shangri-La*, as it taxies across Debden, England, frozen in time, has an emotional impact difficult to control. John Young has captured the essence of the aircraft distilled out of experience, which should be the heart of aviation art. Unfortunately, much of what passes for art is detailed technical illustration which does not give the viewer any idea of what it was really like to set off behind that wizard Merlin.

Alone in the cockpit of a Mustang, I feel secure – the aircraft fits the pilot wonderfully with everything easily accessible. I never manage to control the excitement, the racing heart, as my hands move across the switches to bring it to life. As the massive propeller begins to turn, the airframe wiggles slightly from the force of the starter, then the stacks bark and the Merlin settles down to a loud purr. The smell of burnt oil comes rushing into the cockpit as the hydraulics start to close the fairing doors and raise the flaps. Slowly, she comes to life under your hands and you sit there, allowing coolant and oil to warm up without interference. There is no reining her in or forcing her down the taxiway until she's ready.

Each time I fly the Mustang now I am acutely aware of my responsibility to keep this rich part of history intact. As the throttle moves up to full power, the Merlin screams and my right foot moves down on the rudder pedal to keep it straight. The visceral experience is frightening, joyful, fearful and wonderful all at once. Not until the gear is tucked away and the power brought back to climb do I recover.

Pointing the nose up into the clouds, I am awed by the amount of power I control. Rarely do I fail to smile, though no one is there to see my expression . . . it must look idiotic but I can't help it.

At 24,000 feet, power back to cruise, alone among the clouds and breathing a self-contained atmosphere, I sense that – as John Gillespie Magee wrote – I have 'put out my hand, and touched the face of God'. Sitting within this powerful, beautiful, once-deadly machine becomes a spiritual experience that remains so personal, so unique, that it is difficult to communicate once back down. The power then is only a memory, the joy of manoeuvering about the sky merely a dim recollection.

Then I see *Shangri-La* hanging on my wall, Merlin running, ready to take Don Gentile where I've just been, and I remember. There is no such thing as the greatest in aviation art. There are only those artists who can bring that emotional presence back to earth and those who cannot.

Jeff Ethell. Jeff, a pilot and ordained minister, chose writing as a career and is respected for his wide experience of flying a vast number of different types of aircraft. He regularly flies 'Warbirds' at air shows and, in 1987, ferried a B-17 from Duxford, England, to a museum in Texas, doing a 'buzz job' on his home and family in Front Royal, Virginia, on the way.

It is difficult to make a claim that one particular type of machine is more important than, or technically superior to, another. Comparisons depend on a great number of factors. Whatever claim to fame the Mustang may have, it happened to come onto the world stage at the moment of greatest need and was undoubtedly one of the truly great aircraft of World War II. Its gestation period as a design was extremely short, the first production example flying exactly twelve months after the decision to proceed with the design.

The dire need for the P-51 was generated by the build-up of the bomber element of the 8th Air Force. General Eaker had amassed a fleet which could put 1,000 B-17s and B-24s into the air on one mission. Strategic requirements dictated attacks on many targets that were beyond the range of fighter escort. The P-47 Thunderbolts had to turn for home just as the bombers needed them most.

Heavy losses called for urgent action and the American Mustang with its British Rolls-Royce Merlin engine was given top priority for large-scale production. Pilots were trained on the new fighter and, as it entered service, the air war over Europe saw a decisive change. The Commander of the Luftwaffe, Hermann Goering, being questioned after the war, admitted that in his opinion when the P-51 joined the battle, the war was decided. Not surprisingly, the Mustangs were known by all the 8th Air Force bomber crews as the 'Little Friends'.

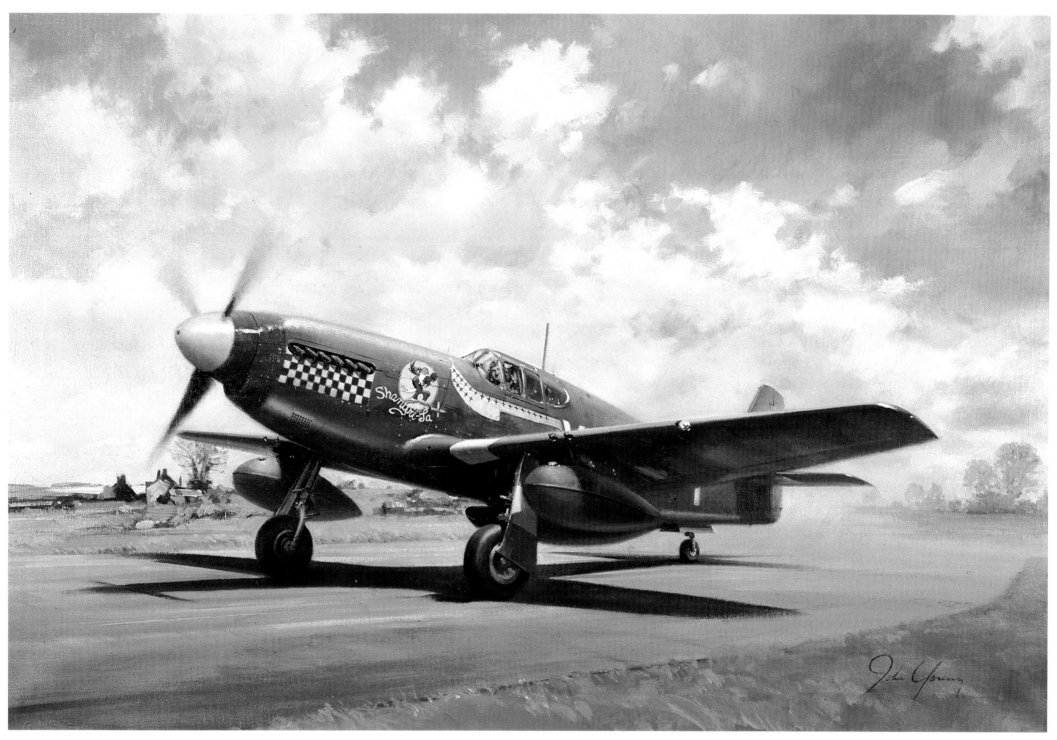

Shangri-La
North American P-51 Mustang
Oil, 24ins x 36ins, 1981
Reproduced by courtesy of J.L. Ethell, Esq.
The legendary fighter pilot, Don Gentile, finished his
combat tour with a tally of thirty victories. On 13 April
1944, he celebrated with 'one helluva beat-up' which
ended when *Shangri-La* struck the ground, its fuselage
breaking in two and the shaken pilot walking ruefully
away.

77

In the early 1980s I was invited to paint the history of the bomber in a series of forty-five oils to be hung in the new Bomber Command Museum at Hendon. The opening of this new wing of the Royal Air Force Museum brought renewed debate on the morality of bombing and the subject of war as a whole. For me, it serves as a memorial to 57,000 men who gave their lives in the Command between 1939 and 1945. What must it have been like to fly over enemy territory? One of the best descriptions I have found was written by a Canadian pilot with 214 Squadron:

To a person wanting to visualize how intense the strain could become, how suppressed fear could swell and gnaw inside, I offer the following as a comparison, perhaps easier to imagine than the unfamiliar surroundings of a darkened bomber cockpit framed in faintly luminous dials.

Imagine yourself in a building of enormous size, pitch black inside. You are ordered to walk very slowly from one side to the other, then back. This walk in the dark will take you perhaps five or six hours. You know that in various nooks and crannies along your route killers armed with machine guns are lurking. They will quickly become aware that you have started your journey, and will be trying to find you the whole time you are in the course of it. There is another rather important psychological factor: the continuous roar emanating from nearby machinery. It precludes the possibility of your getting any audible warning of danger's approach. You are thus aware that if the trouble you are expecting does come, it will burst upon you with the startling surprise one can experience standing in the shower and having someone abruptly jerk open the door of the steamy cubicle and shout over the noise. If the killers stalking you on your walk should happen to detect you, they will leap at you out of the darkness firing flaming tracers from their machine guns. Compared with the armament they are carrying, you are virtually defenceless.

Moreover you must carry a pail of gasoline and a shopping bag full of dynamite in one hand. If someone rushes at you and begins firing, about all you can do is fire a small calibre pistol in his direction and try to elude him in the dark. But these killers can run twice as fast as you, and if one stalks and catches you, the odds are that he will wound and then incinerate you, or blow you into eternity. You are acutely aware of these possibilities for every second of the five or six hours you walk in the darkness, braced always, consciously or subconsciously, for a murderous burst of fire, and reminded of the stakes of the game periodically by the sight of guns flashing in the dark and great volcanic eruptions of flaming gasoline. You repeat this experience many times – if you live.

From A Thousand Shall Fall by D. Murray Peden, QC, DFC, published by Canadian Wings Inc. Box 393, Stittsville, Canada.

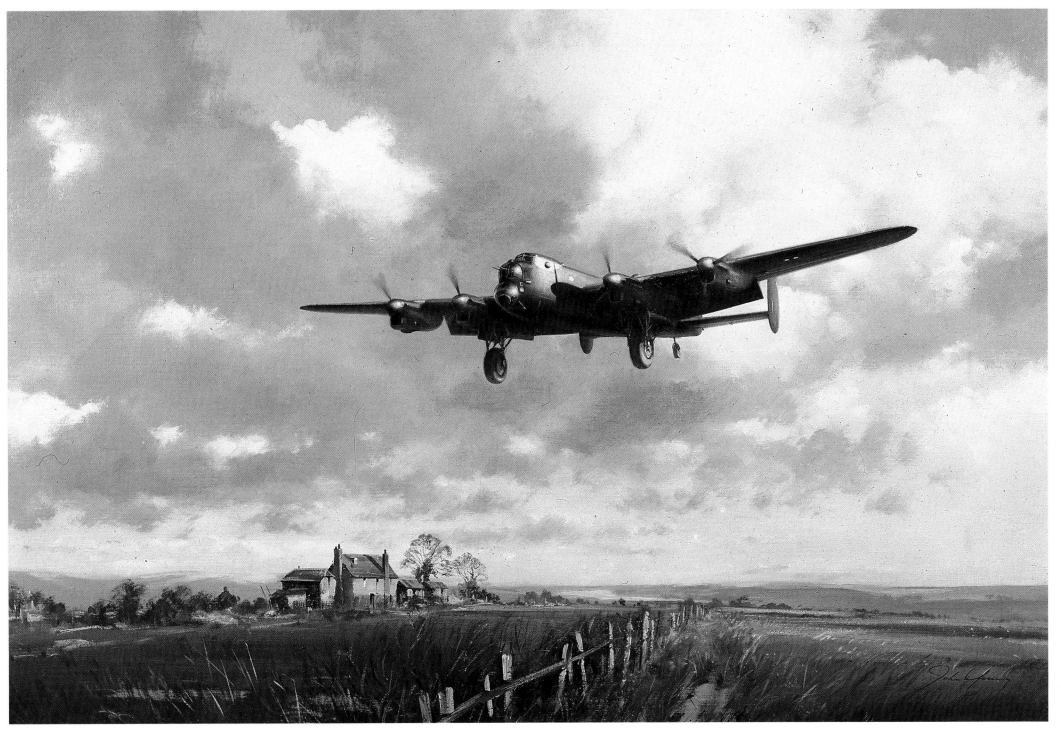

Charlie Safe Home
Avro Lancaster
Oil, 24ins x 36ins, 1988
Private collection.
Winner of the Roy Nockolds Trophy, 1988. I wanted to capture the dawn light, symbolising the long nights these crews endured, by projecting the shadow of the engine sideways on to the fuselage.

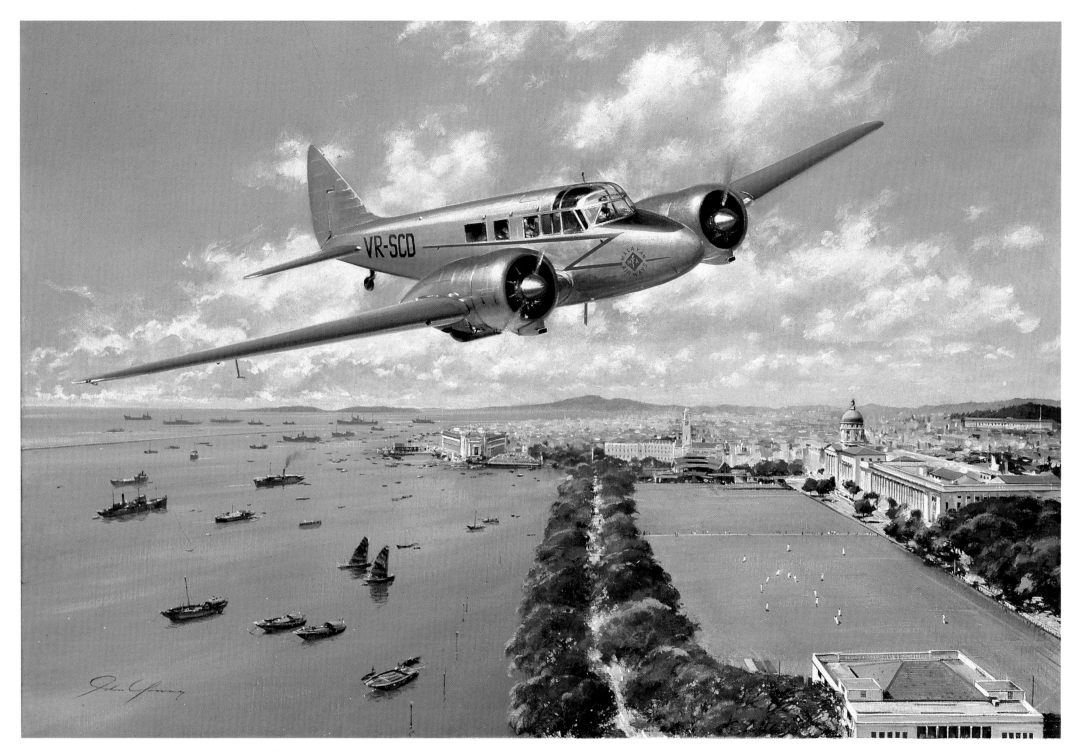

Airspeed Consul over Singapore, 1947
Airspeed AS.65 Consul
Oil, 24ins x 36ins, 1988
Reproduced by courtesy of Willis Faber plc.
A reconstruction of history, showing the first service flown
by the antecedent of Singapore Airways. The city is now
totally different, the waterfront area shown here has been
almost covered with skyscrapers – but the sacred turf of the
cricket pitch remains! The Consul was of wooden
construction, mainly covered in plywood with some parts
using fabric. Together with the metal engine nacelles, the
whole was sprayed with silver dope. The artist has to deal
with the subtle differences between this metallic finish and
the polished metal as in the B-24 Liberator on page 62.

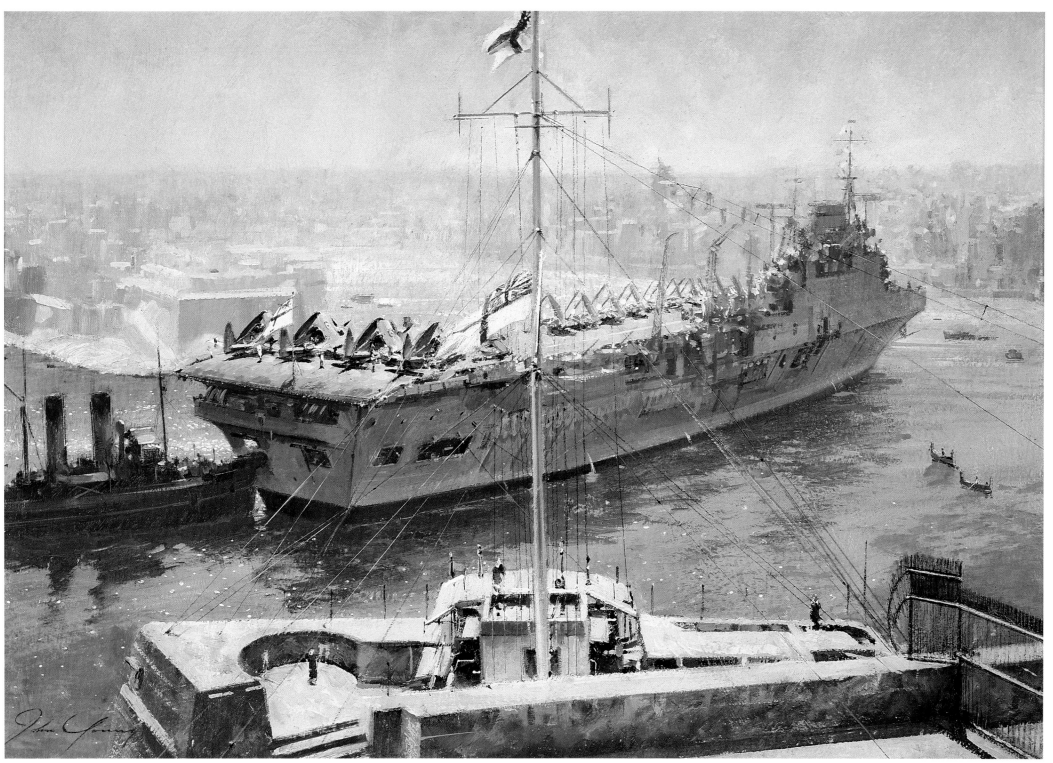

HMS Eagle at Malta
Westland Wyverns and Hawker Seahawks on deck
Oil, 17ins x 25ins, 1988
My first experience of Mediterranean heat and bright
sunlight is summed up in this scene of Grand Harbour,
Valletta, as I saw it in 1956.

Yukon Spring, detail

Man is the intruder in this harsh landscape, his presence
has a mere toehold in the environment. Although this is a
small painting, the feeling of space is important. The eye
must believe in the recession and the distance between the
rocks in the foreground right away to the peak of the
mountain several miles away. Threat towards the flier is
implied by the jagged stones close to the aircraft floats, and
the mountains, wreathed in mist and cloud, also suggest
danger. The necessary lightness of the machine's structure
is hinted at by the pale colour and the flimsy aspect of the
head-on view. Strong black is saved for the heavy radial
engine, the power that will lift the craft from the water and
over the high ridges. Smoke from the settlement and
wheeling gulls indicate life and activity, and the age of the
Yukon gold-rush is echoed in the retired sternwheeler in
the background.

If the Norseman does look fragile amongst this rough
terrain, it should be said that it was a rugged design, well
able to carry heavy oil drums and plenty more. It could
often be seen with a large canoe lashed to one float, the
noisy, powerful engine echoing around the mountains.
Sometimes the glassy calm of a lake presented a hazard to a
landing pilot as it would be extremely difficult to judge
height. His solution was to carry a few pebbles and toss
them out of the window to cause ripples and give a visual
reference to land safely. Then he could unlash his canoe
and paddle to the shore.

Yukon Spring
Noorduyn Norseman
Oil, 20ins x 24ins, 1985
Reproduced by courtesy of Herb Bonnet Esq.
As a boy, I found the stories of bush pilots a welcome
escape from Biggles and similar war storieggles and similar
war stories. This old Norseman is returned to the water
after a winter on skis. Norsemen, in camouflage and with a
wheeled undercarriage, were familiar to me at the end of
the war at my local airfield, including the one in which
band leader Glenn Miller went missing on a flight to
France.

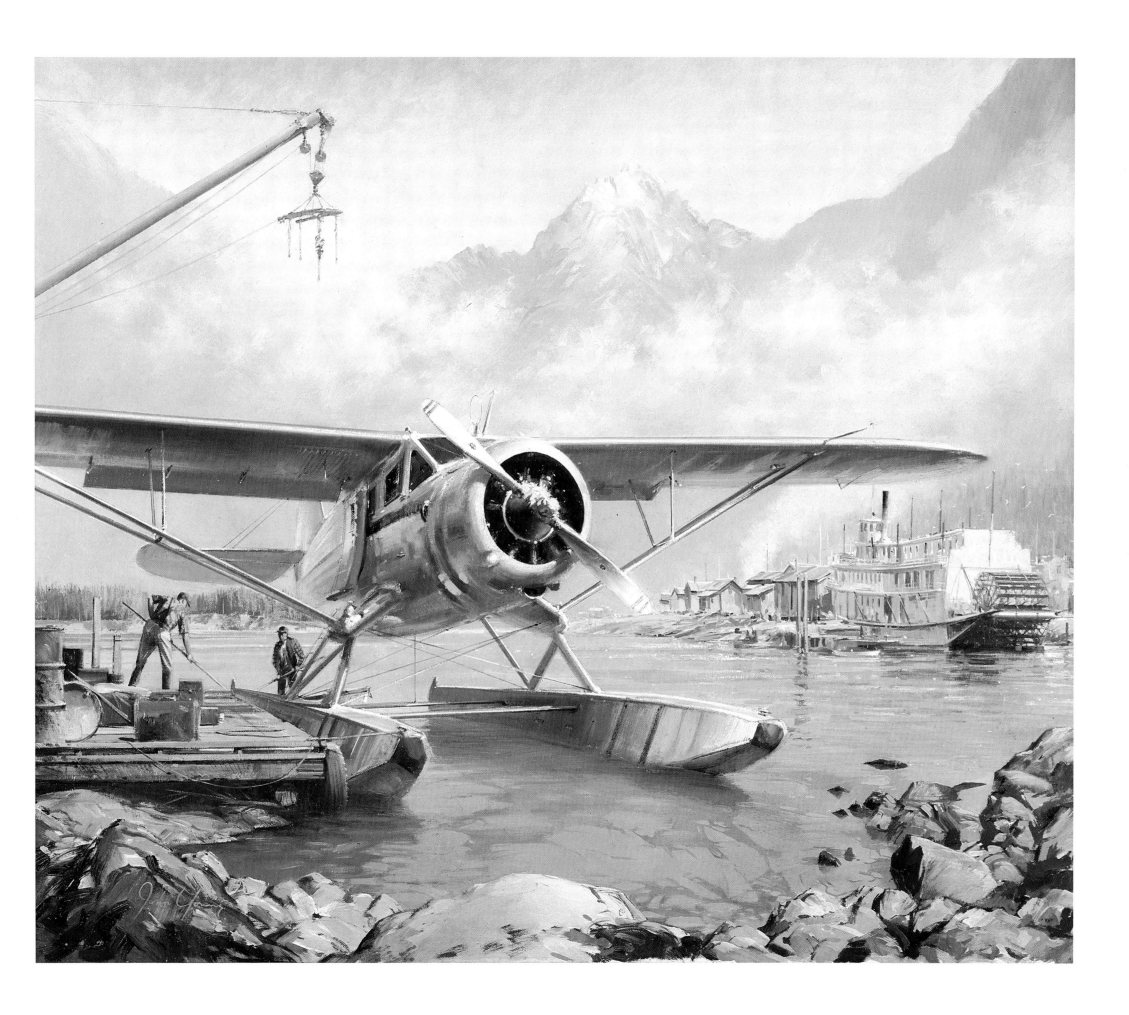

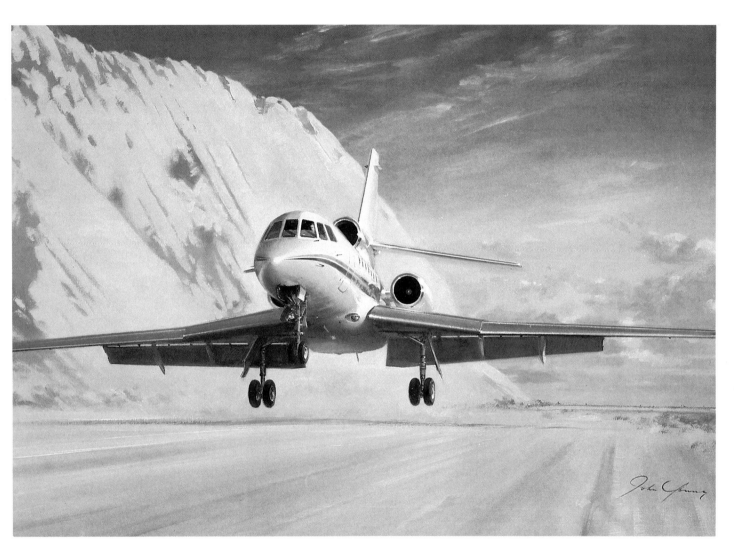

Falcon at Ayers Rock
Dassault-Breguet Falcon 50
Oil, 24ins x 36ins, 1981
Reproduced by courtesy of Falconjet.

modest. His painting of the Falcon 10 (which hangs today in our marketing conference room) stands out as a particular favourite. We wanted to capture the feeling of this versatile little jet which had great success in the Texas market, but with a slightly different twist. We first decided to enhance the western ambience by showing aircraft on the ground as opposed to in flight, which opened up a wealth of possibilities.

The Falcon 10 is unusual among swept-wing jets in that it retains excellent airfield performance at high temperatures and elevations. John quickly sensed that this was better dramatized by putting the Falcon in the right setting than by illustrating its full-span leading-edge slats and double-slotted Fowler flaps; and by showing the aircraft statically, as opposed to taking off or landing, which denies the proximity of objects to give it relative size. Further, the Falcon 10 is unique in its class in that it can operate from unpaved runways, and this is better shown from the ground- or eye-level as well.

John cogitated and scribbled while I sipped coffee and petted the cat. He cried 'Eureka!' as he sketched a grass strip at about 5,000 feet elevation, with ranch vehicles, a windmill and a Super Cub in the background. In the foreground was our gorgeous Falcon, seen from an angle that John thought was most flattering – and it is.

As for that different twist I mentioned – by putting an XA registration number on the tail (partially disguised by the sun's reflection) and a small Mexican flag, John artfully transformed the generic western US scene to a more exotic Mexican locale. And, as a final playful touch, he changed the Super Cub (barely visible on approach, on the left side of the painting) to what must undoubtedly be the only Auster in Mexico.

John House is Director of Communications for the Falconjet Corporation, Teterboro, New Jersey. In his spare time, John flies high-performance sailplanes.

FALCONJET (*John House*)

My first exposure to John Young's work was about 1977 when I saw a painting of his reproduced in *Professional Pilot* magazine. When, in 1981, Falconjet decided to commission some paintings of our aircraft, there was no doubt as to who the artist would be!

A few months later I was at John and Barbara's house in Chesham in the bleak of English winter, sitting cozily at their dining-room table with a black cat on my lap, a cup of hot coffee before me, with doodles and sketches and ideas spread out all over the place, and together John and I developed a plan of action.

The pleasure of working with John was worth every minute of the wait. He produced for us, over the years, eight original paintings in two series of four. Throughout the periods of creative effort, John graciously accepted and encouraged me as collaborator, though my role was actually far more

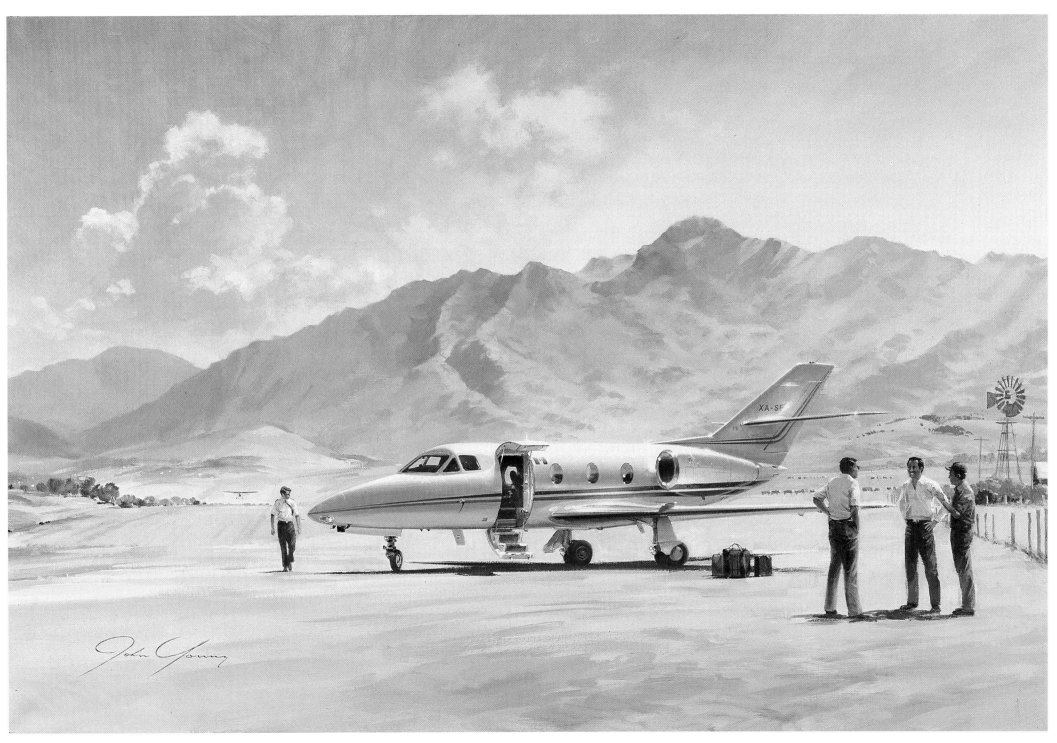

Mexican Falcon
Dassault-Breguet Falcon 10
Oil, 24ins x 36ins, 1981
Reproduced by courtesy of Falconjet.

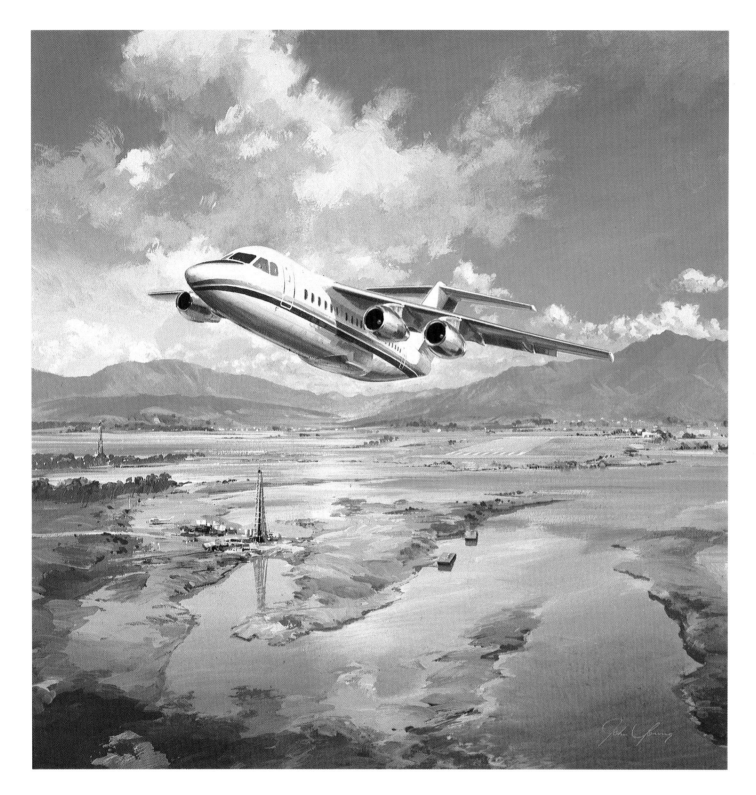

British Aerospace 146
BAe 146-100
Acrylic, 30ins x 30ins, 1978
Reproduced by courtesy of British Aerospace plc, Hatfield.
This painting is an example of the artist's impression,
having been used for publicity purposes for four years before
the aircraft made its first flight in September, 1981.

OPPOSITE **Salute to the Queen**
British Aerospace/Aérospatiale Concorde of British Airways
Oil, 24ins x 36ins, 1986
Reproduced by courtesy of Capt. and Mrs B.V. Hewes.
Crossing the North Atlantic with prestige is epitomised by
the British Airways Concorde passing the Cunard Line
flagship *Queen Elizabeth 2* in New York Harbour as she sails
for England. Her voyage takes five days compared with the
three hours of the Concorde travelling at the speed of a
rifle bullet. It took time to balance the elements of this
painting, beginning with the cityscape and trying the ship
and aircraft in a number of different positions.

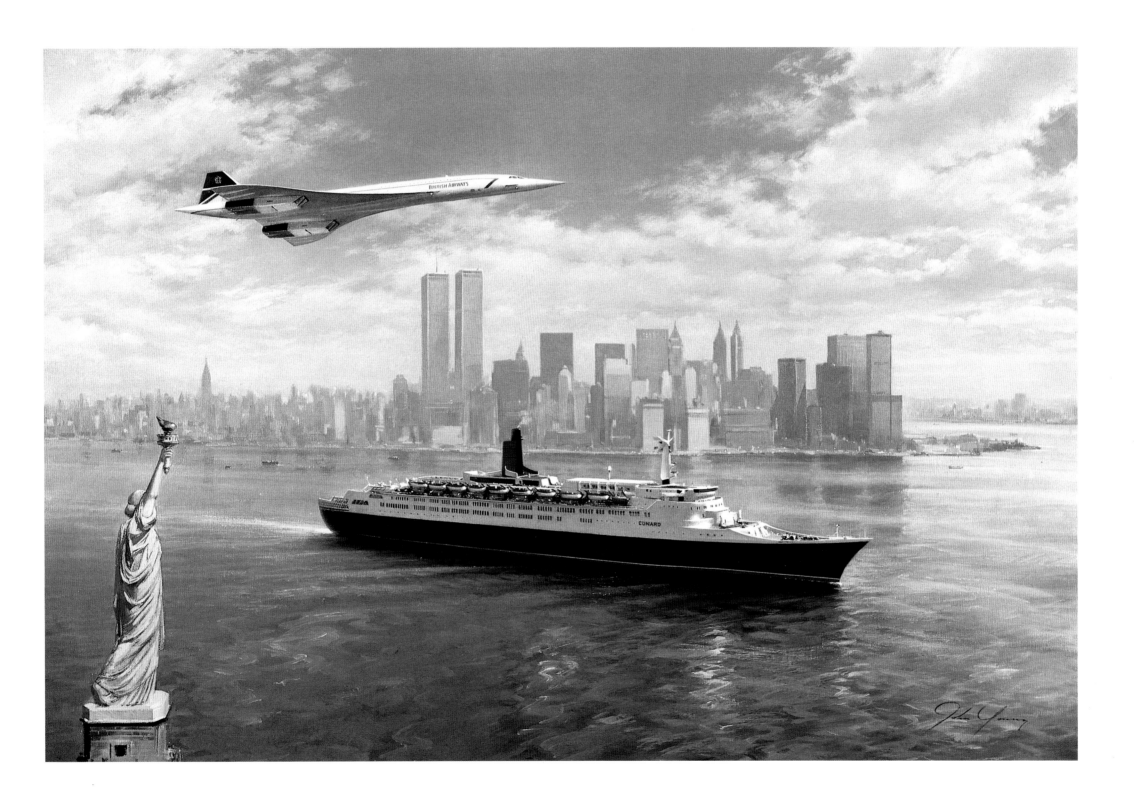

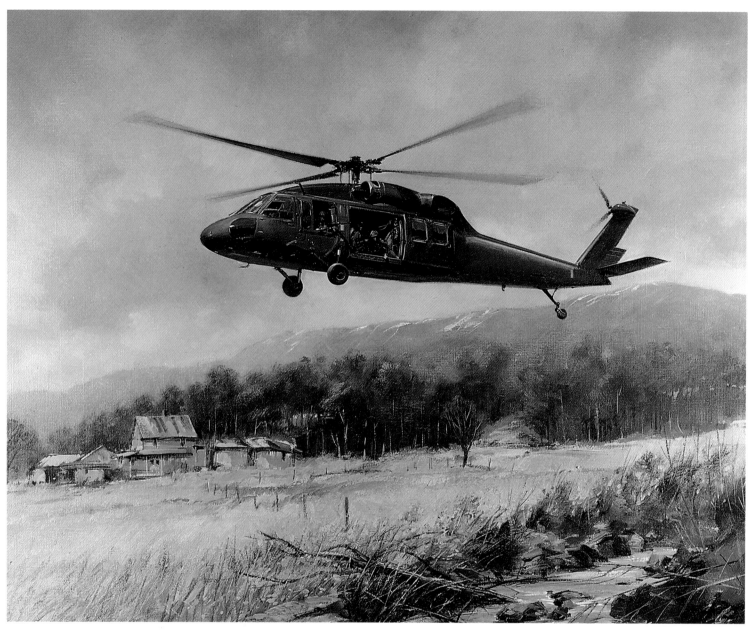

BLACK HAWK *(Bill Minter)*

A surprise gift of extraordinary value was presented to me by my wife, Valerie, on the occasion of our tenth wedding anniversary in August 1986. The painting by our friend, John Young, shows the US Army's UH-60A Black Hawk helicopter flying over a rural landscape in my home state of Connecticut, and it has a deep significance for us both. In addition to marking our first ten years together, it was presented to me in the tenth year of my work on the Black Hawk program for Sikorsky Aircraft. I have been privileged to be closely associated with this program following Sikorsky's success in a rigorous competition in the mid-1970s for the US Government contract to produce the aircraft at its main facility at Stratford, Connecticut.

Well over 1,000 of these aircraft have now rolled off the assembly line, which is located on the banks of the Housatonic River just a few miles from the site where Igor I. Sikorsky launched a new era in aviation history with the flight of the world's first practical helicopter in 1939. Mr Sikorsky's dream was to create a machine that could rescue people where no other method was practical or possible. He made that dream come true. The helicopter has saved an estimated two million lives since its first life-saving mission on the Connecticut coast during a severe storm in 1945. I believe this affirms the intimate relationship of Sikorsky, the helicopter and Connecticut that I have been able to share, and that is captured so beautifully in this anniversary gift from my wife. There is the helicopter with troops poised

Black Hawk
Sikorsky UH-60 Black Hawk
Oil, 20ins x 30ins, 1986
Reproduced by courtesy of Mr & Mrs W.A. Minter.

for a typical combat rescue against the backdrop of a New England setting. The skills of the artist tell a story that is both universal and intensely personal. It captures the essence of the Black Hawk which has been selected by all the US military services and also international customers, and it marks a proud chapter in my career in the aviation industry.

William A. Minter, Division Vice President, Government Compliance, United Technologies, Sikorsky Aircraft. Bill was Vice President of the Black Hawk Product Line from 1978 to 1988.

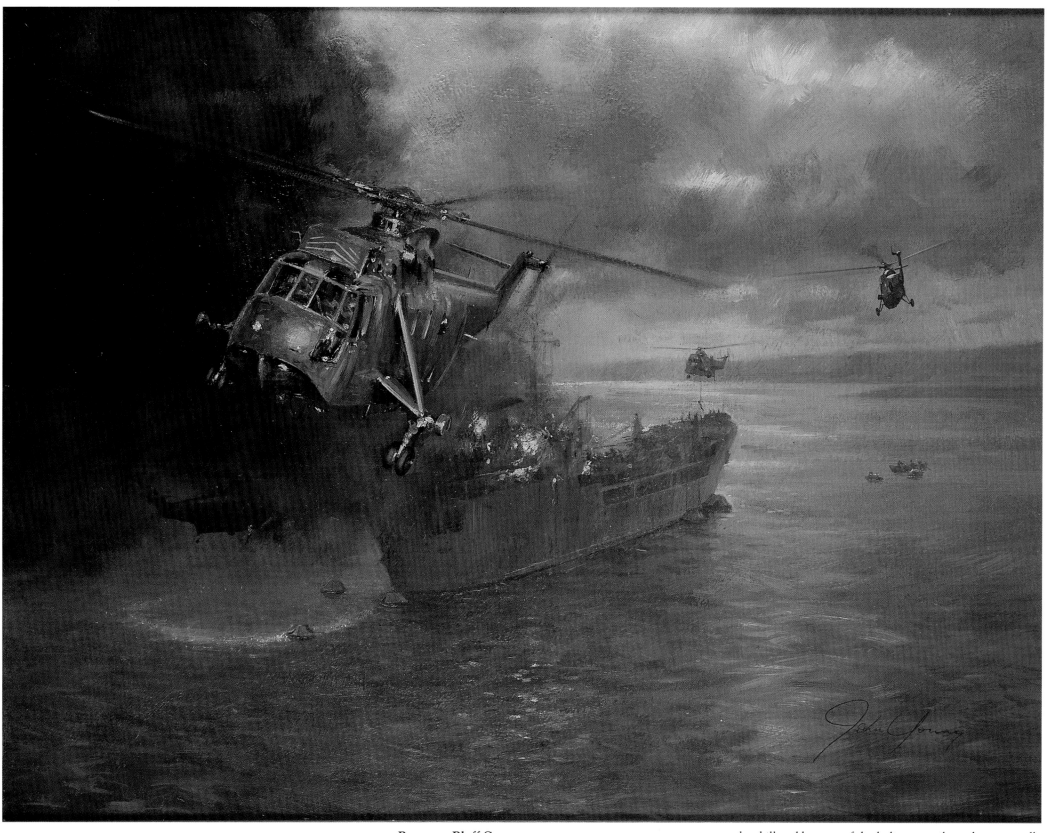

Rescue at Bluff Cove
Westland Sea King HC4
Oil, 27ins x 34ins, 1983
Reproduced by courtesy of Mr and Mrs G. Marjoram.
Having watched newsreel film I was deeply impressed by
the skill and bravery of the helicopter pilots who repeatedly
flew into the smoke to rescue troops from the R.F.A. *Sir
Galahad*. I painted this picture for a Falklands
commemorative exhibition at the Fleet Air Arm Museum.

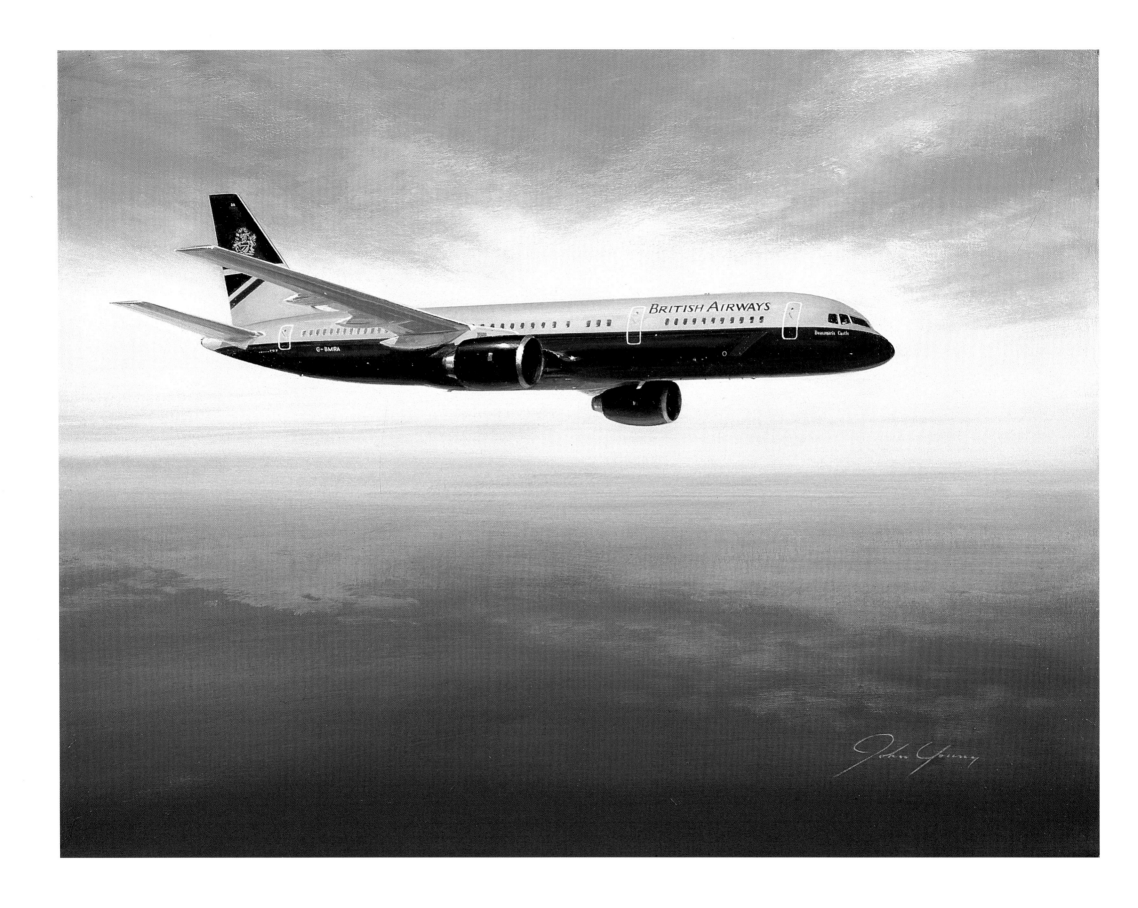

OPPOSITE **Beaumaris Castle**
British Airways Boeing 757 G-BMRA
Oil, 27ins x 34ins, 1985
Whenever I look out of the studio window there seems to
be a 757 over the Bovingdon beacon, either inbound or
outbound from Heathrow.

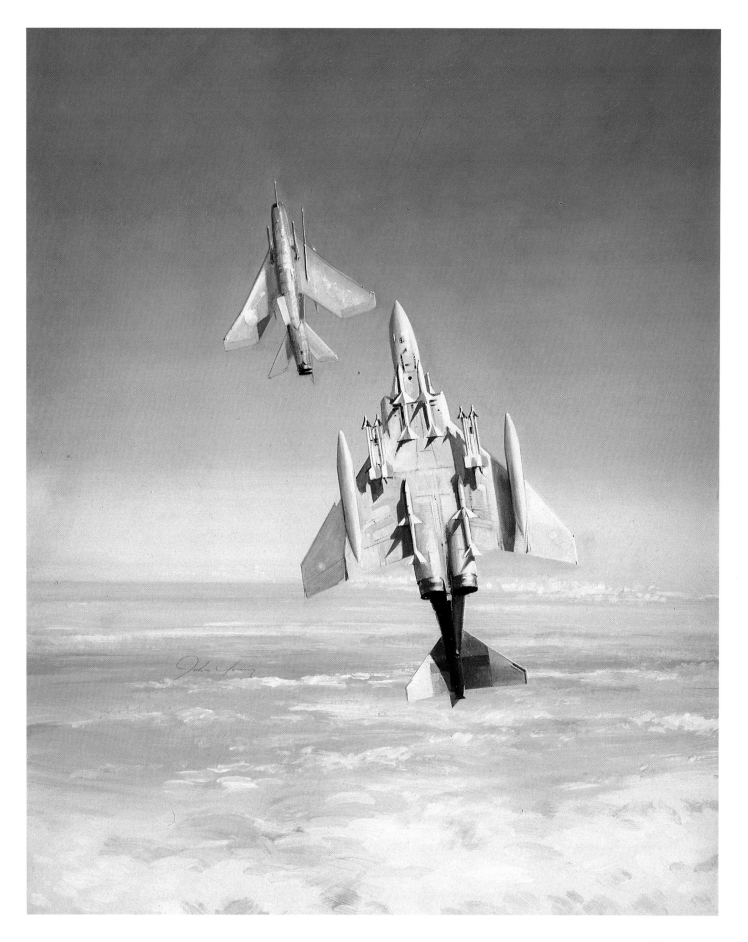

Phantom and Lightning
McDonnell Douglas F-4M Phantom FGR2 follows a BAe
Lightning F6 into a loop.
Oil, 24ins x 20ins, 1986
Reproduced by courtesy of the Ministry of Defence (RAF).
This and the painting on the following page were among a
dozen commissioned for the 1987 Royal Air Force
calendar.

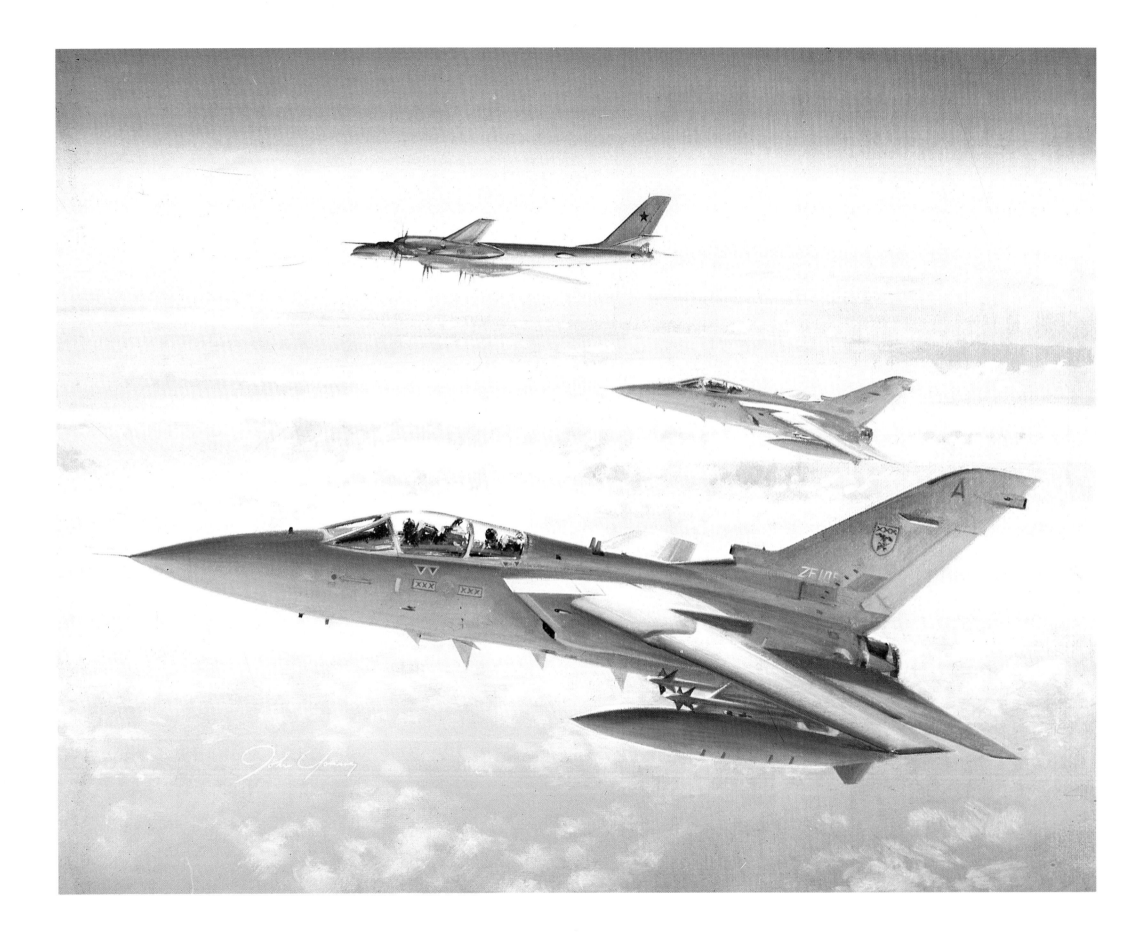

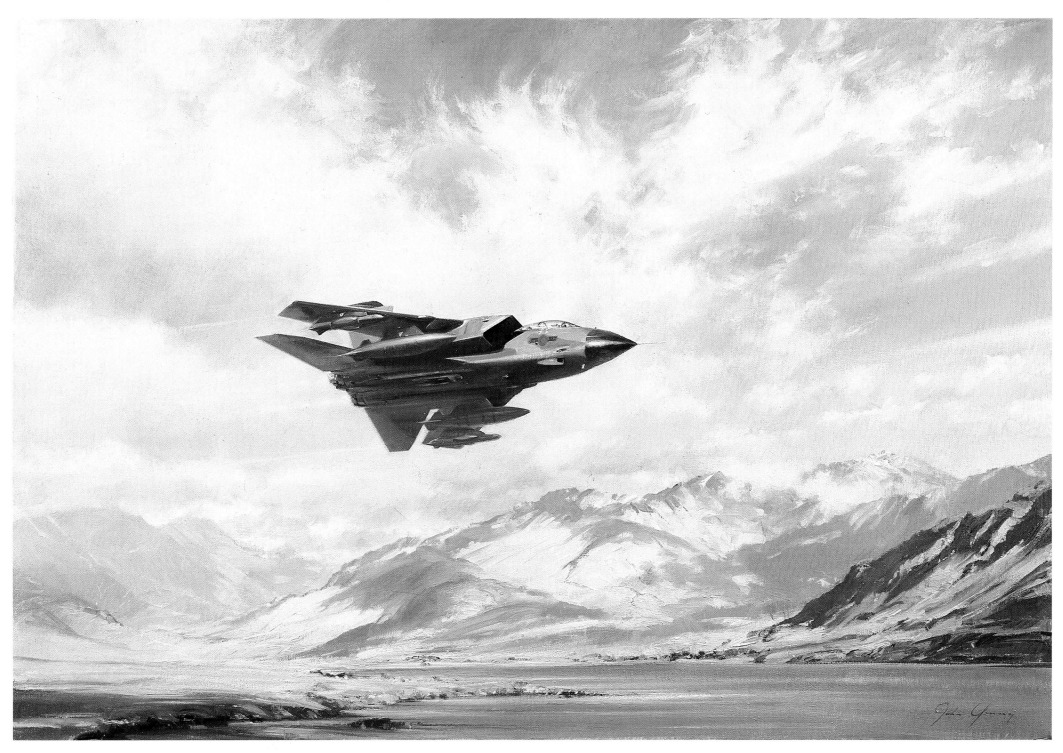

OPPOSITE **Tornados**
Panavia Tornado F.3
Oil, 24ins x 20ins, 1986
Reproduced by courtesy of the Ministry of Defence (RAF).
Two interceptors from No. 29 Squadron escort a Soviet
Tupolev 'Bear'. The Tornado is fitted with a swing wing,
allowing the angle of sweep to be varied, to ensure that the
best lift/drag ratio is achieved in combat manoeuvres.

Mud-Mover
Panavia Tornado GR.1 of 617 Squadron 'The Dambusters'
RAF
Oil, 24ins x 36ins, 1986
Reproduced by courtesy of the Royal Air Force College,
Cranwell.
The IDS version of the Tornado is shown with wings fully
swept and visible shock diamonds from the reheat on a
high-speed flight on the Scottish low-level route.

LEFT **Sunrise**
Oil, 12ins x 16ins, 1982
Reproduced by courtesy of Mr & Mrs W.J. Bond.

RIGHT **Suffolk Sky**
Oil, 16ins x 20ins, 1984
Reproduced by courtesy of Mr & Mrs R.M. Simons.

Burton Agnes Hall
Great Western 4-6-0 No 6998 'Hall' class
Oil, 20ins x 30ins, 1988
Reproduced by courtesy of C. Burden Esq.

Landfall
Acrylic, 20ins x 28ins, 1968
Reproduced by courtesy of Mrs B.A. Young.

Rob with Dick King
Old Rhinebeck Aerodrome N.Y.
1975